Elizabeth Cumming
obtained her doctorate from the University of
Edinburgh in 1987. As Keeper of the City of Edinburgh Art
Centre (1975–84) she organized many national and inter-
national exhibitions and catalogued the city's fine art
collections. Since 1984 she has lectured and curated exhibi-
tions, mainly on Scottish turn-of-the-century
art and design.

Wendy Kaplan
was educated at the University of Pennsylvania
and the Winterthur Museum Program. As Research Associ-
ate at the Museum of Fine Arts, Boston she organized the
major exhibition on the Arts and Crafts in America, *The Art
that is Life* (1987), and was principal author of its award-
winning catalogue. She has written widely on nineteenth-
and twentieth-century design and is a
museum consultant.

WORLD OF ART

This famous series
provides the widest available
range of illustrated books on art in all its aspects.
If you would like to receive a complete list
of titles in print please write to:
THAMES AND HUDSON
30 Bloomsbury Street, London WC1B 3QP
In the United States please write to:
THAMES AND HUDSON INC.
500 Fifth Avenue, New York, New York 10110

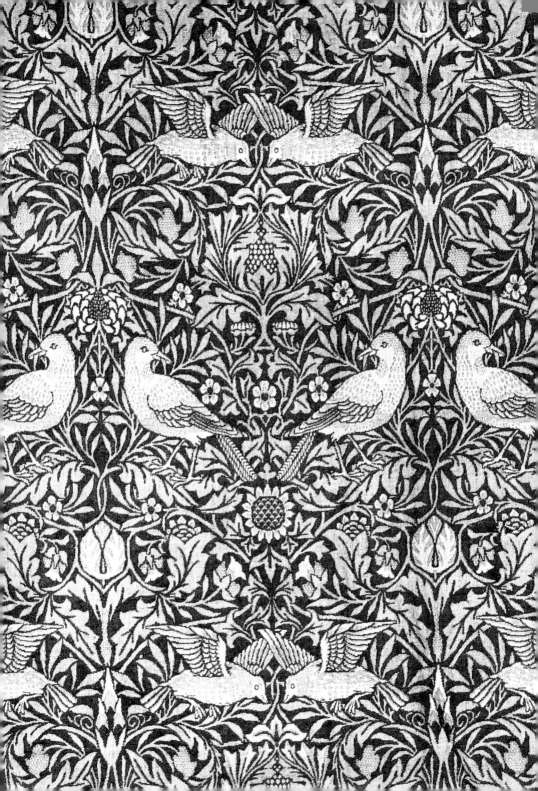

▪ THE ARTS ▪
AND CRAFTS
MOVEMENT

ELIZABETH CUMMING
▪ WENDY KAPLAN ▪

167 illustrations, 31 in colour

Thames and Hudson

For Murray and Philip

Frontispiece
Bird cloth designed by William Morris, 1878

ACKNOWLEDGMENTS

The authors wish to thank the many friends and scholars who have generously shared their expertise, particularly those who have commented on various chapters: Nicola Gordon Bowe, Alan Crawford, Ellen and Bert Denker, Marika Hausen, Gillian Naylor, Cheryl Robertson, Christopher Wilk and Christian Witt-Dörring. Wendy Kaplan extends grateful acknowledgment to the Henry Francis du Pont Winterthur Museum for a Visiting Scholar Fellowship to work on the book. Katharine Martinez and Neville Thompson were unfailingly helpful and enabled her to make the best use of Winterthur's incomparable library. Thanks are also due to Pat Eliot in Advanced Studies and to the Information Systems staff: Ann Marie Keefer, Kathy Howell, Jane Mellinger and especially Ruth Bryant.

Printed and bound in Singapore by C.S. Graphics

Contents

Preface

The Arts and Crafts movement had its roots in late nineteenth-century Britain. Its leading theorists – men such as William Morris, C. R. Ashbee and W. R. Lethaby – had trained as architects and worked towards unity in the arts, believing that all creative endeavour was of equal value. Not only did they want to reform design but to give quality once more to the work process itself. With its division of labour, the Industrial Revolution had devalued the work of the craftsman and turned him into a mere cog on the wheel of machinery. The aim of the Arts and Crafts reformers was therefore to re-establish a harmony between architect, designer and craftsman and to bring handcraftsmanship to the production of well-designed, affordable, everyday objects.

These principles were adopted in America and to a lesser extent in Continental Europe. Although practitioners had widely differing agendas, they shared the ideal of individual expression, of design that could draw inspiration from the past but would be no slavish imitation of historical models. Buildings were crafted of local materials and designed to fit into the landscape and reflect vernacular tradition. To provide design unity with these structures, furniture was often simple and 'honest' – left unpainted to display its method of construction and unpolished to reveal the beauty of its wood. Non-architectural, 'movable' crafts, from printed books and embroideries to jewelry and metalwork, on the other hand, were frequently far from plain and were intended, in an era of economic and social confidence, to equal the technical virtuosity and visual brilliance of earlier civilizations.

The improvement of commercial design always remained as serious a goal as the restoration of craftsmanship. Groups of leading designers not only set up craft societies but independent (if often short-lived) commercial companies. Morris was among the first to recognize that the only way to guarantee greater accessibility to his products was through commercial co-operation. By the height of the movement at the turn of the century new links were forged between

craft and industry. As a result of radical changes in design education recently introduced by Arts and Crafts leaders, manufacturers often turned to these newly trained artists and craftsmen to design textiles, ceramics, metalwork and furniture. The machine became accepted by many craft-designers as both a manufacturing necessity and, in effect, a craft tool. For manufacturers and retailers, however, Arts and Crafts was often simply one more marketable style.

For a few designers Arts and Crafts was part of a wider arena of social reform. For others reform meant a change in working conditions rather than design aesthetics: belief in the restorative power of craftsmanship and the search for a 'simple life' led them to establish workshops in idyllic, rural surroundings where art was promoted as a way of life.

High ideals, unfortunately, could not often be reconciled with practice. Ironically, the movement could only flourish in an age of prosperity created through industrial achievement: the architectural profession in particular depended on rich clients who were perhaps gentry but more often industrialists or members of the expanding professional classes. A more truly democratic architecture was realized only in the bungalow movement in America and post-1900 social housing in Britain. In object design there were similar problems: handwork using the finest materials was expensive and out of the reach of most consumers. The anti-industrial ideal – that of a single person conceiving and making an object from start to finish – was rarely achieved and frequently viewed as an elitist activity. More often furniture designers looked to the traditional, intuitive skills of local craftsmen. To a considerable extent craft-designers also depended on multiple production. Enamellers took their copper plaques to commercial jewellers to be set, and the most common practice in ceramic studios remained the hand-painting of factory-fired blanks.

Since the mid-1970s architectural, design and social historians have begun to record the immense scale and range of both professional and amateur Arts and Crafts activity and to unravel its complex and sometimes contradictory ideologies. Few now accept the view of Nikolaus Pevsner, put forward in his influential *Pioneers of the Modern Movement* (1936), of Arts and Crafts as an antecedent of modernism, to which it had contributed a functionalist and stripped-down aesthetic.

The four principles forged by Arts and Crafts – design unity, joy in labour, individualism and regionalism – form the central discussion of

this book. They are analysed within an outline of interwoven ideological and chronological development in Britain and in America and Europe. The Arts and Crafts architect's goal of design unity often precluded the craftsman's full participation in the creative process, and this vital distinction between architectural and studio crafts has also shaped the book. The discussion of architectural crafts is placed with building design in Chapters Two and Four and studio crafts in Chapters Three and Five. However, a complete survey of the architects, designers and craftworkers involved worldwide in the movement must await a much longer study.

Sources and Early Ideals

The Arts and Crafts movement was founded by theorists, architects and designers in Victorian Britain. They sought to provide an alternative code to the harshness of late nineteenth-century industrialism, to foster spiritual harmony through the work process and to change that very process and its products. Its leaders encouraged individualism, the creation of hand-made goods in place of machine uniformity, and a reappraisal of design materials. The multi-talented figures of the movement were professionally active as architects, as designers, as craftworkers, and often as all three. They were to produce a generation of architect-designers who would reform design, accept technical and aesthetic challenges and be aware of their national heritage.

In Britain the designers of Arts and Crafts buildings and objects did not adopt any neatly identifiable style; indeed, the very word 'style', as applied to historicist revivalism, was anathema to them. A short book entitled *Architecture, Mysticism and Myth*, published in London in 1891, summarized the idealistic nature of the movement when it had become a professional design force in Britain. Its author, the architect and historian W. R. Lethaby, a major figure in the movement, examined the past and looked towards the future when, he wrote, 'the message will be of nature and man, of order and beauty, but all will be sweetness, simplicity, freedom, confidence and light', all terms used at the time not only in application to architecture but to describe the quality of life.

A few architects, designers and artist-craftsmen, including C. R. Ashbee, Ernest Gimson and Eric Gill, abandoned London and moved deep into the English countryside to seek this 'sweetness' and beauty, finding there a respite from a metropolitan way of life. Gill, like Ashbee, wanted to establish a close, classless community living and working together. In his *Autobiography* (1940) Gill was to express this union of idealism with practical endeavour in his hope that he had at least 'done something towards re-integrating bed and board, the small farm and the workshop, the home and the school, earth and heaven'.

Many British Arts and Crafts leaders, like Lethaby, were Socialists but, while sharing Gill's desire to unite life and work, they preferred to act within the existing middle-class social and educational framework. They were also anxious to promote professional integration, to abolish divisions between art and industry, and between art and craft. Indeed, in their eyes the salvation of British industry and design could only be achieved through artistic intervention. Close identification of a way of life with the very creation of objects was none the less central to Arts and Crafts philosophy, was what gave it variety and made it, by and large, a movement focused on domestic design, and also one which, with its code of brotherhood, overlapped with both Victorian philanthropy and the growth of British Socialism.

The Arts and Crafts movement, however, was far from a sudden and spirited reaction to the ugliness of industrial society. It had evolved out of the strict design morality of the Gothic Revival in

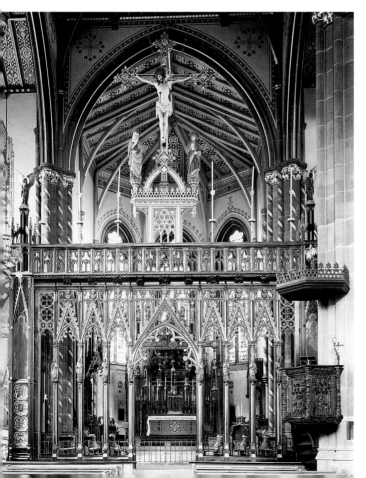

1 A. W. N. Pugin, Metropolitan Cathedral of St Chad, Birmingham, 1839–41. Interior

2 John Ruskin, 1882 study of a hand-carved relief from the north transept door, Rouen Cathedral. In 1869 he wrote that the cathedrals of Rouen and Florence were the 'two most beautiful Gothic pieces of work in the world'

early Victorian Britain, nurtured, supported and helped along its path towards a moral but free aesthetic by a number of strong-willed theorists and practitioners. The architect and theorist A. W. N. Pugin (1812–52) in his books *Contrasts; or, a Parallel between the Noble Edifices of the Fourteenth and Fifteenth Centuries, and Similar Buildings of the Present Day; Shewing the Present Decay of Taste* (1836) and *The True Principles of Pointed or Christian Architecture* (1841) provided the foundation from which the moral aesthetics of Arts and Crafts evolved during the second half of the century. Pugin rejected the early Victorian vogue for Classical architecture in favour of a revival of medieval Gothic, which, he believed, reflected the order and stability of the Christian faith. To stem 'the present decay of taste', he turned to pre-industrial England for inspiration. In *Contrasts* he stated for the first time that architectural beauty depended on 'the fitness of the design to the purpose for which it is intended'. He found in the asymmetry of Gothic architecture a response to need and condition lacking in the current Neo-classical revival. The critic John Ruskin (1819–1900) was to echo Pugin's belief in the utility of Gothic design in his essay on 'The Nature of Gothic' in *The Stones of Venice* (1853): 'It is one of the chief virtues of Gothic builders, that they never suffered ideas of outside symmetries and consistencies to interfere with the real

use and value of what they did. If they wanted . . . a room, they added one; a buttress, they built one; utterly regardless of any established conventionalities of external appearance . . .'

Pugin's dream of re-uniting designer and craftsman and, in broader terms, the spiritual with the everyday, was taken up by Ruskin and the designer and writer William Morris, the two main founders of the Arts and Crafts movement. The belief that the builders and craftsmen of the later Middle Ages enjoyed complete freedom of expression was central to the writings of Ruskin who, like the social philosopher and historian Thomas Carlyle, condemned the machine-orientated society of Victorian Britain. In *The Seven Lamps of Architecture* (1849), a book which inspired architects and designers particularly during the 1880s and early 90s, Ruskin emphasized the beauty of architectural ornament carved by hand, which reflected 'the sense of human labour and care spent upon it'. The idea that any building or object must be created with enjoyment to be of value, first voiced in *The Seven Lamps* but stressed in 'The Nature of Gothic', was Ruskin's major legacy to the Arts and Crafts and one which laid the basis not only for the work of Morris but also for the creeds of craft guilds later in the century.

Ruskin pleaded for individuality in artistic creation at a time when the scale of commercial production was soaring year by year and increasingly isolating the designer of an object from its maker. A general desire to improve standards of design for manufacture was widely felt in Britain and with increasing urgency in the years immediately following the publication of *The Seven Lamps*. The Great Exhibition held in London in 1851 had demonstrated the low quality of British design. It influenced government schemes, led by the Exhibition's director, Henry Cole, to introduce new design museums with historic collections and visiting exhibitions that would inspire contemporary work. In addition, schools were founded to teach new methods of 'ornamental' instruction. Part of the impetus behind the new reforms was a reaction by British manufacturers to the recent fashion for French floral textiles and wallpapers. In order to compete commercially, British design reformers rejected the technically more difficult, naturalistic qualities of the foreign designs and advocated geometric formality. The designs of Owen Jones (1809–74), Superintendent of Works for the Great Exhibition's Crystal Palace, remain the best known of these and his *Grammar of Ornament*, published in 1856, quickly became a pattern book for British design and taste. Jones favoured a mathematical approach to colour and design instead of the imitations of nature offered to the British market.

12

3 Owen Jones, 'Egyptian
Ornament', *The Grammar of
Ornament* 1856 (detail)

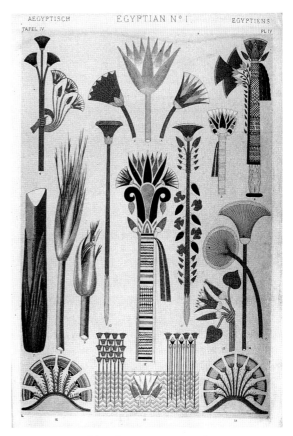

The fine and the applied arts were segregated by the government's
design reform schemes which centred on the new museum and art
school at South Kensington, London, and extended to schools in
Dublin, Manchester, Edinburgh, Birmingham and other cities.
Ruskin scorned the division in his book of 1859, *The Two Paths*,
writing that decorative art was not 'a degraded or a separate kind of
art'. In contrast to Jones, he supported freedom of expression for
the designer and the direct study of nature as a source for both artist
and designer. Most importantly, he re-introduced morality to art and
design, arguing that the way to improve society was to reform its art,
and supported indigenous historical sources for design. Christopher
Dresser (1834–1904), who had trained as a botanist, led the British
counter-attack on Ruskin in his book *The Art of Decorative Design*
(1862). He wanted design to represent the laws of natural growth, not
its appearance. Dresser's scientific qualifications gained him respect,

13

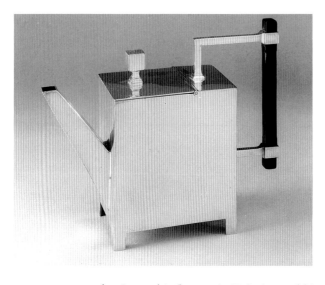

4 Electroplate teapot designed by Christopher Dresser, *c.* 1878–79, made by James Dixon & Sons, Sheffield

authority and influence in Britain, and his own designs, reflecting his
4 theory, were simplified, angular and cheap to manufacture.

In calling in *The Two Paths* for specific consideration of the
domestic arts, Ruskin also demanded design which used natural scale,
form and materials to express 'man's delight in God's work'. He
looked at both the work ethic of the individual and production
methods. His goal was closer collaboration, as in the Middle Ages,
between architect and mason, for craftsmen who would create their
own unique designs and for painters who would grind their own
pigments. His condemnation of capitalist industrialism and his
determination to give practical shape to his ideas led to the founding
of his Guild of St George, with himself as Master, in 1871. Guild
members were obliged to live and work according to Ruskin's
religious and moral principles and contribute to Guild funds; in return
they received fair pay and enjoyed healthy work and shared in
communally owned farms and industries. Attracting minimal
immediate response it did little to improve the general run of society
but it provided a precedent for later craft guilds.

Although Ruskin's lectures to students and workers in Oxford,
London and other British cities drew large audiences, and his writings
were widely read and admired on both sides of the Atlantic, it was
William Morris (1834–96) whose ideas exerted the longest and most
powerful influence. Like Ruskin, he came from a comfortable
background which allowed him both the time and the means to select
a vocational career. Like Ruskin, too, he became a renowned and

revered educationalist, theorist, writer and lecturer. Both men were driven by their revulsion of what they saw as a sick society, Morris writing that 'apart from my desire to produce beautiful things, the leading passion of my life is hatred of modern civilisation'. Morris took Ruskin's love of the handwrought roughness of the crafts and wanted to see it applied to modern commerce: his goal was to challenge manufacturers to simplify design not only in order to raise standards and keep unit costs at an affordable level but also to draw together the designer and the craftsman. But whereas Ruskin stood clear of politics and the work process he advocated, Morris, reaching maturity during a period of greater democracy and a new status for the worker, became not only an active Socialist but a craftsman and a designer much admired by his peers.

Ruskin had advised artists and designers to turn to nature for inspiration and instruction. Morris's designs, with their plant and later p.2 their bird detailing, were a response to Ruskin but were also, in their flatness, part of the new design movement. They show as well Morris's interest in historical textiles which stemmed from his time as an Oxford apprentice to the architect G. E. Street (1824–81) in 1856. Street, like Pugin, was an exceptional designer of architectural fittings and furniture and, moreover, was particularly experienced in traditional building crafts. He believed in an interdisciplinary approach to architecture: he thought an architect should be not only a builder but also a painter, a blacksmith and a designer of stained glass.

There were other major influences on Morris at this time. He had met the painter Edward Burne-Jones (1833–98) when they were both undergraduates at Oxford. Sharing an enthusiasm for old buildings and historic crafts, and with Ruskin's *Seven Lamps* as a guide, they studied at first hand the 'axe hewn' and 'mountainous strength' of the Gothic architecture of northern France. Morris also looked at the Oxfordshire vernacular architecture with Street's senior draughts-man, Philip Webb (1831–1915). He and Webb were especially committed to unpretentiousness and honesty in architectural think-ing, which distinguished them from most high Victorian architects. They considered, for instance, that an architect's design should be a reflection both of its site and purpose. Moreover, their detailed study of medieval architecture led them to espouse Street's conviction that a thorough working knowledge of building materials was as essential to an architect as a happy relationship with his craftsmen.

In 1859 Morris commissioned Webb to design a house for him and his bride, Jane Burden. A functional dwelling without historicist

9 pretensions, Red House, in Upton, Kent, took its name from its construction material, red brick. The garden, designed by Morris, was established on both romantic and practical lines, with a medieval combination of orchards and garden plots separated from long grass walks by rose trellises. Described in 1862 as 'more a poem than a house' by Morris's friend, the Pre-Raphaelite painter and poet Dante Gabriel Rossetti (1828–82), the house was decorated by Rossetti, the Morrises and their friends, with murals and embroidered hangings using richly coloured flower, tree, animal and bird motifs. Webb designed many of the fittings, including furniture, some of which was
15 painted by Burne-Jones and Rossetti with scenes from medieval romances, and also window glass, metalwork candlesticks, and table glass made by James Powell & Sons of Whitefriars, London. The type of decoration used in furnishing Red House, with its medieval Gothic spirit and strong colours, presented a more relaxed, intimate alternative to the dramatic, medieval designs of the 1860s by the London 'art-architect' William Burges (1827–81).

The launch from this personal scheme into the commercial world was swift and confident. The decorative and fine arts were formally

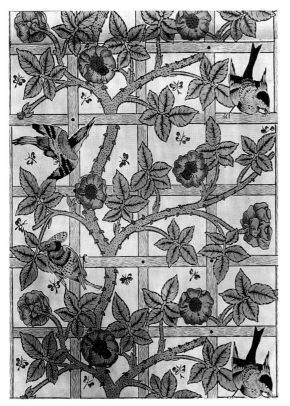

5 *Trellis* wallpaper designed by William Morris, 1862

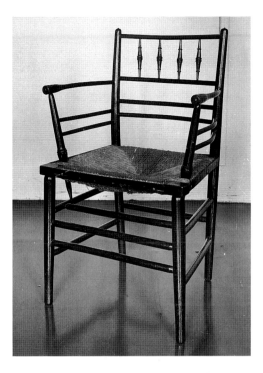

6 'Sussex' chair designed by D. G. Rossetti, *c.* 1865, sold by Morris & Co.

re-united: in 1861 the first prospectus of the firm of Morris, Marshall, Faulkner & Co. described Morris and his friends as 'Fine Art Workmen in Painting, Carving, Furniture and the Metals' and their aim to produce 'harmony between the various parts of a successful work'. The firm could provide mural decoration (in pictures or pattern work), carving, stained glass, metalwork (including jewelry) and furniture. Wallpaper was first produced in 1862 when *Trellis* 5 appeared, designed by Morris with bird detailing by Webb, a keen naturalist whose animal drawings were also used in stained glass, and later on, tapestry. Based in Red Lion Square until 1865, the firm, like 8 Red House, was a collaborative venture, with artist members, friends and spouses producing much of the work.

The firm moved, with the Morris family, to larger premises in Bloomsbury in 1865 and in 1875 was restructured as Morris and Company with Morris as sole proprietor. Its methods and materials were a mix of traditional and new ideas. The 'Sussex' range of chairs 6 designed by Rossetti, for instance, was adapted from English country designs of the mid-eighteenth century and married ebonized wood in current commercial use with natural rush seating crafted by hand.

Old and new ideas were also integrated at Kelmscott Manor in Oxfordshire, leased by Morris as a country home from 1871. A sixteenth-century house, Kelmscott was furnished with eastern ceramics and both English traditional and Morris furniture.

Morris expanded the firm in new directions. He opened a shop at 264 (later 449) Oxford Street, London, in 1877, a workshop for hand-knotted rugs in Hammersmith the following year and, in 1881, a tapestry-weaving workshop at Merton Abbey in Surrey. In the 1860s and 70s he used outside firms to print his own company's textiles and also supplied designs to others, notably the Royal School of Art Needlework. Established in 1872 to provide 'suitable employment for poor gentlefolk' in the restoration of old work and the creation of new, the School's primary goal was to restore 'ornamental Needlework to the high place it once held among the decorative arts'. Like the Ladies' Ecclesiastical Embroidery Society founded by Street's sister in 1854, the School used both traditional designs and those supplied by enthusiasts including Street and a fellow Gothic architect G. F. Bodley.

By latching onto these organizations, and through them the burgeoning philanthropist movement, Morris was able to extend his design influence. He became increasingly dismayed, however, by the obvious contradiction between his ideal of a democratic art and the 'idle privileged classes' who formed his patrons. His pursuit of good design translated into carefully executed, cheap products remained a dream. The realization that his labour-intensive products could not be purchased by ordinary people went hand-in-hand with his growing commitment to Socialism: in 1883 he joined the Democratic Federation. Despite this, his love for the beauty of careful, slow craftwork remained unquenched and sat uncomfortably beside his Socialist ideals for the rest of his life. His last venture was the Kelmscott Press, founded in 1890 near his Hammersmith home, Kelmscott House, to revive the art of the printed book. The Kelmscott books used texts ranging from Ruskin and Morris's own prose romances to Chaucer. Morris wanted these books, like the products of his firm, to be the antithesis of recent crude commercial production. They were monochrome artworks, many of which were printed to designs by Burne-Jones and produced in limited editions for an upper-class, well educated market.

A much wider interest in the crafts meanwhile had been gaining ground across Britain. Led by high-minded upper- and middle-class women, reformers or church officials, organizations across Britain

strove to maintain or revive regional crafts in order to both help the craftworker and ensure the survival of craft techniques. The scale of this craft movement, which owed much of its impetus to political decisions, economic change and regional social conditions, was much larger, in aggregate, than the London activities of design reformers.

The craft workshops followed a few established much earlier in response to economic necessity and social responsibility. The Golspie Society in northern Scotland, for example, had been founded by Harriet, Duchess of Sutherland, in 1849 in the wake of the Highland Clearances which had devastated farming communities and caused immense poverty. The craftworkers here and elsewhere were, on the whole, female, and their disciplines were ones traditionally executed by women – lace-making, spinning, weaving and knitting. Many later groups were more directly inspired by the work of Ruskin, who lent financial support to the uneconomic craft of hand-spinning on the Isle of Man during the 1870s.

The success of the cottage home industries was due to the leadership of the upper classes, the involvement of a new moneyed middle class eager to find and express its role in society, and the commitment of both to workforce welfare and, by extension, public awareness. The

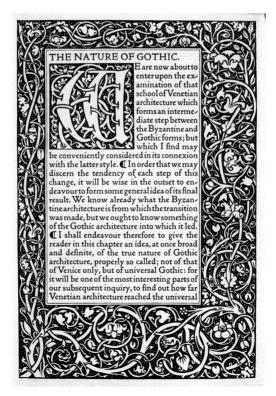

7 John Ruskin *The Nature of Gothic*, printed and published by the Kelmscott Press, 1892. First text page with borders by William Morris

THE NATURE OF GOTHIC.

E are now about to enter upon the examination of that school of Venetian architecture which forms an intermediate step between the Byzantine and Gothic forms; but which I find may be conveniently considered in its connexion with the latter style. In order that we may discern the tendency of each step of this change, it will be wise in the outset to endeavour to form some general idea of its final result. We know already what the Byzantine architecture is from which the transition was made, but we ought to know something of the Gothic architecture into which it led. I shall endeavour therefore to give the reader in this chapter an idea, at once broad and definite, of the true nature of Gothic architecture, properly so called; not of that of Venice only, but of universal Gothic: for it will be one of the most interesting parts of our subsequent inquiry, to find out how far Venetian architecture reached the universal

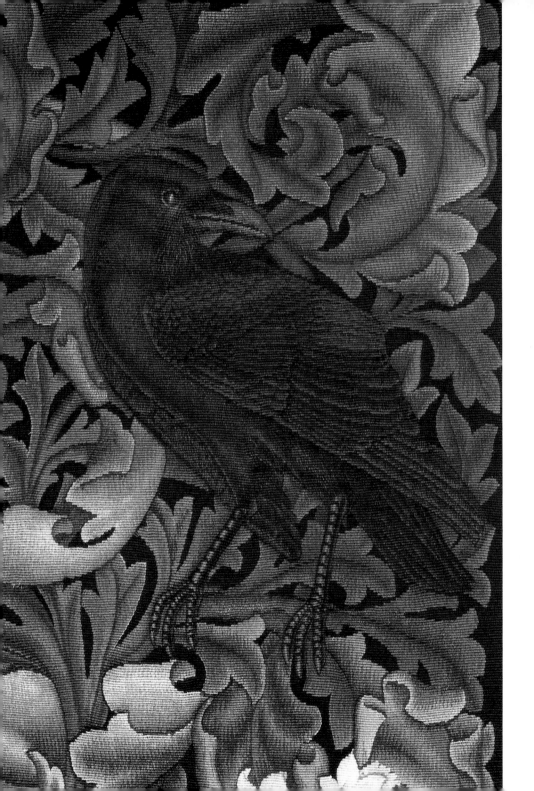

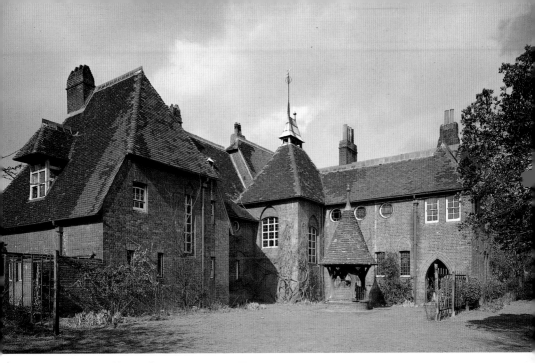

9 Philip Webb, Red House, Upton, Kent, 1859–60

Home Arts and Industries Association, supporting professional and amateur work, was founded in 1884 to provide a London shopwindow and co-ordinate provincial activities. Within two years regional associations also covered Wales, Ireland and Scotland. While there was some overlap between the country craft revival and Morris's intended commercial revolution, the wide-reaching home industries movement had no sympathy for the rallying call of Morris's socialism which threatened, in their eyes, a newly found social stability.

The settlement house movement, providing accommodation, group craft classes and fellowship, formed an urban counterpart to the rural home industries. Organizing committees and instructors came from various middle-class backgrounds: many were architects, industrial designers or trained artists; other participants with a shared social conscience included university professors or clerics. It reached its peak during the early and mid-1880s when, for example, Toynbee Hall was founded by Canon Barnett and his wife Henrietta among the working class of London's East End, and the Edinburgh Social Union and branches of the Kyrle Society in Birmingham, Leicester and Glasgow were set up. All were concerned with the welfare of the

< 8 *The Forest* tapestry, 1887, designed by William Morris, J. H. Dearle and Philip Webb, woven by Morris & Co. (detail)

worker and in particular with redirecting the leisure hours that reformers feared would otherwise be spent in drinking or gambling. Classes in woodcarving and metalworking, led by local men and women, aimed to occupy free time and provide aesthetic stimulation and, not least, objects with which to beautify the home. The Edinburgh and Glasgow societies were among those who organized the mural decoration of mission and school halls by local artists. For some of the nation's working classes, at least, art did become part of everyday life.

Craft as a tool in moral reform was practised throughout Britain but advancement in design was centred on London. Morris was not alone in regarding architecture as the primary art form to which all others were related, nor in putting into practice his Ruskinian idea of artists and craftsmen banding together. The Century Guild, a loose collective of designers, was founded in 1882 by A. H. Mackmurdo (1851–1942). Brought up in a family whose circle included Ruskin, Carlyle and Herbert Spencer, Mackmurdo trained in the office of James Brooks, an architect he described as a craftsman who designed 'every detail to door hinge and prayerbook marker'. Ruskin and the young Mackmurdo travelled together in Italy and France and studied nature and architecture to understand 'the law underlying all organic form'. When Mackmurdo founded his Guild, 'to render all branches the sphere no longer of the tradesman, but of the artist' and to restore building, decoration, glass painting, pottery, woodcarving and metalwork 'to their rightful places beside painting and sculpture', his philosophy echoed those of both Ruskin and Morris.

Mackmurdo was generally more concerned with design reform than changing the role of the designer or artisan in society. Much of the Guild's textile or furniture output was produced by manufacturers such as Simpson and Godlee or Collinson and Lock. Mackmurdo recognized the conflicts in Morris's philosophy, writing in his journal that the latter was not able to devise a plan for a new social structure and that his 'socialism has no philosophical basis'. He himself was willing to stand outside politics while remaining, like many architects, flexible in his interests and commissions. He drew up plans, for instance, for a working men's club in Birkenhead, Liverpool, and for middle-class community housing in Ealing, London, as well as for the private house.

The Century Guild, intent on raising both the quality and stature of design, produced some of the finest work not just of the decade but of the century. Guild textiles, furniture and metalwork abolished the

10

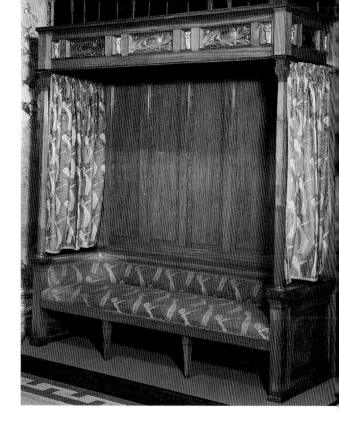

10 Century Guild settle, c. 1886, designed by A. H. Mackmurdo, metalwork by Benjamin Creswick, with Herbert Horne's *The Angel with the Trumpet* fabric, blockprinted by Simpson and Godlee

mechanical symmetry and weight of Victorian decorative art, established a new lightness in design and used flicking rhythmic forms to express the organic richness of natural growth.

The strong interdisciplinary aim of the Guild was reflected in both its products and the wide skills and interests of its members. Furniture bore metal inlay, drapery or painted panels. *The Hobby Horse* (1884, 1886–92), founded by the Guild, was the first literary journal to have a specific design remit, and it reflected Guild aesthetic principles: it was produced with the encouragement and advice of the typographer and Socialist Emery Walker (1851–1933) who was to advise Morris on the Kelmscott Press. Selwyn Image (1849–1930), a former curate who had studied with Ruskin, provided graphic designs for this journal and many independent publications, and was also a designer of needlework, mosaics and stained glass. Herbert Horne (1864–1916), writer, poet and textile designer, had been articled to Mackmurdo in 1883 and became the journal's main editor. Others worked more independently but were Guild associates, for the Guild acted also as an

11

11 Selwyn Image, cover of *The Hobby Horse* 1886

agency for designer-craftsmen and some firms including Morris & Co. Benjamin Creswick (1853–1946), sculptor, metalworker and designer, was a former Sheffield cutler, while Clement Heaton (1861–1940), a stained-glass artist and metalworker, had trained in his father's firm.

Central to the Century Guild was its professionalism and its sense of brotherhood. Its members mixed socially with fellow aesthetes and the literary circles of the day. In its everyday work in Fitzroy Square, a residential area associated with the Aesthetic movement, the Guild was able to build a new status for the designer and affect consumer taste. Like the Morris company, it also advertised itself at the many municipal industrial exhibitions of the 1880s and received private commissions for architectural and interior designs, of which the best-known remains Pownall Hall, Cheshire, for Henry Boddington.

12

24

Ruskin's advocation of individualism and the importance of meticulous execution in producing everyday objects together with the example of the Morris company had begun to re-unite design and craftsmanship on a wide scale. New art societies were established to meet the needs of an expanding design profession. The first of these, the Art Workers' Guild, was founded in 1884 by a group of free-thinking architects – Lethaby, E. S. Prior, Ernest Newton, Mervyn Macartney and Gerald Horsley, all pupils of the London Scot architect Richard Norman Shaw. The Art Workers' Guild, like 'The Fifteen', a new group of designers, was established in direct opposition to the Royal Academy, who refused to exhibit decorative art objects, and the conservative Institute of British Architects. It set out not only to raise design standards but actively to promote, like the Century Guild, 'the Unity of all the Aesthetic Arts'. The meetings of the Art Workers' Guild were a forum for the exchange of ideas and theories and, not least, socializing.

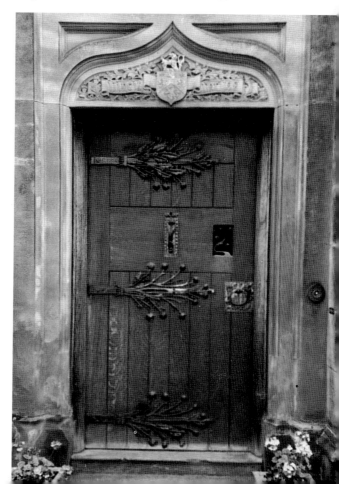

12 Century Guild door, 1886, Pownall Hall, Cheshire

The Art Workers' Guild at first attracted local London architects, although by 1886 a number of designer-craftsmen had also joined, including Lewis F. Day (1845–1910), a leading designer of not only textiles but wallpapers, stained glass, embroidery, pottery, book covers and furniture, the book-designer and binder T. J. Cobden-Sanderson (1840–1922) and the mural decorator George Heywood Sumner (1853–1940, a Century Guild associate and the latter's brother-in-law), and the architect and metalworker W. A. S. Benson (1854–1924). By the early 1890s the Guild had become the hub of the Arts and Crafts movement in Britain.

In the mid-1880s the Art Workers' Guild was both exclusive and private. Restricted to men, its members were elected and it had a hierarchical committee structure chaired by a Master. By 1886 a group of designers, most of them Guild members, recognized a pressing need to establish closer contact with the public. Led by Walter Crane (1845–1915) and Benson, they proposed in 1887 to hold an annual public exhibition of 'Combined Arts' which Cobden-Sanderson for the first time termed 'Arts and Crafts'. Invitations to show were sent to manufacturing firms considered to be sympathetic and also to Guild members. The goal was to establish a proper status for the artist-craftworker and the designer and to put these in touch with industry and the users of their products. The first of three annual shows of the Arts and Crafts Exhibition Society opened at the New Gallery in Regent Street in October 1888; after 1890 exhibitions were mounted every three or four years. The first exhibition was accompanied by talks and demonstrations by Morris, Crane, Cobden-Sanderson and leading designer-craftsmen. Many were repeated 'for working men' at the second meeting of the National Association for the Advancement of Art and its Application to Industry held in Edinburgh in November 1889, a professional congress which was important in disseminating Arts and Crafts values. The meeting discussed, among other matters, the relation between architecture and the decorative arts, workshop organization and the role of museums in education.

Most designers, whatever their political conviction, were conscious of the need for market survival, and unwilling to leap into the whirlpool of radical Socialism. Many were content to apply a romantic brand of Socialism to their local area in their quest for a new equality of architect, designer, craftsman and artist. The architect C. R. Ashbee (1863–1942), like Mackmurdo, was a designer and administrator rather than a craftsman. He started a Ruskin reading

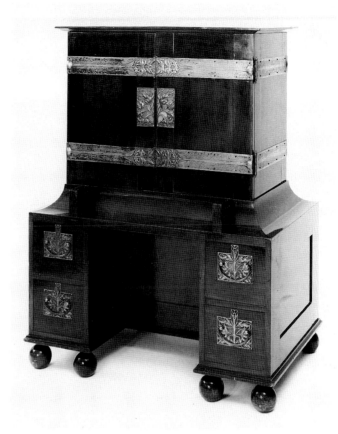

13 Guild of Handicraft writing cabinet designed by C. R. Ashbee, made by T. Jeliffe, W. Stevens, J. Pyment, W. White and J. Bailey, *c.* 1898–99

class at Toynbee Hall in 1886, which led to a School of Handicraft and complementary Guild of Handicraft, both formally inaugurated in 1888. Workshops were at first devoted to three, by this date standard, disciplines of 'practical work: woodwork, metal work and decorative painting'. Silverwork, ironwork and jewelry were added to furniture and woodcarving in the early 1890s.

The Guild moved to Commercial Road and in 1891 to an eighteenth-century house and garden. Essex House in the Mile End Road was in the heart of London's working-class East End. However, in order to fulfil his goal of self-sufficiency and integration with nature, Ashbee increasingly desired a more bucolic environment. The Guild, a ready-made community of more than a hundred, left London for Chipping Campden in the Cotswolds in 1902 – where as a limited company it lasted six years – to achieve the simple life, a

reciprocal ethic of good health and happy work. Woodcarving and metalwork remained the main craft disciplines, along with the transferred Essex House Press, founded in 1898 with the purchase of stock from the Kelmscott Press. Ashbee had wished his Guild to assume the mantle of fine printing, and a sense of heredity had thus been achieved with the move of both Kelmscott equipment and men to Essex House. The Guild also contributed to the integrated interior by providing, for example, fittings for rooms by M. H. Baillie Scott for the Grand Duke of Hesse at Darmstadt in 1897 and also, after 1902, panelling in the library of Madresfield Court, Worcestershire, for Lord and Lady Beauchamp.

Achieving quality of design always depended for Ashbee, as it had for Ruskin and Morris, on good social conditions. A practical 'endeavour towards the teaching of John Ruskin and William Morris', the Guild was run on democratic principles and devoted as much to leisure pursuits and improving domestic conditions as work itself. It aimed to promote 'a higher standard of craftsmanship, but at the same time . . . protect the status of the craftsman'. In practice, however, fellowship and quality of life were more important to Ashbee than the standard of work produced by his men: 'the real thing is the life', he wrote, 'and it doesn't matter so very much if their metalwork is second rate'.

In his romantic Socialism and his pursuit of the craftsman ideal Ashbee was directly influenced by the poet and philosopher Edward Carpenter. His community became an exemplar of Carpenter's ideal of the 'simple life', where craftsmen worked together and shared their leisure hours in sing-songs, excursions and play acting: Ashbee provided a swimming pool for use by both the Guild and Chipping Campden. But for Ashbee and indeed the majority of professional designers (whether or not they were Socialists), the ideal of a brotherhood of craftsmen denied the inclusion of women as full members. Women who were art school-trained were confined to the pursuit of craft as a pastime or as philanthropy, or to crafts considered appropriate for their sex – textiles and pottery decoration. Until the 1890s entry to the design profession was restricted to those women, such as May Morris (1862–1938) or Kate Faulkner (died 1898), who were related by birth or marriage to men in the profession.

The Guild of Handicraft had a worldwide influence as deep as that of the Morris company. Over two decades it provided a model of communal living, profit sharing and joyous labour that was an inspiration to Arts and Crafts idealists on both sides of the Atlantic.

14 Guild of Handicraft silver-mounted decanter
designed by C. R. Ashbee, c. 1904 >

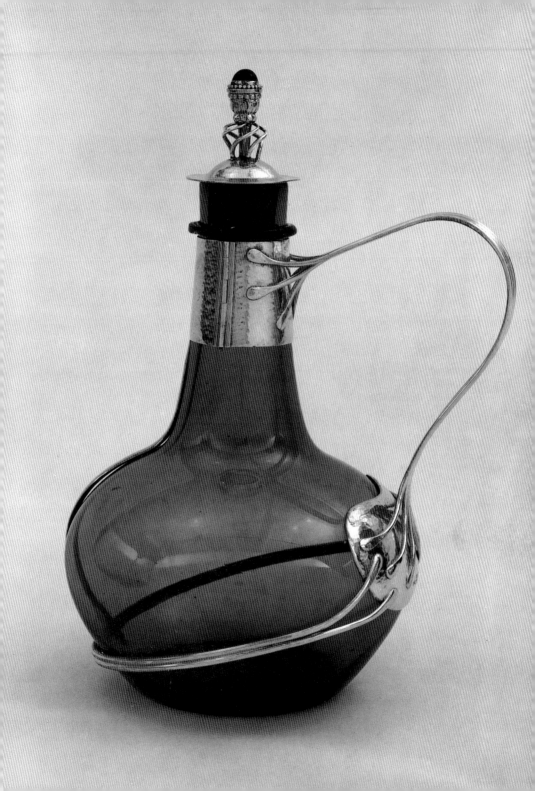

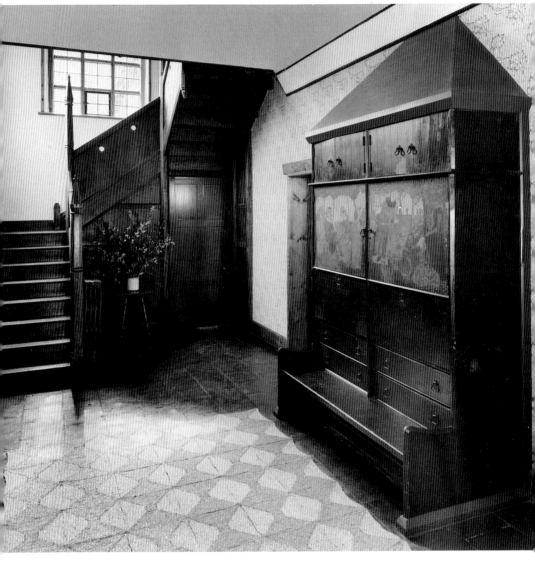

15 Philip Webb, Red House, 1859–60. Entrance hall

Architecture in Britain

Philip Webb's Red House of 1859 for Morris was the first Arts and 9
Crafts building, and the most influential one over the next half
century. In both conception and furnishing it was the earliest house to
result from a new collaboration between architect and artist.
Nodding to Gothicism in its use of simple, pointed arches and, inside,
in the elongated wooden newel post at the foot of the staircase, it 15
abandoned the symmetry of classical architecture in favour of a
practical rationality: the building was planned from the inside out to
meet the needs of everyday family life. The house, moreover, was
designed to fit snugly into the local building tradition. It used warm
red brick inside and out while the form of its courtyard well aptly
referred to the conical roofs of the Kent oast house.

Red House was not designed according to the arbitrary dictates of
style: rather, its form was shaped by the arrangement of its rooms and
their relation to one another. Webb introduced a line of rooms along a
corridor which was bent into an L-shape round a courtyard to give a
sense of intimacy and informal welcome to visitors. Convenience,
however, was not a major factor in the plan. Although the dining-
room and the kitchen, serving also in the evenings as the servants'
sitting-room, faced west towards the evening sun, and children's
bedrooms were isolated from the noise of evening activity, the
principal rooms faced north-west.

Admiration for Red House among the profession by the late
1870s was due partly to the popularity of both Morris and his
company, partly to support for Ruskin's call for 'changefulness' in
design and detail and his advocation of the use of hand-crafted
materials, and partly to respect for Webb's rejection of stylism. His
ideas were interpreted and extended in a variety of ways, resulting in
buildings identified not by any specific historical style but instead by
common principles. Arts and Crafts designers over the next half
century were also to put function first, relate their structures to the
landscape and select their materials with the greatest care: the location
of many, but not all, may be guessed from examination of their form

and fabric. They followed Pugin's rule that 'there should be no features about a building which are not necessary for convenience, construction or propriety', published in *True Principles*. A building, he insisted, should be an honest reflection of materials and carefully related to its site. He had practised what he preached, using local flintstone, for instance, in both the house he built for himself in Ramsgate, Kent (1843–44), and in its church of St Augustine (1845–52).

Pugin presented three basic rules for architecture: structural honesty, originality in design, and the use of regional materials or character, all of which were to be taken up and used in new ways by Arts and Crafts architects. Ruskin too had directed architects towards the Gothic: he emphasized the natural qualities of medieval building produced by guilds of builders and craftsmen who he insisted had worked together in perfect harmony.

The writings of both Pugin and Ruskin had in fact affected the principles and designs of mid-Victorian architects long before they were taken up by the Arts and Crafts architects. Two of these architects, William Butterfield (1814–1900) and Street, designed ecclesiastical buildings but it was their domestic commissions which took them towards new horizons. Their schools and vicarages, such as
16 Butterfield's Coalpit Heath vicarage in Avon (1844–45), while maintaining Gothic detailing, were characterized by imaginative use of materials, architectural colour, and practical consideration of function. Both men, like Pugin, stressed the importance of integrating the designs of furnishings and buildings. Pugin's encouragement and revitalization of the crafts of stained glass and ceramics as well as metalwork were taken up by these men as they were by Morris, Webb and, later, many others.

The ideas that a building's function should dictate its design, that it should be built where possible of carefully selected, undisguised materials and that it should contain related interior fittings were thus current by the 1850s. Two additional elements now joined the architect's vocabulary, namely a reconsideration of the local architectural tradition and an acceptance of the architect's right to a wider aesthetic freedom. The first was developed by another architect
17 influenced by Pugin and Ruskin, George Devey (1820–86). He designed more than twenty country houses and estate cottages, and altered or added to many more. Devey had trained as an artist under the Norwich School watercolourist John Sell Cotman and provided sensitive additions to Elizabethan or Jacobean buildings which were

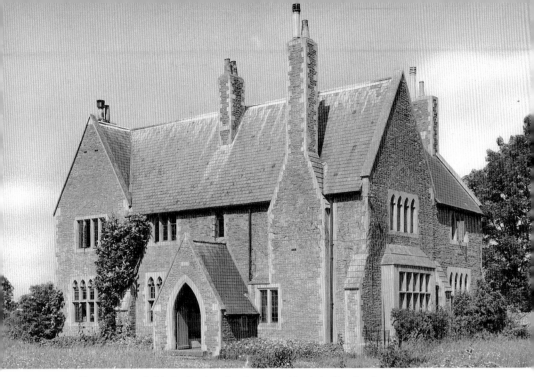

16 William Butterfield, St Saviour's vicarage, Coalpit Heath, Avon, 1844–45

17 George Devey, cottages at Penshurst, Kent, 1850

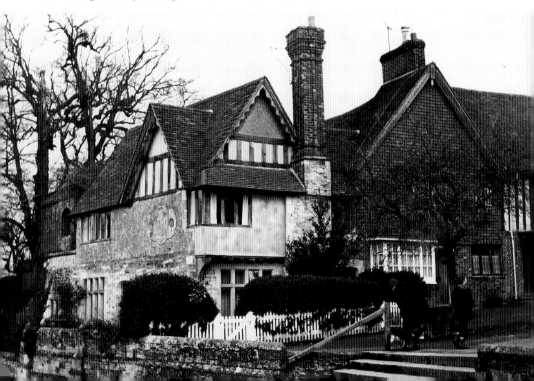

totally in keeping in terms of materials, construction and appearance. His new buildings harmonized with the old, reflecting their traditional techniques and materials. At Penshurst, Kent, in the 1850s Devey built a square of modest tile-hung, plastered and half-timbered cottages beside a group of fifteenth-century houses and church. With Devey the vernacular, summed up by Gertrude Jekyll in 1904 as 'the crystallisation of local need, material and ingenuity', was firmly established as an important ingredient in English house design.

The second new rule was developed by both Webb and Norman Shaw (1831–1912), the leading exponent of visual freedom in High Victorian British architecture. Shaw succeeded Webb as chief draughtsman to Street in 1859 and possessed, like many Scots, a strong sense of the picturesque. From Street he learned a love of crafts and, like Devey, Webb and many future Arts and Crafts architects, he made a particular study of the English vernacular, sketching traditionally built houses in Yorkshire, Kent and Sussex in the early 1860s. Shaw removed the preconception that country-house architecture must be in a revivalist style. He developed an eclectic visual vocabulary that depended on combinations of half-timbered or tile-hung upper floors with local stone or brick lower floors and the use of mullioned windows. His deliberately asymmetrical 'Old English'

18 Richard Norman Shaw, Leyswood, Groombridge, Sussex, 1868. Bird's-eye perspective

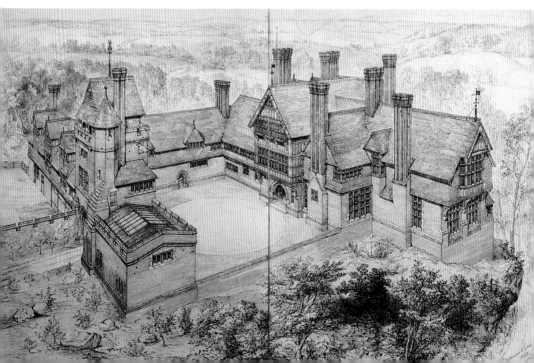

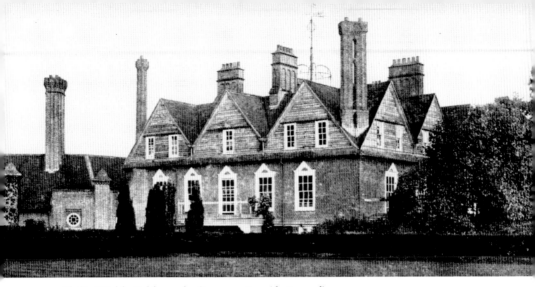

19 Philip Webb, Joldwynds, Surrey, 1873 (destroyed)

buildings gave the impression of gradual evolution. He also made dramatic use of the chosen site and shared with Devey a love of tall, decorative chimneys. While Devey responded closely to traditional building types, Shaw invented a bold, fantastic language of his own which he used in both new houses and those he extended. Leyswood, Groombridge, Sussex (1868), was described by contemporaries as 'quaint', with its brew of Italian, English and Scots Baronial.

18

For twenty years Shaw's 'Old English' satisfied country clients with its assurances of impressive effect, comfort and building craft. On a smaller scale, Shaw's popular 'Queen Anne' London houses from the 1870s combined details of Dutch gabling and elegant touches of British eighteenth-century architecture such as Palladian or segmentally headed sash windows. Using Classical motifs and brick he developed an architecture free from revivalist dominance. Some of Shaw's most varied town housing designs were for the north London estate of Bedford Park in the late 1870s, where his use of coloured brick earned the suburb G. K. Chesterton's sobriquet 'Saffron Park'. Unlike Arts and Crafts architects, however, Shaw sometimes exploited the landscape with almost merciless theatricality. His most dramatic use of site was at Cragside in Northumberland where his extensions of 1870–85 sprawled high across the top of a steep slope.

Shaw's large practice, with its encouragement of individualism and free thinking, became a nursery for many leading Arts and Crafts men, yet he remained an establishment figure. He continued to view

35

the architect as a master designer-engineer and to be unconvinced of the new interdependence between architecture and the crafts.

Philip Webb designed houses that seem plain, chaste and modest in comparison with those of Shaw, but reveal a passion for good building technique and the use of the finest materials. He disliked copying a mass of ornamental detail from the past, although he did not see much sense in deliberately avoiding external symmetry: houses such as Joldwynds (1873) in Surrey used regular, symmetrical multi-gabling and elegant, tall chimneys of uncovered traditional brick. A Webb house, however, whether new or altered, was dictated from the outset by consideration of the functional interior relationships of rooms, corridors and stairwells.

Shaw and Webb were therefore major figures in the domestic revival movement in Britain. The new axioms they added to British architecture – freedom of expression in terms of design and materials, and an increased awareness of local tradition – influenced a whole generation. As Shaw was encouraged by Webb's high standards and Webb, in turn, by Shaw's free thinking, the exchange of architectural ideas extended beyond the office. Greater architectural individualism and the growing status of architecture as a combined art, craft and structural discipline was spread through the Art Workers' Guild, particularly by Shaw pupils. Shaw himself took an interest in their meetings but did not attend.

Centres for debate were established throughout the country. The Northern Art Workers' Guild, founded in Manchester by the architect Edgar Wood in 1896, was a comparatively late development, joining the Architectural Associations of London, Edinburgh, Birmingham and other cities. During the 1880s the Society for the Protection of Ancient Buildings (SPAB), known affectionately as 'Anti-Scrape', provided a particularly important London forum. Founded by Morris in 1877 in reaction to the recent restoration of Tewkesbury Abbey by the Gothic revivalist Sir George Gilbert Scott, it became a meeting ground for artists, aesthetes, historians and, increasingly, architects – indeed anyone interested in the future of old buildings. Having few assistants, Webb came into contact with the younger architects mainly at the meetings of SPAB. His emphasis on craftsmanship and SPAB's promotion of the science of medieval building fostered an architectural conscience just as much as did the writings of Ruskin and Morris. Few architects in the 1880s were concerned with social issues: while most of them employed local masons, their priority was to work out aesthetic rather than social

problems and their patrons were the landed families or the professional classes.

The example of Devey and Webb showed that the vernacular had a place, and an important one, in modern architecture. The younger architects of the 1880s and early 1890s looked to the past for both inspiration and practical guidance in building. The examination of the vernacular focused attention on national heritage. Architects wrote illustrated histories of their countries: *The Castellated and Domestic Architecture of Scotland from the Twelfth to the Eighteenth Century* by David MacGibbon and Thomas Ross was published in Edinburgh between 1887 and 1892, and a *History of Renaissance Architecture in England 1500–1800* by Reginald Blomfield in London in 1897. These and many other volumes, together with obedience to Pugin's rule of regional variation, helped to promote visual diversity across Britain. The sixteenth-century towerhouse, its rugged form dictated by northern climatic conditions, was re-used in Scotland. James MacLaren (1843–90) adapted the simple form of the rounded Scots tower in his wing of Stirling High School (1887–88), while Stewart Henbest Capper (1859–1924) and Sidney Mitchell (1856–1930) added towerhouse forms and multi-gabling to an eighteenth-century building at Ramsay Garden on the edge of Edinburgh Castle rock 20

20 Stewart Henbest Capper and Sidney Mitchell, Ramsay Garden, Edinburgh, 1892–94

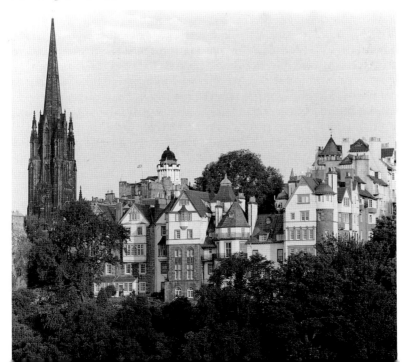

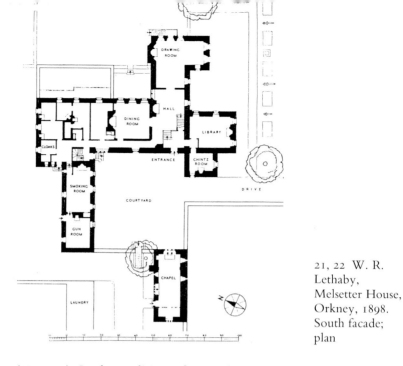

21, 22 W. R.
Lethaby,
Melsetter House,
Orkney, 1898.
South facade;
plan

(1892–94). In the tradition of Scottish eighteenth-century building
W. R. Lethaby (1857–1931), formerly Shaw's chief assistant, a
leading member of the Art Workers' Guild and Webb's biographer,
21,22 used white harled stonework and crow-stepped gables at Melsetter
House in Orkney, extended for a Birmingham industrialist in 1898.
Here Lethaby also applied the sixteenth-century towerhouse Z-plan,
tucking an entrance courtyard into the southeast angle of the
building, as Webb had at the Red House almost forty years earlier.

Shaw office architects were particularly adept at this 'locality
character', distilling the vernacular with great care. One of Lethaby's
23,24 finest buildings, the church at Brockhampton, Herefordshire (1901–
02), was modelled after the English tithe barn. Like other Arts and
Crafts buildings of its time it blended the historic with a new visual
grammar. Lethaby, however, was unusual in marrying traditional
building methods to new technical advances. He justified the use of
modern materials by pointing to historical precedent: concrete, for
instance, was 'only a higher power of the Roman system of
construction'. Brockhampton had a roof of concrete capped with
thatch, a traditional Herefordshire material, to give internal dryness
and warmth. In contrast to Ruskin, for whom architecture with its
hand-crafted ornament stood apart from mere building, and Gilbert

38

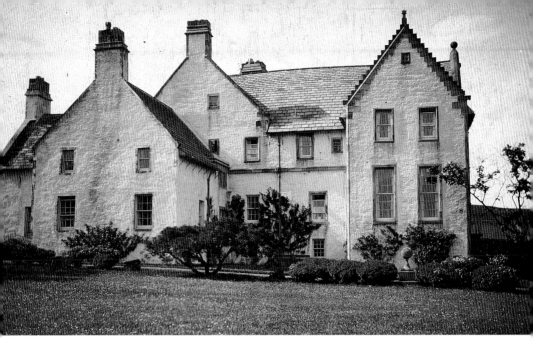

Scott for whom it was the 'decoration of construction', Lethaby believed that good architecture was first and foremost 'masterly structure with adequate workmanship'. The path towards a new aesthetic emphasizing building craft reached a landmark with Lethaby's work, but both he and other Arts and Crafts architects used the vernacular as a starting point, honing historical precedent to its essentials and formulating new designs. Lethaby wrote his 1891 symbolic interpretation of architecture, *Architecture, Mysticism and Myth*, against this background.

The passion for combing the past for inspiration and solutions to practical problems was widespread across Britain. The new buildings of the 1890s were considered successful if, while not imitative of one particular style, they gave the impression of having evolved naturally through the centuries. Historic buildings, even the simple medieval country barn equated by Morris with the cathedral, were less patterns for modern design than open books waiting to be newly interpreted. Knowledge of construction techniques was acquired as much through looking at and measuring these as by office training and part-time college study. A few architects learned through building with their own hands: Ernest Gimson (1864–1920) and Detmar Blow (1867–1939), his assistant, themselves built parts of Stoneywell Cottage 26

39

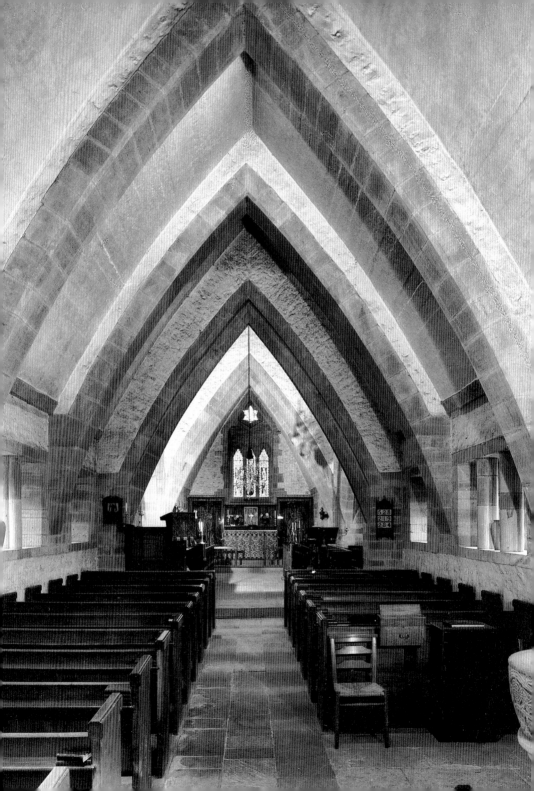

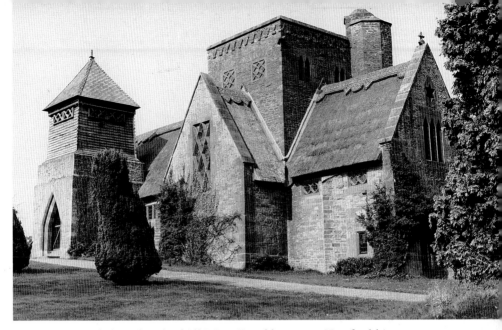

23, 24 W. R. Lethaby, Church of All Saints, Brockhampton, Herefordshire,
1901–02. Exterior from the south-east; interior facing east

(1898–99), Ulverscroft, Leicestershire, and Lethaby was master
builder as well as architect at Brockhampton. The restoration of 23,24
historic buildings, which required a thorough understanding of both
style and structure, provided one of the richest experiences of all, yet
posed not only ethical but visual problems. SPAB insisted that new
work be unpretentious, use good materials, harmonize with old
stonework and yet still look modern.

'Free design' meant that both form and materials could be used in
new, experimental balances. Structural features became exaggerated
to emphasize how a building was put together and to suggest organic
form emerging from the landscape. A feature of several MacLaren
house designs, for example, was a sturdy corner chimney rising from
the ground. This was used in a cottage at Fortingall, Perthshire (c. 25
1889), and a Sussex house, Heatherwood, completed posthumously in
1890–91. The device was adopted by many Art and Crafts architects
during the following decade, including Baillie Scott at the Red
House, Isle of Man (1892–93), and Gimson at Stoneywell. Nestling 26
into the rocky landscape, Stoneywell's crooked chimneys, irregular
plan, small windows and, on its north facade, rough, hand-cut
stonework, gave it an air of natural, quiet evolution.

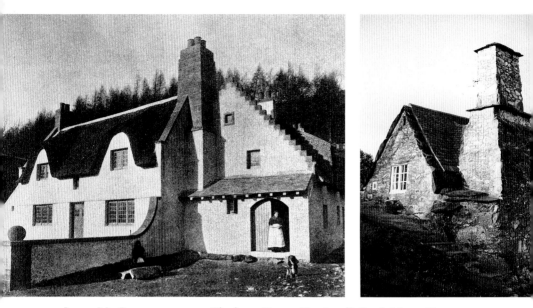

25 James MacLaren, cottage at Glenlyon House, Fortingall, Perthshire, 1889–90

26 Ernest Gimson, Stoneywell Cottage, Ulverscroft, Leicester, 1898–90. North front

Design freedom also meant individual interpretation of shared principles. Architects emphasized construction and function through deep enveloping roofs, long bare walls and asymmetrical window patterns. The ruggedness of Stoneywell contrasted with, for example, 27 the concentrated, horizontal forms of Perrycroft, Colwall, near Malvern, designed in 1893–94 by C. F. A. Voysey (1857–1941) and 28 the vertical towerhouse detailing of Hill House, Helensburgh, near Glasgow of 1903–04 by Charles Rennie Mackintosh (1868–1928), yet their buttress chimneys served the same purpose as those of MacLaren, to anchor the buildings visually in the landscape. The historical connotations and simple, dominant form of the buttress made it popular for country design where there was no intrusive townscape to consider. Arts and Crafts vocabulary also contained features more distantly related to the vernacular: the deep-hooded, round entrance doorway and the low, protective eaves common in the 1890s, for instance, recalled the safe haven of the medieval country church; the home thus provided a symbolic refuge from the industrialism of late Victorian society.

42

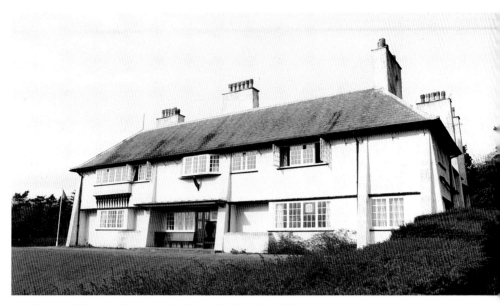

27 C. F. A. Voysey, Perrycroft, Colwall, Herefordshire, 1893–94

28 Charles Rennie Mackintosh, Hill House, Helensburgh, Dunbartonshire, 1903–04

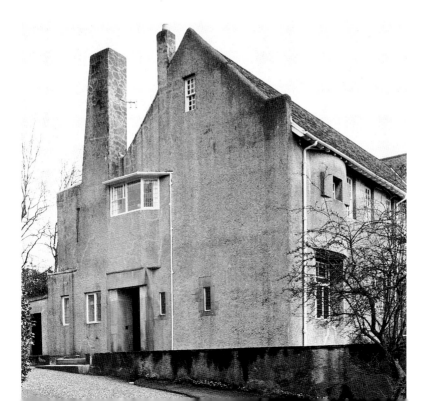

29 E. S. Prior, Home Place, Holt, Norfolk, 1904–06. Garden front

By concentrating on functional and visual symbolism, 'art' architects produced new plans and re-evaluated their materials. E. S. Prior (1852–1932), another Shaw pupil, devised unusual plans and was one of the first to emphasize visually a house as a shelter. An example was his 'butterfly' plan, which offered an alternative to the popular L-shape plan. Used at The Barn in Exmouth, Devon (1896–97), the plan bent the centre of the now fashionable arrangement of a corridor and rooms to form two arms curving towards each other in a symbolic embrace of welcome. This plan, adopted in many parts of Britain and Europe, was adapted by several country-house architects, including Edwin Lutyens who used it, most aptly of all, for Papillon Hall in Leicestershire (1903–04).

Arts and Crafts architects considered that beauty came not only from plans but how and from what buildings were crafted. They saw building materials, especially old ones, not only as structural aids but as art objects in their own right. They examined individual colours, forms and textures, and often glorified them. Prior, in a paper on 'Texture as a Quality of Art and a Condition for Architecture' given at the 1889 Edinburgh congress, spoke of 'velvet' thatch, the 'soft warm' tile and 'silvered splashed' lead. He used large pebbles at The Barn to catch the light, cast shadows and provide a range of colours

44

30 E. S. Prior, The Barn, Exmouth, Devon, 1896–97

and shapes. Country materials found locally were deemed to provide a sufficiently wide colour range or at least, as the architect and writer Halsey Ricardo (1854–1928) wrote in 1896, 'colour enough to set off and harmonise with the palette served by Nature'. This tactile delight in materials continued well into the new century, when Lutyens in particular united unexpected combinations of local materials with imaginative settings. At Marshcourt, Stockbridge in Hampshire (1901–04), for example, he took chalk dug from the local beds, combined it with both flint and russet brick and produced vigorous geometric patterns.

Vernacular materials and forms were scrutinized through the art of restoration and were seen to be not only aesthetically satisfying but often more functional than previously realized. Robert Lorimer (1864–1929) was one architect who devoted a substantial proportion of his career to restoration or alteration. His early work included the restoration of a towerhouse in Fife, Earlshall (1892–94). The forms, 31 spatial relationships and techniques of sixteenth-century building soon became absorbed into Lorimer's new designs. His large houses were stone-built, sometimes harled, used crow-stepped gables and steep pitched roofs and blended stair projections with plain facades. In England Lutyens matched Lorimer's adoption of the vernacular. For 32

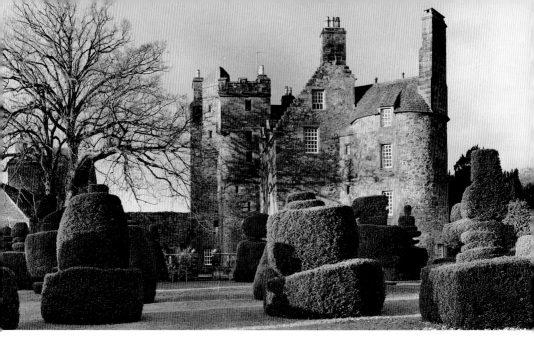

his romantic country houses of the late 1890s and 1900s he turned to
the Elizabethan brick house. He exaggerated dominant features such
as the tall brick chimney, the mullioned window and the deep gable,
and reconstituted their relationship according to interior function.
Lutyens's astonishing variety of forms recaptured the spirit of the
Elizabethan age, recalling the words of the essayist Francis Bacon:
'houses are built to live in, and not to look at; therefore let use be
preferred before uniformity, except where both may be had'.

The aim of creating harmony with the past also now extended
beyond the confines of the house itself. The 1892 commission to
restore Earlshall gave Lorimer his first opportunity to re-establish an
old walled garden, where he planted yews to be clipped in the form of
chess pieces: topiary was viewed as an appropriate means of adding
rhythm, colour and scale to a garden. For many, the restored or
introduced formal garden balanced the 'natural' house. The textural
qualities and colour of materials (whether shrubs or plants, stone or
brick) could be emphasized through geometric, controlled organiza-
tion. Architectural details of the seventeenth and eighteenth centuries
– the sundial, the fountain and the gazebo – were re-introduced. The
aim, as Prior was to write in 1901, was to provide 'a sunny wall, a
pleasant shade, a seat for rest, and all around the sense of the flowers,
their brightness, their fragrance'.

32

31

46

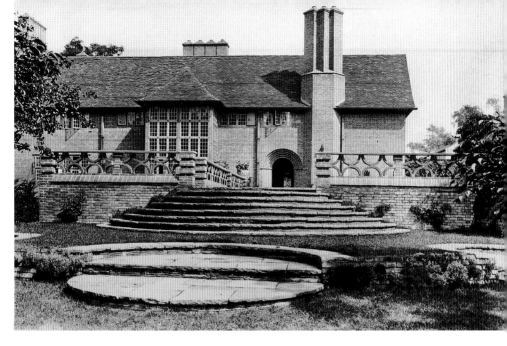

31 Robert Lorimer, Earlshall, Fife, 1892–94

32 Edwin Lutyens, Deanery Garden, Sonning, Berkshire, 1899–1902

33 Gertrude Jekyll and Edwin Lutyens, the garden, Hestercombe, Somerset, 1906

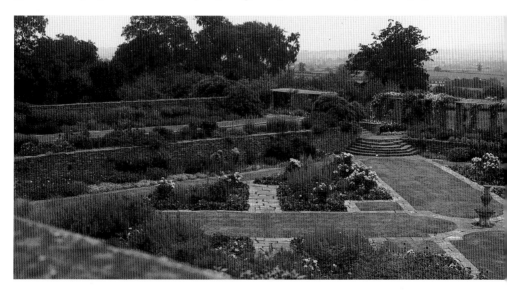

Formal garden practice was specifically advocated by two people, the leading British ecclesiastical architect J. D. Sedding (1838–91) and Reginald Blomfield (1856–1942). Sedding's *Garden Craft Old and New* was published posthumously in 1891 and Blomfield's first book, *The Formal Garden in England*, appeared in 1892. They declared the 'refinement' and 'reserve' of the native English tradition to be superior to the Italian romantic vista. A well-designed garden was considered by many architects, in the words of Baillie Scott, 'almost as important as a well-designed house . . . we can hardly do better than to try and reproduce some of the beauties of the old English gardens, with their terraces and courts and dusky yew hedges, which make such a splendid background to the bright colours of flowers'.

Studies in practical gardening were also published. *Alpine Flowers for English Gardens* (1870), *The Wild Garden* (1870) and *The English Flower Garden* (1883) by William Robinson (1838–1935) combined history with practical advice. Indigenous British plants came into favour, partly stimulated by Morris's use of native flowers in his textile and wallpaper designs. His ideal garden of 'roses and trellises, hollyhocks, great spires of pink, orange and red, and white, with their soft, downy leaves, fiery nasturtium and many sunflowers', published as early as 1856 in 'Story of an Unknown Church' in his *Oxford and Cambridge Magazine*, described an equivalent of the texture and colour of vernacular building.

Gertrude Jekyll (1843–1932) may be regarded as the leading Arts and Crafts garden designer in Britain. From her early years she was a disciple of Morris and a self-taught artist, silversmith and embroiderer. Jekyll's love of the colour and variety of nature, so much part of Arts and Crafts ideology, was expressed in the creation of her own garden and house at Munstead Wood, Surrey, designed by Lutyens in 1896–97 in which he employed both local materials and traditional forms. The house made Lutyens's name and the consequent professional partnership of Jekyll and Lutyens in more than one hundred British gardens provided a new harmony of home and landscape. As Arts and Crafts architects considered the seasonal use of various rooms in a house, so Jekyll observed the colour, shape and scent of her plants, their individual importance emphasized, perhaps, by her increasing myopia. The gardens of Munstead Wood, Deanery Garden at Sonning in Berkshire (from 1901) and Hestercombe in Somerset (1906), for example, were dominated by wide, comfortable grass paths or paved ledge walks and mass planting to give great sweeps of colour. The ideals of Morris were thus joined to both the

33

48

traditional skills of the gardener and modern horticultural knowledge.

The principle of design unity applied as much to the interior of an Arts and Crafts building as to its environment. As exterior design reflected interior function and form, so too ceiling, floor and wall finishes, furniture, textiles and metalwork played their part in a total design. The Art Workers' Guild, with its motto of unity in the arts, the Northern Art Workers' Guild, SPAB and other societies generated many collaborations in decorative aspects of a building's interior. On the whole, public buildings, especially churches, were less fully integrated than domestic work but, giving reality to Ruskin's dream, they could involve a team of designer-craftworkers each trained as an architect or an artist. Architects saw themselves as both functionalists and craftwork catalysts. Henry Wilson (1864– 1934), pupil and successor of Sedding, carried the ecclesiastical ideals of Street into the twentieth century. Architect, designer and enameller, Wilson believed in the indivisibility of the arts, writing in 1898 that the architect 'should be the invisible, inspiring, ever active force animating all the activities necessary for the production of architecture.'

34

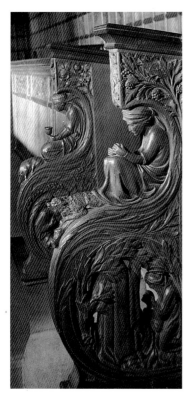

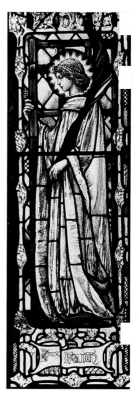

34 Henry Wilson, Welbeck Abbey chapel, Nottinghamshire, c. 1890–96. Choir-stalls

35 Christopher Whall *St Faith*, stained-glass window, Gloucester Cathedral, c. 1900

Stained glass and mural decoration were the two media that achieved a full integration with architecture. In 1889 Prior invented 'Early English' slab glass, which, unlike normal commercial glass, had an uneven surface and used colour in new intense and inventive combinations. Made by Britten and Gilson it was first taken up by Christopher Whall (1849–1924), the leading English glass designer of his generation. Both Prior and Whall rejected the strict division of labour found in commerce. They wanted to see glass designers and makers working in closer collaboration, using materials as the basis of style and making unique contributions in terms of colour and light to spatial definition.

35

Mural and stained glass artists both saw analogies with music in their craft. Whall and the Edinburgh muralist Phoebe Traquair (1852–1936) both wrote of their wish to make a window or a wall 'sing'. The harmonies of new colours were the result of technical experiment and historical investigation as Renaissance techniques were revived across the country in the 1890s and 1900s: tempera was used by Joseph Southall (1861–1944) in Birmingham, *sgraffito* by Heywood Sumner in the south of England and gesso by Margaret Macdonald in Glasgow.

Many architects also called on friends to implement the concept of architectural unity. Gimson, for example, both designed and executed plasterwork for Avon Tyrrell (1891–93), a Lethaby house in Hampshire, while in 1889 Lethaby himself gilded and painted an altar table for a Prior church at Bothenhampton in Devon. Prior glass, Gimson plasterwork and De Morgan tiles (see Chapter 3) decorated Ricardo's house in London (1905–07) for Sir Ernest Debenham and Mackintosh designed wall stencilling for George Walton's refurbishment of Glasgow's Buchanan Street Ladies' Tea Rooms for Miss Cranston (1896).

Ashbee operated his own guild, but most architects commissioned independent local craftsmen to execute their designs. These craftsmen enjoyed varying degrees of autonomy: in Edinburgh Lorimer gave the domestic metalworker Thomas Hadden and the cabinet-makers Whytock and Reid only rough sketches, while Voysey supplied F. C. Nielsen and Thomas Elsey with measured drawings for furniture and metalwork respectively.

Although many Arts and Crafts architects designed furniture, total freedom in its realization was not easily achieved. They dreaded having to accommodate a client's furniture which, for M. H. Baillie Scott, could look 'all the more incongruous if the rooms themselves

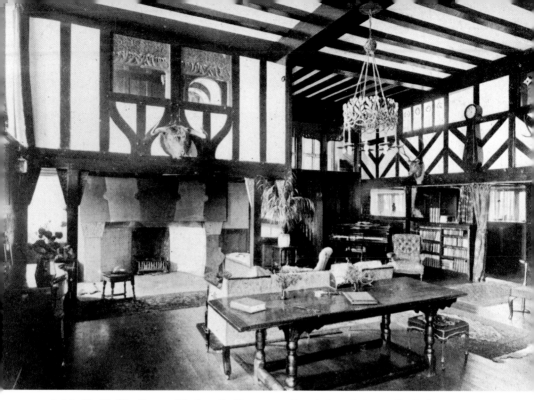

36 M. H. Baillie Scott, Blackwell, Bowness, Cumbria, 1898–99. Period photograph of the hall

are architecturally beautiful'. A compromise of buying furnishings (especially for an old restored house) was sometimes the answer: Lorimer and Lutyens, for example, purchased furniture or tapestries for their clients from a new professional, the antique dealer. Others, like Baillie Scott, Mackintosh and Voysey, however, rejected the very idea of purchase but instead viewed a building, inside and out, as the product of a single mind.

Designing the furniture for most of his buildings, M. H. Baillie Scott (1865–1945) developed the idea of the integrated interior. English oak or elm planking was used both for doors and furniture, their hand-hewn roughness replacing more expensive, highly finished imported woods. Mortise and tenon joints were not only left exposed but exaggerated to accentuate hand craftsmanship. Baillie Scott's aim was to create simplicity, a sense of repose and a homogeneous atmosphere. He took Morris's general dictum to have only beautiful objects in a

house one step further: beauty was to be achieved only through objects designed by an 'exquisite appropriateness to its position and to its use'. The placing of each interior design component was crucial and he urged architects to design 'in a negative way by adding nothing to the few essential features'.

Baillie Scott developed a number of key features in the Arts and Crafts interior. The hearth with its deep ingle and settles, used in houses by Shaw onwards, became the heart of the home and recalled the warmth and hospitality of the country cottage or farmhouse: by 1904 the German historian Hermann Muthesius could write that 'to the English a room without a fire is like a body without a soul'. Baillie Scott replaced the Victorian entrance hall with an Elizabethan dwelling-hall where the integrity and simplicity of the medieval barn was reflected in half-timbering or wall panelling. As an Isle of Man architect, Baillie Scott drew his ideas partly from the local half-timbered vernacular, as did other north country designers. The Anchorage, Handsworth, Birmingham (1898), by Joseph Crouch and Edmund Butler, for instance, had a panelled and half-timbered dwelling-hall: a painted frieze by a Birmingham artist, F. W. Davis, corresponded to the wall stencilling sometimes used by Baillie Scott and Mackintosh.

Both Baillie Scott and Mackintosh used fitted and movable furniture in their search for decorative unity and also used a code of interior design which differentiated between rooms traditionally associated with women and men. Plain or stencilled 'feminine' white walls and furniture were used in the bedroom, the drawing-room, the kitchen and the bathroom, while sturdy oak panelling and furniture dominated the rest of the house – the hall, stairwell, dining-room and the smoking and billiard rooms. Baillie Scott introduced painted and stencilled ceilings, walls and furniture whose decoration echoed European peasant work that had been illustrated in *The Studio*, the London art journal founded in 1893 which did much to publicize Arts and Crafts at home and abroad.

After 1900 Mackintosh took the principle of the integrated interior even further. He designed as many details as possible for his houses, including house and garden furniture, friezes, cutlery, silverware, light fixtures, hall-chimes and carpets. His interiors reflected his clients' patterns of living, as did most Arts and Crafts buildings, but he tightened design to the precision of grid forms and plain walls and floors punctuated with pure geometric motifs. Unlike other Arts and Crafts architects, Mackintosh was indifferent to good craftsmanship.

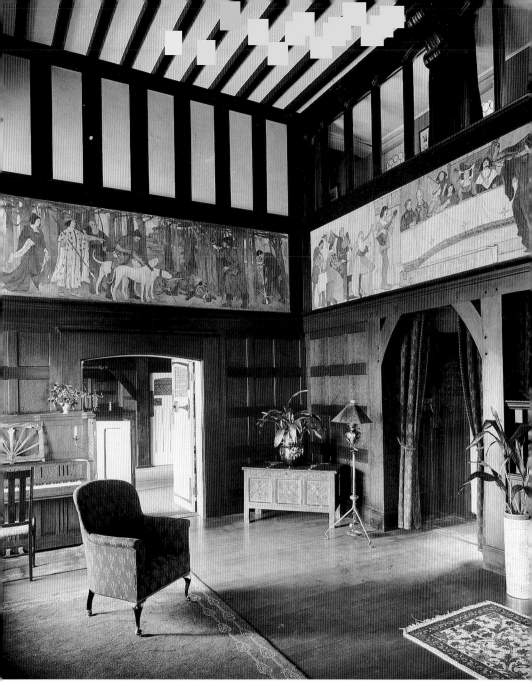

37 Joseph Crouch and Edmund Butler, The Anchorage, Handsworth,
Birmingham, 1898. Period photograph of the hall

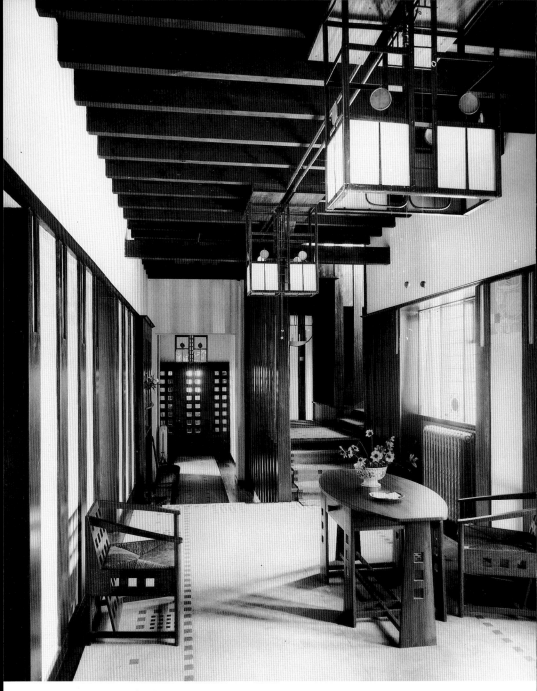

38 Charles Rennie Mackintosh, Hill House, Helensburgh, 1903–04. Entrance hall

His furniture was poorly made and often ignored traditional construction: his work therefore found less sympathy within Britain. Mackintosh's vernacular inspiration and skilful manipulation of not 38 only exterior form but interior space in the inglenook, window seat or box-shaped stairwell alone categorize him as an Arts and Crafts designer: to his British contemporaries his work was unwholesome and linked to continental Art Nouveau.

Mackintosh's work is an extreme example of the polarization of the basic principles of Arts and Crafts architecture in Britain around 1900 when architects chose to support either artistic design or a dominant functionalism. The art architects, mainly establishment men, set out to counter the 'squirm' of north European Art Nouveau with a new rational architecture based on British forms of the immediate pre-industrial age. The architects of this Neo-Georgian revival, led by the Art Workers' Guild members Blomfield, Macartney (1853–1932), Prior and Newton, presented regularity, balance and craftsmanship as the keynotes of their work. It appealed, of course, especially to those patrons who sought to reflect a past age of political, economic and cultural stability in their own times.

Christopher Wren, the giant of the seventeenth-century English Renaissance, was admired by these architects and inspired their response to the past. The Neo-Georgians, as Guild men, recognized the importance of individuality and their buildings were far from being debased forms of seventeenth- and eighteenth-century design. Steep Hill on Jersey (1899) by Newton (1856–1922) and his Bickley 39 houses of the years 1902–05 are characterized by increasing symmetry and refined materials while retaining sensitivity and changefulness of form. The influence of Neo-Georgian ideas was widely felt in Britain, turning many art architects in a new direction. The career of Lutyens, for example, evolved from the free vernacular learned in the office of Ernest George through the inventive 'Wrenaissance' of the 1900s to a disciplined Classical grand style: his Heathcote, Ilkley, Yorkshire, of 40 1906 was a particularly original response to Baroque Classicism.

Although the Neo-Georgians emphasized the crafts in their designs, other architects considered such work ostentatious and limited in application, and instead gave priority to functional, social and economic concerns. Comfort for the users of a building was an essential design requisite for Arts and Crafts architects, including the Neo-Georgians, but was particularly stressed by Voysey and by two Northern Art Workers' Guild members, Barry Parker and his brother-in-law Raymond Unwin.

55

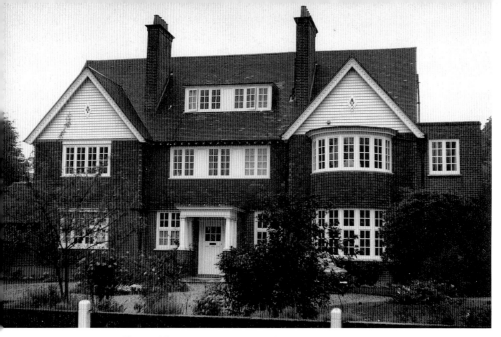

39 Ernest Newton, 2 Pines Road, Bickley, London, *c.* 1903

40 Edwin Lutyens, Heathcote, Ilkley, Yorkshire, 1906

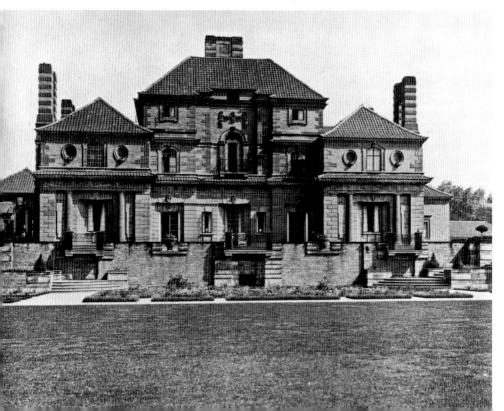

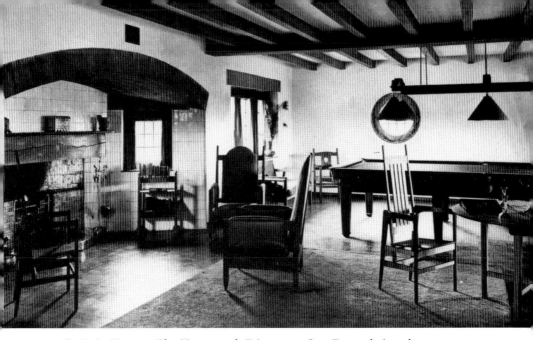

41 C. F. A. Voysey, The Homestead, Frinton-on-Sea, Essex, designed 1905–06. Drawing-room

For Voysey a passion for precise craftsmanship was matched by a concern for economy. He believed that houses should have 'light, bright, cheerful rooms, easily cleaned and inexpensive to keep'. His furniture, textiles, keyhole and finger plates were placed in buildings with whitewashed walls, large, welcoming tiled fireplaces and white or natural oak-beamed ceilings. His own house, The Orchard, Chorleywood, designed in 1899, and The Homestead, Frinton-on-Sea, designed in 1905–06 for a bachelor, presented rare opportunities to work with a minimum of client interference. The Orchard used a favourite colour scheme of white, green and red. Built to a plan which gave pleasant views of the garden and orchard and avoided excessive heat in summer, it had easily cleaned, hard-wearing slate tile paving and flooring in the hall and kitchen, green cork tile flooring throughout the first floor, and bright red curtains. The Homestead had a green slate roof, a red tiled entrance-porch arch and an austere, masculine white and oak-beamed drawing-room.

Voysey's definition of comfort ('Repose, Cheerfulness, Simplicity, Breadth, Warmth, Quietness in a storm, Economy of upkeep, Evidence of Protection, Harmony with surroundings, Absence of

41

dark passages, even-ness of temperature and making the house a frame to its inmates. Rich and Poor alike will appreciate its qualities') was developed by Barry Parker (1867–1947) and Raymond Unwin (1863–1940) in their book *The Art of Building a Home* (1901). They equated design primarily with problem-solving: 'the essence and life of design lies in finding that form for anything which will, with the maximum of conveniences and beauty, fit it for the particular functions it has to perform, and adapt it to the special circumstances in which it must be placed.'

Later Voysey houses reflected the long low frontage of the Cotswold vernacular and used a deep, simple hipped slate roof with internal lower ceilings to provide internal warmth. Outside walls, often economically built of brick, were roughcast to give the thickness of stone, then whitewashed. Parker and Unwin used a related language. Their house for C. F. Goodfellow at Northwood, Staffordshire (1899–1902) had an extended gable to give coolness in summer. They moved the courtyard, a feature common by this date, to the centre of the building, providing a sense of open space and easy access to all rooms by means of sliding doors: this was intended to 'bring brightness and cheeriness and airiness right into the midst of the house'. The house also had a plain, sheltered verandah which united it more closely with the landscape. The interior of the Goodfellow house, with its exposed timber beams, whitewashed plaster and deep inglenooks, was equally simple. The range of their work distinguished Parker and Unwin's practice from that of Voysey. Voysey designed private homes, a small number of public buildings and, in 1904, terraced housing for 'mining artisans' in Yorkshire but avoided the wider collectivism of town planning. Parker and Unwin's philosophy, on the other hand, extended beyond individual house design to the 'garden city' movement of the early twentieth century.

In garden cities of the early 1900s Arts and Crafts design (if somewhat diluted) and social principles were used together on an unprecedented scale. Ruskin and Morris had dreamt of an ideal setting in which citizens could live and work. Both responded to working-class misery, unemployment and bad housing partially caused by the change from a rural to an urban, industrial economy since the early nineteenth century. Morris had longed for an England where the differences of town and country would dissolve to create a harmonious, happy, healthy community based on the model of the fourteenth-century village settlement. For Ruskin the solution to Britain's increasing problems was contained within the form of the

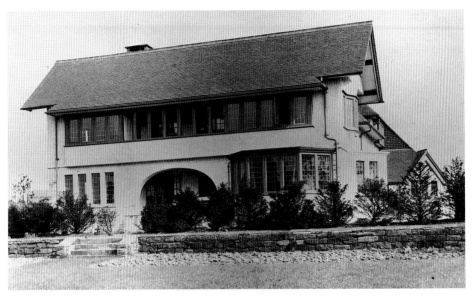

42, 43 Barry Parker and Raymond Unwin, house for C. F. Goodfellow, Northwood, Staffordshire, 1899–1902. Garden front; living-room

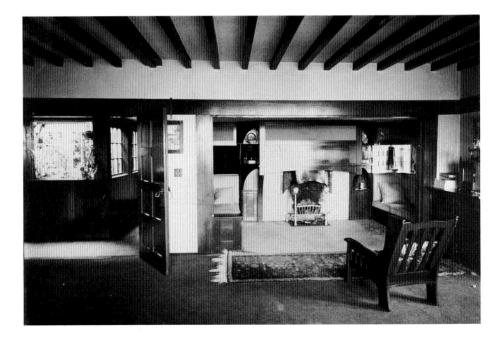

city itself, for which he advocated careful planning. In *Sesame and Lilies* (1865) he called for the building of new homes 'strongly, beautifully, and in groups of limited extent, kept in proportion to their streams and walled round, so that there may be no festering and wretched suburb anywhere, but clean and busy street within and the open country without'.

The genesis of the garden city movement lay in the ideal housing provided by a few philanthropic industrialists in northern Britain during the previous century. The proto-Socialist Robert Owen's wish to house and to provide leisure and educational facilities for his mill workers, realized at New Lanark in central Scotland in the 1810s and 20s, influenced Victorian manufacturers in Yorkshire and Lancashire. Sir Titus Salt's model estate, Saltaire, near Bradford, was started in 1850 and planned by H. F. Lockwood (1811–78) and R. Mawson (1834–1904), an established Bradford practice. They devised a utilitarian, self-sufficient scheme to provide not only three-bedroomed houses but parkland, playing fields, bath-houses, and almshouses for the elderly. William Hesketh Lever (later Lord Leverhulme) built Port Sunlight on the south bank of the Mersey from 1889. His aim was to provide houses 'in which our workpeople will be able to live and be comfortable . . . in which they will be able to know more about the science of life than they can in a back slum and in which they will learn that there is more enjoyment in life than in the mere going to and returning from work'. More than one thousand homes were built around a town centre laid out with wide avenues and parks. The first houses, built in 1889–90 to designs by William Owen (1846–1910), had red brick, white-painted casement windows and tile-hanging – all Shaw-derived, Arts and Crafts details – simply as decorative features. Later houses at Port Sunlight, such as those by J. Lomax Simpson (1850–1937), used timber and pargetting details.

44

When Lever bought Thornton Manor, near Port Sunlight, in 1891 he set about rebuilding the village of Thornton Hough. Although not an architect he had definite, romantic views on what an English village should look like. He insisted, for example, that Lomax Simpson plant a chestnut tree outside the new smithy. Lever's architects adopted both the local vernacular and the vocabulary of Arts and Crafts architecture. Thus their buildings were non-duplicated; a tiny village-green shelter sported half timbering and a thatched roof; and picturesque, non-structural half-timbering in traditional Cheshire patterns was used in cottages of 1893 and a meeting club-house of 1904.

45

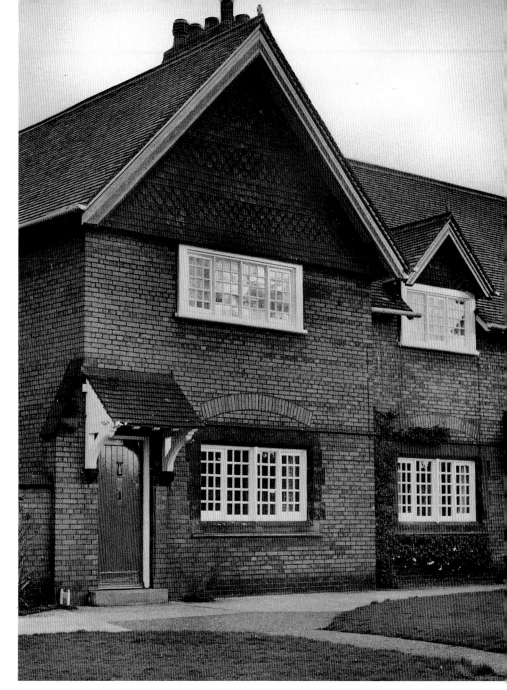

44 William Owen, cottages at Port Sunlight, Lancashire, 1889–90

45 Douglas and Fordham, cottages at Thornton Hough, Lancashire, 1893

Both Lever and the Cadburys, who built the community of Bournville at Birmingham from 1898, were men of high moral principles. Bournville architects gave each home an individual garden and emphasized the importance of hygiene and health. As at Port Sunlight, semi-detached houses, not tenement blocks, were built to give workers both individual pride and a sense of community. The Cadburys were particularly aware of social responsibility, as was Joseph Rowntree, a fellow Quaker and chocolate manufacturer who founded the village of New Earswick in Yorkshire at the beginning of the new century and employed Parker and Unwin to lay out the estate and design each house. Parker's concern with environmental effect, formally published in 'The Art of Building a Home' in 1901, the year in which New Earswick was planned, reflected Morris's idealistic philosophy. Houses were to be planned from the inside out, with rooms 'large enough to be healthy, comfortable and habitable'.

The creator of the term 'garden city', Ebenezer Howard (1850–1928), was a non-architect theorist. Influenced by Whitman, Emerson and Ruskin, he wished to create 'a new civilisation based on service to the community'. Howard insisted that each plan, like an Arts and Crafts building, should relate to its chosen site, and that the size of

towns be regulated by economic research. His influential book, *Tomorrow: a Peaceful Path to Real Reform* (1898; revised and re-published in 1902 as *Garden Cities of Tomorrow*), united philanthropy and Socialist ideas in a code-book for practical social reform.

Arts and Crafts architects supported Howard's condemnation of metropolitan growth. In 1903 Howard helped to found the Garden City Pioneer Company: a plan for the First Garden City of Letchworth, in Hertfordshire, was submitted by Lethaby and Ricardo but defeated in competition by the experienced Unwin and Parker. Ruskin's vision of a 'belt of beautiful garden and orchard round the walls, so that from any part of the city perfectly fresh air and grass and sight of far horizon might be reachable in a few minutes' walk' found expression as a large agricultural belt surrounding the town. A system of estate ownership and leasehold was found to operate satisfactorily, and competitions were held to marry good design to economic needs. Letchworth was built until the First World War to housing designs by architects including Ricardo, Baillie Scott 46

46 M. H. Baillie Scott, Tanglewood, Letchworth Garden City, Hertfordshire, 1906–07. Entrance doorway

and Unwin. The town attracted both professional men and women dedicated to the simple life and those who wore smocks and sandals, adopted vegetarianism or joined the Letchworth Morris Men (the latter were gently ridiculed in the London popular press.) Forty years later a government report stated that its citizens were healthier than those of any other industrial town.

A second garden city, Welwyn, was established in 1919 as a result of Howard's personal initiative. Hampstead Garden Suburb in north-west London, initially the concept of Henrietta Barnett, was created in the intervening period. Barnett wished the suburb to be an ideal, harmonious community of all classes and all generations. With Unwin as planner from 1905, it benefited from the experience of Letchworth and a number of Arts and Crafts architects were again employed, including Baillie Scott and Lutyens. Low-density planning, programmed in Unwin's publication, *Nothing gained from overcrowding, or how the Garden City type of development may benefit both owner and occupier* (1912), was achieved by a financial equation of fewer roads and land costs. Even so, the Suburb was expensive and inaccessible to many workers. Unlike a garden city, it was never intended to be economically self-sufficient but simply residential; it therefore became a middle-class successor to Bedford Park.

The Garden City Association, established in 1899 with branches throughout Britain, promoted a synthesis of Socialist and garden city ideals. The demand for 'well and economically arranged' houses was stimulated by Association exhibitions mounted across Britain, particularly between the Wars. Influencing municipal housing schemes, they helped to create a democratic architecture based on simple, practical and financially viable principles. This contrasted with the new private homes of 'Metro-land', the London suburban belt of new towns developed by the prospering Metropolitan Railway company. In Metro-land suburbs such as Uxbridge and Watford houses were built whose Arts and Crafts-derived mass-produced details lacked both sensitivity and context.

The demise of Arts and Crafts architectural design in Britain was gradual. Since 1900 the growth of both popular architectural journalism and the conservation movement had helped foster not only a craft vocabulary but a general distrust of non-indigenous design. When the modern movement was first promoted in the late 1920s and early 30s, journalists and the public struggled to fit it into a visual tradition. They ultimately succeeded by seeing a continuum between the Arts and Crafts movement and European modernism.

The theorists of both shared many ideological roots, emphasizing the morality of good architecture and the need for functional design – ideals originated in England by Pugin and Ruskin. During the 1940s, by demonstrating this common pedigree, critics in Britain began to effect a wider understanding of modernism. To accept it, they believed, meant forsaking neither the past nor recent achievements: on the contrary, modernism was to the present what Arts and Crafts had been to the 1890s. As one of the most influential popular critics of the time, J. M. Richards (born 1907), wrote in *An Introduction to Modern Architecture* (1940), a 'belief in modern architecture' was 'not incompatible with the admiration for the old: indeed the two amount to the same thing for the qualities of good architecture are unchanging . . . to have the courage of our own convictions, allowing us to build frankly for our own time, is the only true way of maintaining the traditions we have inherited.'

47 M. H. Baillie Scott, design for the music room, Winscombe House, Crowborough, Sussex, *c.* 1900 (detail)

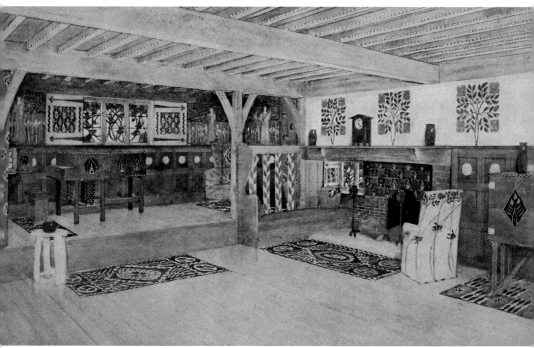

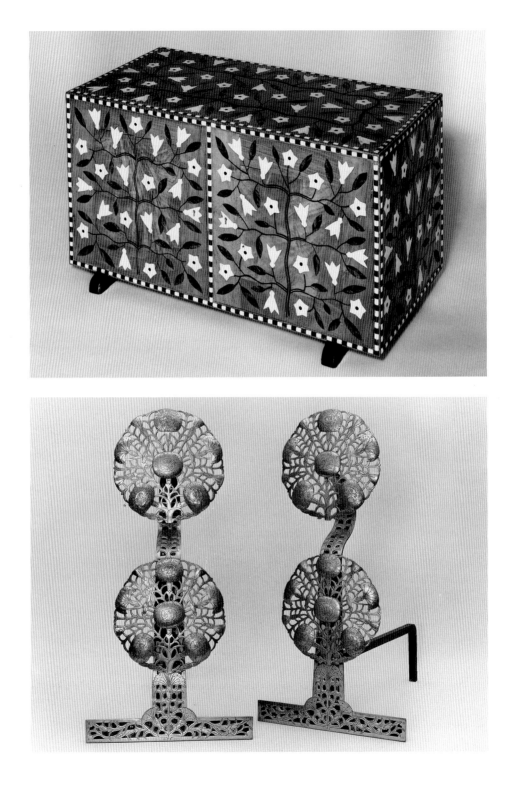

Studios, Education and Industry

British design reformers, unlike architects, searched far beyond their national boundaries for inspiration. The crafts of the east, from countries such as Japan, India and Persia, had been widely admired since the late 1870s, when the richness of their colour and designs influenced the designers and artists of the Aesthetic movement. Arts and Crafts designers considered that such crafts, past and present, reflected working and living conditions, the harmony of eastern village life beyond the reach of British industrialism.

For Ashbee, British and Indian cultures were uniquely integrated through his friendship with the Anglo-Ceylonese geologist and anthropologist Ananda Coomaraswamy (1877–1947). Coomaraswamy had researched and collected the arts of India and Ceylon (now Sri Lanka) since the early 1900s and in 1906 commissioned Ashbee and the Guild of Handicraft to restore and convert Norman Chapel in Chipping Campden. He also bought shares in the failing Guild in 1907, and purchased the Essex House Press. He and Ashbee both believed that successful commerce and work could prosper only as a continuation of traditional cultures which, unlike industrialism, did not deny the past. Within these cultures the work process, called by Lethaby 'a necessary basis for all right religion, art and civilisation', assumed a central role in the search for spiritual fulfilment.

Idealists like Ashbee considered that good design could only be created in new workshop communities modelled on historic prototypes and located in rural surroundings: life on the land was equated with economic and spiritual well-being. The simple life, and with it the restoration of dignity for the worker, was not, however, the only reason London architect-designers were lured to the country and its native crafts. Many had worked on country house commissions and, like Webb and Morris, were anxious to contribute to the vernacular tradition in building and design. In 1893 Ernest Gimson, 48,49 Sidney Barnsley (1865–1926) and his elder brother Ernest (1863–1926), an architect trained by Sedding, moved to the Cotswolds. They settled in Ewen, near Cirencester, and, following the example of

67

48 Cabinet, *c.* 1905, Ernest Gimson

49 Firedogs, 1904, designed by Ernest Gimson, worked by Alfred Bucknell

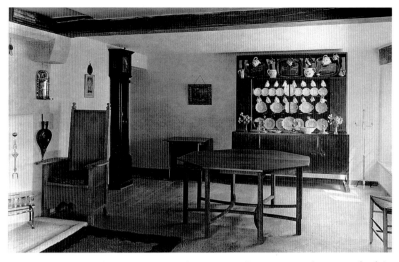

50 The interior of Ernest Gimson's cottage, Sapperton, photographed in 1904. Kenton & Co. chair designed by W. R. Lethaby and table designed by Gimson, made in the Daneway workshops

Morris at Kelmscott Manor, moved a year later to a sixteenth-century house, Pinbury Park, near Sapperton, where they set up a craft workshop in 1900. In 1902 they leased larger workshop space in the fourteenth-century Daneway House in the village of Sapperton.

Gimson and Sidney Barnsley had followed Morris company practice by designing, crafting and retailing their goods. In 1890, with their fellow Art Workers' Guild architects Blomfield, Macartney and Lethaby, they established the London firm of Kenton & Co. Although the company lasted only two years, for each of them it was valuable experience to identify commercial needs and crystallize design principles. Their simple furniture was designed according to basic construction principles, and carried no superfluous ornament. If decoration was used it was inlaid, with exquisite materials like mother-of-pearl or ivory reflecting the interest in Indian crafts.

In order to improve their skills, architect-designers learned the rudiments of traditional crafts from local craft workers or asked them to make up objects. Gimson studied rush seating and wood turning with Philip Clissett, an elderly Herefordshire chair bodger brought by MacLaren to the attention of the Art Workers' Guild; and after 1903 he used a Sapperton blacksmith, Alfred Bucknell, to fashion his sconces, firedogs and fire irons. When Lorimer was restoring Earlshall, he turned to William Wheeler, a joiner in the nearby village

51 Lustre dish, 1880, designed by William De Morgan, made at the Orange House Pottery, Chelsea

52 Vases, 1920 and 1924, Ruskin Pottery

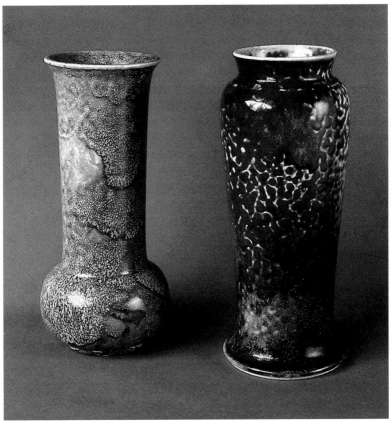

of Arncroach, to make up chest and dresser furniture adapted from old Scots renaissance designs and to Jeannie Skinner, the local postmistress, to sew his embroideries. Like the furniture of the Morris company, many of his designs were only loosely based on traditional forms but used old craft techniques. Lorimer's Scottish kists, or chests, and dressers, Gimson's West Country metalwork designs and plasterwork, Sidney Barnsley's emphatically solid oak furniture and the new work of Ashbee's Guild of Handicraft all used clean lines to convey the beauty of natural materials and simple, strong construction. These objects, like 1890s buildings, declared how they were made. Exaggerated wooden joint or metal handle forms were integral to the design. Their designers, moreover, took pride in choosing native materials such as oak or elm that best reflected their ideas of the vernacular and in tooling their pieces by hand: few pieces of machinery, apart from circular woodcutting saws, were in use at either the Cotswold school or Guild workshops.

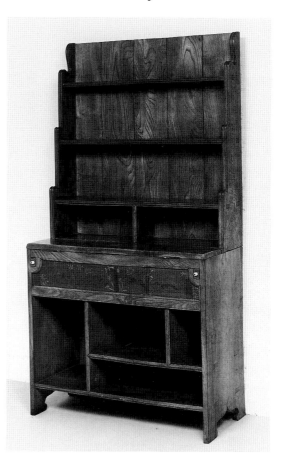

53 Dresser, c. 1893, designed by Robert Lorimer, made by Whytock & Reid for Earlshall, Fife

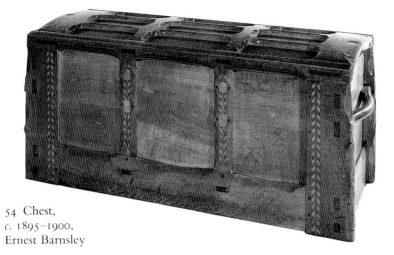

54 Chest,
c. 1895–1900,
Ernest Barnsley

While Sidney Barnsley designed and made his own furniture, believing the realization of the designer-craftsman ideal too precious to be broken, his brother and Gimson actively recruited craftsmen for 54 their Sapperton workshop, including a Dutchman, Peter Waals (1870–1937), who had worked in Brussels, Berlin and Vienna, as foreman in 1901. Following the principles of the Cotswolds Group, Waals allowed the form, colour and quality of the woods – oak, chestnut and sometimes walnut – to dictate the design.

This high-minded rural romanticism of the 1890s and early 1900s also existed elsewhere. The Haslemere Peasant Industries, Surrey, set up by Godfrey Blount (1859–1937) in 1896, was an artistic community with a goal as idealistic as Ashbee's. Blount supported the ideals of integrating work, leisure and the country life and the philanthropic principles of the home industries movement. He sought 'the revival of a true country life where handicrafts and the arts of husbandry shall exercise body and mind and express the relation of man to earth and to the fruits of earth'. Blount and his wife Ethel Hine supported the simple life in all its various aspects. With Ashbee's wife Janet they were prominent in the Healthy and Artistic Dress Union, founded in London in 1890 to promote the wearing of unusually comfortable, loose-fitting clothes made of hand-woven cloth.

The Peasant Industries, like the Home Arts and Industries 57 Association, was an umbrella organization for a number of new, small

71

workshops employing a local skilled workforce, and it also ran a London depot for the sale of work. Blount and his wife were more concerned than Ashbee with local craft traditions: the Industries encompassed weaving and embroidery as well as mural decoration, woodwork, ironwork, bookbinding and printing – all practised by both amateur and professional craft groups at this date. When Ashbee took over the old Silk Mill at Chipping Campden he did not revive the cloth industry: the Guild, despite Ashbee's admiration of Indian culture, had no textile section at all. Instead, the Silk Mill was used for workshops in woodcarving and cabinet-making, silverwork and jewelry, and enamelling and ironwork, all subjects transferred with the Guild from London.

From the mid-1890s Arts and Crafts building, furniture and ceramic design all moved towards greater emphasis on spare form and surface texture. No longer would furniture woods be camouflaged: in chairs, ebonized finishes were replaced by uncoloured woods, and seats and backs were often made with leather or rush. In ceramics, terracotta, the most 'natural' clay, was painted or sometimes left plain; both were used, for instance, in the decoration of the chapel at Compton in Surrey (1896–1906) by the Compton pottery, a women's guild directed by Mary Watts, the wife of the painter G. F. Watts.

55 Binding with inlays by Edith de Rheims for *Celtic Fairy Tales, c.* 1901. Illustrated in *The Bindings of Tomorrow* published by the Guild of Women-Binders, 1902

56 Pendant and chain with plaque and drops of opal and amethyst, *c.* 1900, Nelson and Edith Dawson

The writings of Ruskin and Morris influenced a wide range of designer-craftsmen in the 1890s. Morris's ideal of a craftsman designing and making an object from raw material to finished product was achieved most readily in ceramics while Ruskin's idea of the beauty of imperfection could be materialized in pottery more easily than other media. The art of a single person throwing, shaping, firing and decorating ceramics was seen to bear the stamp of artistic integrity. Potters could work, moreover, quite independently of industry if they so wished: there was no reliance here on manufacture, no preparation of copper or silver sheeting or seasoning of woods. As the first craft discipline to present an equally inexpensive alternative to mass production, ceramics could also directly challenge the factory system. Factory wares were designed on a drawing-board, machine-made by a second person and decorated by a third. A smaller studio workshop was able, on the other hand, to combine designer, maker and decorator. In both cities and country towns small factories were

established that employed experienced potters to work, train and share their knowledge with other craftworkers.

Small, independent potteries such as the Ruskin Pottery (1898–1933) and the Della Robbia Pottery (1893–1906) were concerned less with new forms than with surface and glaze experiment. The high-temperature glazes of the Ruskin Pottery established in West Smethwick near Birmingham by William Howson Taylor, son of the Birmingham School of Art headmaster, were particularly adventurous. The relationship between craft and industry could be a close one, as Taylor demonstrated. He drew upon local expertise, hiring factory staff from the nearby Wedgwood firm and, like other ceramic studios, contracting larger companies to supply the Pottery with blanks and give his decorators their essential chemical training. The Della Robbia Pottery, established in Birkenhead by Harold Rathbone and Conrad Dressler, used surface *sgraffito* marks with coloured enamels to emulate the richness of Italian majolica.

By 1900 larger manufacturing companies recognized the ready market for such work and established hand-painting and handcraft sections producing 'one-off' decorated wares. Doulton, in Lambeth, London, and Wedgwood both introduced craft studios where art school-trained artists experimented with glazes and form. Two associates of the Gimson circle, Louise Powell and her husband Alfred Powell, were appointed to Wedgwood's Etruria factory where from about 1905 they shaped and decorated lustre and tin glaze ware. The Doulton company employed, among others, the sculptors Charles Vyse and Phoebe Stabler.

The designer who most influenced these potters was William De Morgan (1839–1917), an exceptional colourist and designer who also worked alongside the factory system, decorating ready-made blanks. De Morgan first turned to ceramics from stained glass to experiment with lustre: he developed the use of a film of copper or silver on glazes, basing his work on a study of Hispano-Moresque and Italian wares to give ruby-red, delicate golden or bluish-grey colours to pots and tiles. Some of his exotic designs and colours were also influenced by the Orient. As Morris collected and adapted Eastern carpet and tile designs, so his friend produced 'Persian' ceramics inspired by Iznik wares of the fifteenth to seventeenth centuries and decorated with plant or bird forms in luminous blue, green and yellow enamels.

De Morgan employed assistants, including his later partners Charles and Fred Passenger, to paint his wares, but was willing to take financial risks in order to maintain artistic freedom. Not a member of

74

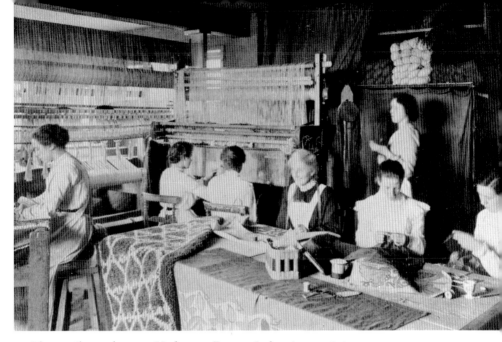

57 The textile workroom, Haslemere Peasant Industries, *c.* 1898

the Art Workers' Guild, he despised the machine as used in industry and worked towards a goal of technical excellence in handcrafted decoration. Although an independent designer he also worked closely with architects and fellow craftsmen, developing colour theories and the use of ceramics as an architectural feature with Ricardo, his partner in Fulham, London, between 1888 and 1898.

For six years from 1882 the De Morgan workshop had been based in Merton Abbey, the Surrey village where Morris had established his weaving sheds the previous year. London always retained its position as the major centre for design reform and De Morgan returned to the city to consolidate and expand his business. A number of independent craftsmen and their families subsequently gravitated to Hammersmith in west London, where the Socialist intellectualism of Morris's circle was sustained into the 1900s. Arthur Penty (1875–1937), a former architect and author of a definitive collectivist treatise, *The Restoration of the Gild System* [sic] (1906), lived in Hammersmith, as did Romney Green (1872–1945), a poet and mathematician turned cabinet-maker. Emery Walker, Cobden-Sanderson and Morris's younger daughter May (an embroiderer and designer) and the metal-worker Edward Spencer lived in the eighteenth-century Hammer-

smith Terrace. In 1905 they were joined by the calligrapher Edward Johnston and the Fabian Socialists Eric Gill and Douglas Pepler.

Home and work were as integrated here as in many country communities. Cobden-Sanderson founded the Doves Bindery in 1893 and, with Walker, set up the Doves Press in Hammersmith Terrace in 1900. The Press, which continued until 1917, and the Ashendene Press (1894–1935), established by C. H. St John Hornby (1867–1946), a Hammersmith resident and later a partner in the firm of W. H. Smith, were among the finest and best-known of the many British private presses of the early twentieth century. Their aim was to contribute to what Cobden-Sanderson called in *The Ideal Book, or Book Beautiful* (1900) the 'wholeness, symmetry, harmony, beauty, without stress or strain' of life. Press designers worked on their books with the precision of engineers – selecting texts, hand-printing their papers, designing typefaces, page and cover layouts and colouring and tooling their leathers meticulously. Art, for Cobden-Sanderson, was but 'every man's duty carried one stage further into beauty'. His high ideals matched the beauty of Doves Press books and his writing in *Ecce Mundus, or Industrial Ideals* (1902) and *Science and the Cosmic Vision* (1916) carried Lethaby's earlier romantic notions into the twentieth century.

58 Mary Newill *Queen Matilda working the Bayeux Tapestry*, stained-glass window, The Anchorage, Handsworth, Birmingham, 1898–99 (detail)

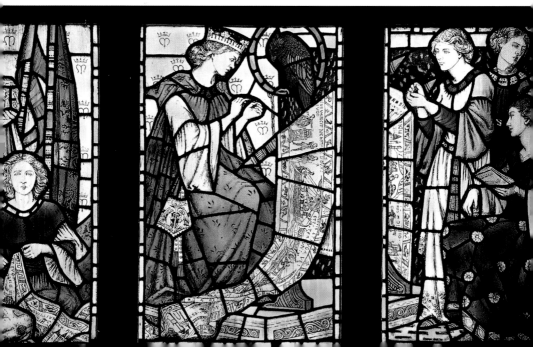

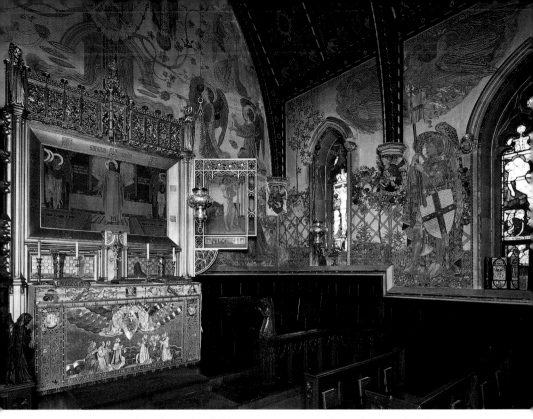

59 Beauchamp Chapel, Madresfield Court, Worcestershire, decorated and furnished by the Birmingham Group, 1902–23

Private presses were staffed by men, but the craft of bookcover tooling offered middle-class women still tied to the home a practical and, for once, professional alternative to needlework, miniature painting or china decoration. Instructed in tooling by male trade professionals, groups of women binders who had exhibited in London in 1897 formed a federation in 1898 with the encouragement of Frank Karslake (1851–1920), a London businessman and bibliophile. Their collective name of 'The Guild of Women-Binders' is misleading, for members were only involved in finishing. Not all covers, moreover, were executed by their designers: Elizabeth McColl, for instance, tooled designs by her brother, the critic and curator D. S. McColl, and Florence and Edith de Rheims sometimes those of Constance Karslake. Like many city craft groups, the Guild was a mix of professional and skilled amateur enthusiasts; it drew its

55

members from the Kirkby Lonsdale Handicrafts Classes and the Leighton Buzzard Leather Class to the Chiswick Art Workers' Guild and both the Edinburgh Social Union and the Edinburgh Arts and Crafts Club. Frank Karslake operated a shop in central London where commissions could be placed, and at the height of its activities (between 1898 and 1902) the Guild of Women-Binders perpetuated the overlap of home industries and high Arts and Crafts.

Critics at the time claimed the Guild to be inspired, like the private presses, by the spirit of the Kelmscott Press. Its aims were to produce 'not mere conglomerations of gold-tooling and meaningless inlays' but to respond to the spirit of texts (as a building might its landscape setting), to harmonize colour with form, and to show respect for the tooled material. The Guild's bindings were far from plain. Their elaborate designs, bright colours and rich gilding resulted from the British Arts and Crafts concern with exquisite materials. The exception was the pictorial 'Edinburgh Binding' of embossed and tooled undressed morocco or pigskin, which was analogous to the contemporary use of 'raw' unglazed ceramics or unstained woods.

60 Binding on John Milton's *Minor Poems*, by T. J. Cobden-Sanderson, 1890

LE MORTE D'ARTHUR. ⟨⟨INCIPIT LIBER PRIMUS. ⟨⟨CAPITULUM I.
⟨⟨Fyrst how Utherpendragon sente for the duke of Cornewayl and Igrayne his wyf, and of their departyng sodeynly ageyn.

IT BEFEL IN THE DAYES OF UTHER PENDRAGON WHEN HE WAS KYNGE OF ALL ENGLOND, AND SO REYNED THAT THERE WAS A MYGHTY DUKE IN CORNEWAILL THAT HELDE WARRE AGEYNST HYM LONGE TYME. AND THE DUKE WAS CALLED THE DUKE OF TYNTAGIL AND SO BY MEANES KYNGE UTHER SEND FOR THIS DUK, CHARGYNG HYM TO BRYNGE HIS WYF WITH HYM, FOR SHE was called a fair lady, and a passynge wyse, & her name was called Igrayne.

⟨⟨So when the duke & his wyf were comyn unto the kynge by the meanes of grete lordes they were accorded bothe, the kynge lyked and loved this lady wel, and he made them grete chere oute of mesure, and desyred to have lyen by her. But she was a passyng good woman, and wold not assente unto the kynge. And thenne she told the duke her husband and said: I suppose that we were sente for that I shold be dishonoured. Wherfor husband I counceille yow that we departe from hens sodeynly that we maye ryde all nyghte unto oure owne castell,

61 Detail of page from Sir Thomas Malory's *Morte d'Arthur* with initials by Graily Hewitt, printed at the Ashendene Press, 1910–13

Many Guild covers were inspired not by British but by French or German historic work. The heritage of the past encouraged new techniques, but it was not necessarily British prototypes – as was the case with ceramic slipware or Jacobean furniture and embroidery – on which designers modelled their ideas. They looked, as had the Morris circle, to nature and the arts of both the Orient and the Middle Ages.

The golden age of a craft discipline might also now include the Italian Renaissance. If architects dismissed the buildings of the Renaissance as alien to their ideals, designers wanted to share in what the critic Bernard Berenson in 1894 called its 'intellectual curiosity and energy grasping at the whole of life'. As the Pre-Raphaelite painters had focused public attention on the art of the early Italian Renaissance artists – their romance of imagery, their fresh, luminous colours and, not least, their experiments with painting and craft technique – so turn-of-the-century designers, supported and encouraged by the new writings of art historians, viewed the Renaissance as both an age of humanism and the dazzling climax to late medieval civilization. In the 1890s the *Libra dell'arte*, the painter Cennini's technical treatise of *c.* 1390, was translated by Lady Christiana Herringham as *The Book of the Art of Cennino Cennini*, Ashbee's press printed *The Treatises on Goldsmithing and Sculpture* of Benvenuto Cellini, and the books of Berenson and Walter Pater emphasized not only the unique richness of Renaissance culture but also the 'tactile' values of its painting.

62 P. Oswald Reeves *A Double Star* 1909, slipcase for his personal copy of his *Days to be remembered*

63 Rug with zoomorphic design, *c.* 1928, Dun Emer Guild

Metalwork was inspired, therefore, by both late medieval and Renaissance designs and techniques from Germany, France and Italy. The medieval chalice and casket and the late Renaissance *nef* (an elaborate table napkin holder in the form of a ship's hull) were revived by Alexander Fisher (1864–1936) and Wilson in London, and, under their influence, Traquair in Edinburgh and the metalworker and illustrator Arthur Gaskin (1862–1928) in Birmingham. Fisher became 65 the most influential enameller in Britain. A former pupil of Dalpeyrat at the South Kensington school, he taught the subject in his London studio to members of the aristocracy and the leisured middle classes. Fisher promoted painted enamel as a jewel or an art object (in a single or multiple plaque form) set in gold, silver, bronze or even steel. Jewelry settings were Renaissance-based: the popular belt buckles, 64 cloak clasps, hairwork, rings and pendant necklaces were designed to be worn with the simpler, healthier clothes fashions. Painted enamel came closest of all the new crafts to miniature or easel painting, which gained it wide acceptance. The perfumed language of Fisher's instructional book, *The Art of Enamelling on Metal* (1906), reflected the intense iconography of many enamel pieces: describing the 'radiant preciousness' of enamel, he wrote that it could reflect the 'velvet of the purple sea anemone, the jewelled brilliance of sunshine on snow, the hardness greater than that of marble, the flame of sunset, indeed, the very embodiments in colour of the intensity of beauty'.

Although they often used precious metals, enamellers aimed to create a people's jewelry by substituting cheap glass enamels for gems. Moreover, its laws of production appealed to Arts and Crafts idealists: enamel jewelry was designed and made by at the most three people, in place of a whole team of gem cutters, silversmiths and polishers. Enamelling was also a Guild of Handicraft medium but to a large extent it became a women's craft and one which, under Fisher's influence, was both a hobby and a professional discipline. Like potters, enamellers generally mastered their craft by trial and error and taught one another new skills. Husbands and wives sometimes collaborated on setting and enamel: Nelson and Edith Dawson in London, Harold 56 and Phoebe Stabler in Liverpool, Arthur and Georgie Gaskin in Birmingham all worked together while some of Traquair's decorated shell cups were designed by her architect son Ramsay. Not only did they use Fisher's painted enamel, but *champlevé, cloisonné* (Phoebe Stabler studied with a Japanese enameller) and the technically challenging, unbacked *plique-à-jour*. Some enamel plaques were flower paintings, others more narrative in subject.

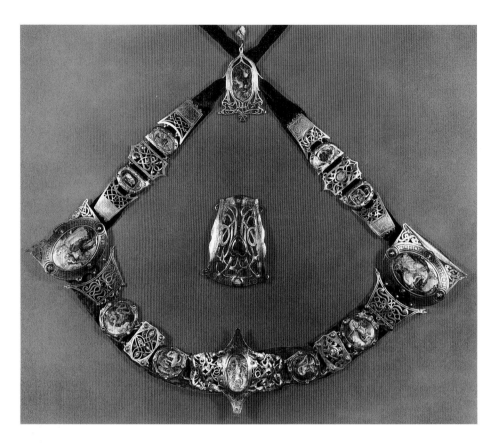

By the 1890s some craft workshops, like Fisher's, taught a single discipline; others pursued Ashbee's interdisciplinary ideology. These studios encouraged intuitive design and technical virtuosity through shared experiment; a Renaissance-inspired *bottega* system of communal watching, creating and learning became a vital ingredient of design reform during the decade and began to influence official design teaching. In art schools direct copying from the antique and historic ornament became less important than practical workshop education. Professional instruction in architecture and design followed the same code: the art of the past was still to be studied, but its purpose was now to provide more indirect, analogous inspiration. Architects who had fought hard to raise the standards of design and the status of craft wanted schools to turn out architectural, industrial or domestic craftsmen who were highly skilled, reasoning and able to produce unique, non-repetitive work.

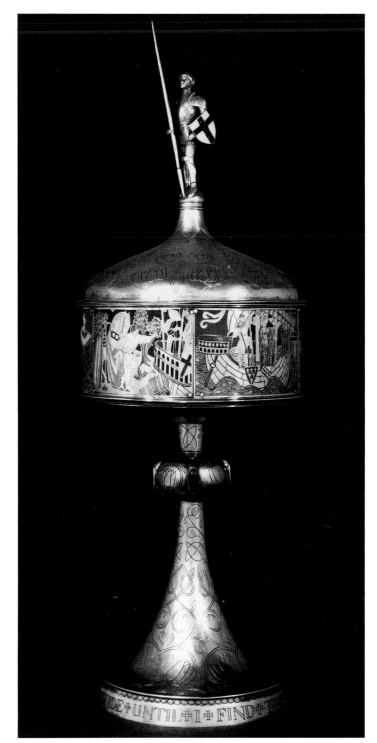

64 OPPOSITE *The Wagner Girdle and Buckle* 1896, Alexander Fisher. Plaques depict the story of Tristan and Isolde

65 *The Galahad Cup of Honour* 1902–03, Arthur Gaskin

The new subject of 'applied art' encompassed engineering, art and technical expertise. At Liverpool, where the university was the centre of design teaching, the Roscoe Chair of Fine Art was changed in 1894 into one of 'Architecture in association with Applied Art'. Here as elsewhere the growth of new classes was so fast that makeshift accommodation, the 'Art Sheds', was hastily improvised. Throughout the country links were actively forged with local industries. The training of working artisans became an art school director's priority, and part-time day and evening classes, taught by commercial craftsmen, were integrated with those for designers and architects. Commercial crafts such as stained glass and bookbinding and more industrial ones including metalwork and ceramics were introduced to offer students as wide an education as possible. In 1892, for example, Francis Newbery (1853–1946), the progressive director of the Glasgow School of Art, introduced Technical Art Studios where artist-craftsmen gave artisans a 'Technical Artistic Education'; Edinburgh's new School of Applied Art under the direction of a local architect, Robert Rowand Anderson (1834–1921), offered classes for engravers, plasterers, cabinet-makers and architects.

The Central School of Arts and Crafts in London, opened in 1896, and the Glasgow School of Art taught particularly broad ranges of crafts, from illumination to lead plumbing. Their teachers encouraged pupils not to work towards written examinations, but instead to be inspired by contemporary life and to solve their practical and aesthetic problems through the study of precedent and to acquire thereby a respect for materials. The Central School was dominated by the inspirational philosophy of Lethaby, its part-time co-director from 1896 to 1902 and principal until 1911. The directors of these two schools took on highly skilled, but not necessarily professional, craftworkers as teachers. Ricardo was head of architecture at the Central School and Whall of stained glass, but Edward Johnston (1872–1944), a young amateur calligrapher later to achieve fame as a designer for the London Underground, taught illumination. In Glasgow Jessie Newbery (1864–1948), the wife of the director, taught embroidery from 1894 and introduced simple methods, lines and materials for clothes and domestic articles, using pastel colours, crewel wools or appliqué techniques. Like many teachers, including Lethaby, she stressed the need for modernity, advocating '*that* for our fathers, *this* for us'.

Art school students and teachers helped create the regional character of the crafts. In Birmingham Arthur Gaskin, the artist

Henry Payne (1868–1940), the designer of embroideries and stained glass Mary Newill (1860–1947) and the illustrator Charles Gere 58 (1869–1957) were all teaching at the Art School's 'Art Laboratories' by the mid-1890s. Calling themselves the Birmingham Group, they forged a corporate identity inspired by the writings of Ruskin, northern Italian Renaissance painting and the work of the English Pre-Raphaelites including Burne-Jones, a local artist. Their mural decorations, book illustrations, embroideries and enamelling illustrated late Romantic poetry and medieval romances. They experimented not only with enamelling but the Renaissance technique of tempera, an egg-based easel and mural painting medium revived in Birmingham by Joseph Southall. Members of the Birmingham School were as much concerned with decorative unity as the Morris circle, the Century Guild or Ashbee's Guild; they received many local commissions, the most outstanding of which was the decoration and furnishing of the chapel of Madresfield Court (the model for Evelyn 59 Waugh's Brideshead), whose library the Guild of Handicraft fitted. The chapel combined tempera mural decoration by Payne and his assistants with enamelwork by Arthur and Georgie Gaskin (1866– 1934), a reredos designed by the architect W. H. Bidlake (1861–1938) and an altarpiece by Gere.

Professional group collaboration also existed in Glasgow. The designers sometimes called 'The Four' – Charles Rennie Mackintosh, Herbert MacNair (1868–1955), Margaret Macdonald (1865–1933) and her sister Frances (1874–1921) – worked both independently and together from the 1890s. Introduced by Francis Newbery, each was influenced by the formal organization and economy of Japanese art and their Celtic heritage: the elongated, gaunt austerity of their work earned them the name of the 'Spook School'. Frances Macdonald married MacNair in 1899, the year after their temporary move to Liverpool, where they took an active part in 'Art Sheds' teaching and designed furniture, enamel jewelry and silverwork. Margaret, who married Mackintosh in 1900, was also, like her sister, Georgie Gaskin and Phoebe Stabler, a distinguished artist in her own right. Collaborating with Mackintosh on the design and the execution of several house interiors, including Hill House, she worked furniture or 66 wall panels in *repoussé* metal or painted gesso and designed textiles.

In Birmingham Arts and Crafts centred round the work of the Group and the Art School, but in Glasgow the extreme modernism of 'The Four' distanced them from the School-based craft movement. Teachers and pupils at the School of Art adapted 'The Four's' tense,

85

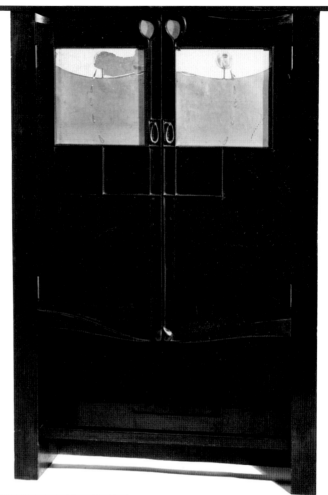

66 Writing desk, 1902, designed
by Charles Rennie Mackintosh,
gesso panels by Margaret
Macdonald Mackintosh

67 Cushion cover, *c.* 1900, Jessie
Newbery

disciplined forms and interest in their Celtic heritage, but were more influenced by London methods. Glasgow metalwork, enamelling and embroidered textile studios, as a collective whole larger and more enduring than others outside London, were influenced by the teaching of Jessie Newbery and her colleagues and were dominated 67 by women. Their independent and professional 'sister studios', run by School graduates, were active across the city until the First World War.

The crafts in Edinburgh and Dublin were also dominated by a mix of Celticism and London influence. By the mid-1890s a distinctive Edinburgh 'style' had emerged which was shared by a number of private studios and two schools. Traquair, Dublin-born and trained, 69 expressed the polymath ideal, working as embroiderer, illuminator, bookbinder, mural decorator and enameller. Like many Edinburgh craftworkers, she was principally a colourist interested in illustrating nature, history, legend and myth. The unofficial Old Edinburgh School of Art, directed by John Duncan (1866–1945) from its 68 inception in 1892, offered classes in design, mural decoration in oil and tempera, woodcarving and metalwork and formed part of a cultural Celtic renaissance spearheaded by the botanist and sociologist Patrick Geddes (1854–1932). Centred on Ramsay Garden, the 1890s revival aimed to establish cultural identity through lectures, classes and summer schools. The School of Applied Art, on the other hand, encouraged an academic approach to local heritage through a National Art Survey of buildings and furnishings carried out by architectural bursars from 1895.

The Dublin craft revival developed slightly later than in Scotland, during the growth of Irish nationalism after 1900. Dublin, like Belfast, Limerick and Cork, had been an active centre for home industries, including lacemaking and woodcarving, twenty years earlier. The post-1900 movement focused on indigenous traditions in the wake of political upheaval and included perhaps more amateur work (from handcraft to mural decoration) than anywhere in the British Isles. The chapel at the Dominican Convent, Dunlaoghaire, for instance, was painted with Celtic designs by Sister Conceptua Lynch from 1920 until 1939. The professional movement owed more to London practice: leading designer-craftworkers included the enameller Oswald Reeves (1870–1967), a pupil of Fisher, the stained- 62 glass artists Harry Clarke (1889–1931) and Alfred Child (1875–1939), a former Whall apprentice and with Sarah Purser (1848–1943) principal artist of the glass and mosaic co-operative An Túr Gloine

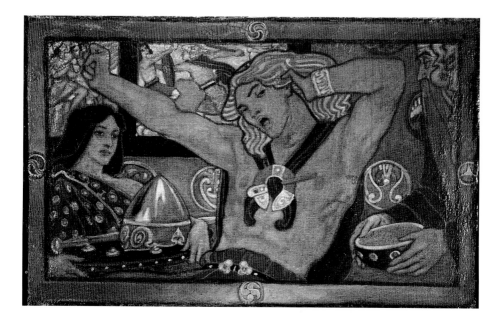

(The Tower of Glass). As in Edinburgh, Glasgow, Birmingham and London, the Dublin movement involved collaborative decoration of buildings. For Cork's Honan Chapel Clarke designed glass, Reeves made a tabernacle door and the Dun Emer Guild designed and embroidered a new cope.

The crafts of the Dun Emer Guild, founded by Evelyn Gleeson (1855–1944) in 1902 on her return from London, were most directly inspired by the native Celtic vernacular. Discussions with Emery Walker and the poet W. B. Yeats led to the founding of the Dun Emer Press (1903–07) and the Dun Emer Industries (1904–08) by Gleeson, which were run by the Yeats sisters Elizabeth (1868–1940), a bookbinder, and Lily (1866–1949), an embroidery student of May Morris. The textiles of Dun Emer Industries and its successor, Cuala Industries, united Hibernian interlace patterns with rich colour and texture.

By 1900, four years after the death of Morris, the British craft movement was rooted as a widespread multi-disciplinary profession. Cities became associated through their art schools with particular media – embroidery and metalworking, for example, with Glasgow, and enamelling, printing, mural decoration and illustration with Birmingham and Edinburgh. The Arts and Crafts Exhibition Society in London, the Northern Art Workers' Guild in Manchester and the

63

68 OPPOSITE John
Duncan *The
Awakening of
Cuchullin* mural,
c. 1894, Ramsay
Lodge,
Edinburgh

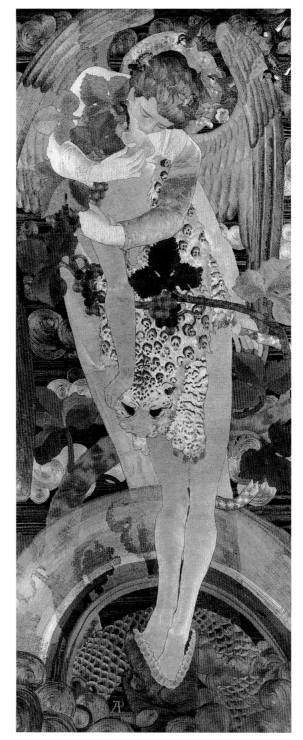

69 Phoebe
Traquair
The Victory
embroidery,
1900–02. The last
of four panels
inspired by
Walter Pater's
story 'Denys
l'Auxerrois' in
*Imaginary
Portraits* (1887)

Scottish Guild of Handicraft in Glasgow were among the most active societies exhibiting the work of both individuals and groups.

The rapid expansion of the craft movement in the 1890s gave a new impetus to amateur work. The amateur crafts were acknowledged not only as an aid to moral improvement but as an educational tool. Teachers recruited by the Sloyd Association, a home industries society providing classes in woodcarving, and the Educational Handwork Association, founded in 1897, had brought crafts into the mission hall, the school classroom and the group workshop. By the early 1900s the amount of adult amateur craftwork had increased significantly. Sometimes it was exhibited with professional work: the nationwide Clarion Guild of Handicraft's evening classes and exhibitions, founded in 1902 by Julia Dawson of the British Socialist newspaper *The Clarion*, were among the most actively supported.

Journals and books on the crafts were published to satisfy professional needs and to meet the increase in amateur middle-class demand. A range of periodicals from *The Studio* to *The Art Workers' Quarterly* (1902–05) offered practical guidance and encouraged individualism and the establishment of workshops far beyond the principal centres. Amateur work by women was encouraged by *The Needle* (1903–10), *The Ladies' Fancy Work Magazine* (1907) and *Home Handicrafts* (1907–17). The most important books published were written by Central School teachers in the 'Artistic Crafts Series of Technical Handbooks' between 1901 and the First World War. Deemed 'suitable for Schools, Workshops, Libraries and all interested in the Arts', they were written by its teachers – Henry Wilson, Douglas Cockerell (1870–1945), a former Doves Bindery apprentice, George Jack (1855–1932), the principal furniture designer to the Morris company, Luther Hooper (1849–1932), the founder in 1901 of the Green Bushes Weaving Houses at Haslemere, and Edward Johnston. Of other books the most influential were on enamelling and embroidery. Fisher's *The Art of Enamelling*, a blend of instruction and historical discourse, and Edith Dawson's *Enamelling* appeared in 1906. *Educational Embroidery* (1911) by Margaret Swanson and Ann Macbeth, Jessie Newbery's successor in Glasgow, was one of the most practical and popular craft manuals, filled with patterns to make simple children's clothes and useful household objects.

The growing consumer market extended beyond craft objects to house furnishings. Arts and Crafts architects were redefining the decoration of interiors, from windows to floors, curtains to carpets, and manufacturing firms in turn responded to design reform and to

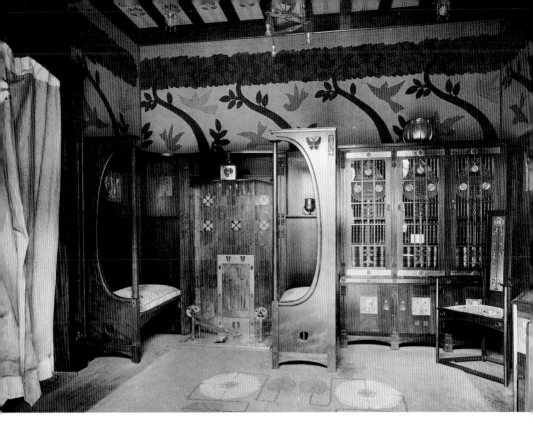

70 Library designed by George Logan for the Wylie and Lochhead Pavilion, 1901 Glasgow International Exhibition

demand from an expanding British middle-class market. They turned to leading designers of the movement – George Walton (1867–1933), George Logan (1866–1939), Voysey or Baillie Scott for furniture and Voysey, Lewis Day, Crane, Lindsay Butterfield (1869–1948) and the Silver Studio (1880–1963) in London for textile and wallpaper designs. Textile designers used stylized plant and flower forms in the mid- to late-1890s and strong, sometimes startlingly bright colours – reds, hot orange-pinks and a favourite, more 'natural' colour, green. Those firms employing Arts and Crafts designers included the Glasgow cabinet-makers and retailers Wylie and Lochhead and the carpet manufacturers Templeton & Co., Tomkinson and Adam of Kidderminster, and in Ayrshire the textile and carpet-makers Alexander Morton & Co. The Morton company in particular provided some much needed employment and simultaneously

70

71

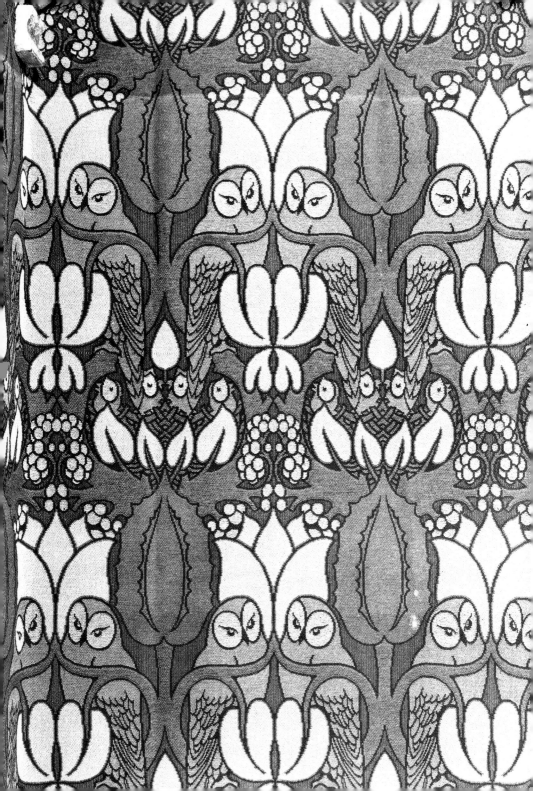

71 OPPOSITE *Owl* tapestry, 1898, designed by C. F. A. Voysey, woven by Alexander Morton and Co.

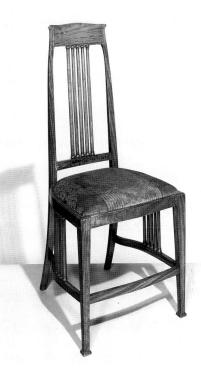

72 Liberty chair, published in their *Inexpensive Furniture* catalogue, 1905

benefited from cheap labour. In 1898 it established a carpet factory, where the craft of hand-knotting was re-introduced, in County Donegal, one of the poorest areas of Ireland.

The spread of commercial mass-produced furniture helped to popularize the ideas of architect-designers. Designed to be part of an integrated interior, the furniture was exhibited as room settings in trade exhibitions at home and abroad. Textiles and ranges of 'craft' furniture, metalwork and ceramics were available through large department stores in all major British cities of which the most important to the movement was Liberty's in London. The shop had been opened in 1875 by Arthur Lasenby Liberty and its affluent clientele were to include by 1910 the residents of the new garden cities as well as the London suburbs. Liberty's stocked both one-off, hand-made items, such as Compton pottery, and factory-made goods. Demand was such that the store, while continuing to use a number of independent suppliers, also operated its own textile and furniture manufacturing workshops, beginning in 1904 and 1905.

70

72

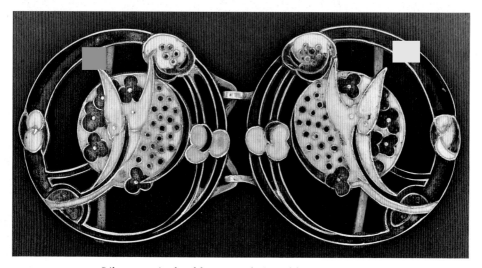

73 Liberty waist-buckle, 1906, designed by Jessie M. King

Metalwork was made for Liberty by the Birmingham firm of W. H. Haseler. According to Liberty policy, most designers and craftworkers did not mark their work: however, commissions were given to many local designers including Arthur Gaskin, Bernard
73 Cuzner (1877–1956), and Oliver Baker (1856–1939). Jessie M. King (1876–1949), a Glasgow designer of textiles and decorator of ceramics for Liberty, and Archibald Knox (1864–1933), from the Isle of Man, were two 'outside' designers who could successfully work to the requirements of metalwork mass production. Their Celtic-inspired, simple patterns and colours were well suited to machine-made goods.

But Morris's ideal of making the professional crafts available to all still remained a matter of compromise. The Liberty customer wanted to buy silver or pewter which, like ceramics, had a hand-made look
74 but Liberty's successful ranges of 'Cymric' silver and 'Tudric' pewter, made by Haseler often to Knox designs, were almost entirely machine-made, though seeming at first glance hand-wrought. Cymric silver, for example, was dye-stamped flat, complete with ornament and 'hammer marks', then shaped and finished with a touch of 'honest' hammering. 'Messrs Nobody, Novelty and Co.', as Ashbee referred to Liberty's, crudely imitated the style, not the principles, of his Guild of Handicraft and Liberty's cheaper products undoubtedly contributed to the gradual commercial demise of the

94

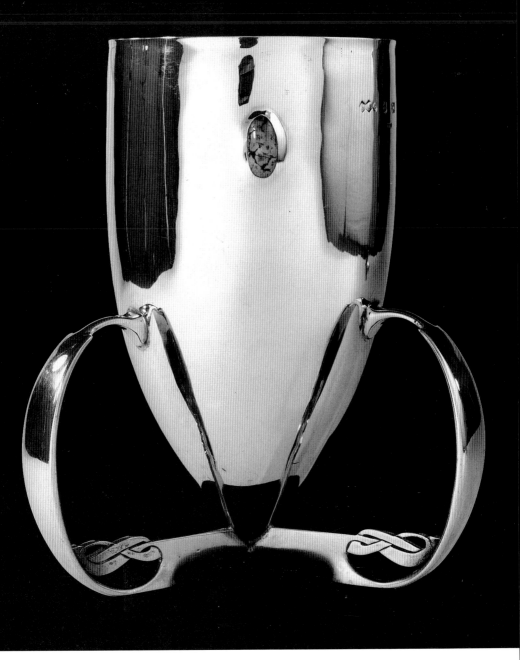

74 Liberty 'Cymric' silver vase with a turquoise matrix, 1902, designed by
Archibald Knox

Guild in the 1900s. For many craft designers they represented a wrong turning along the path to the reform of commercial design and a loss of professional integrity.

In refocusing ideals designers debated basic issues concerning the choice and application of form and materials and, not least, production methods. By the early 1900s the question of the appropriateness of form in British design had also assumed a political dimension. In 1901, for example, London anti-'squirm' architects and designers protested at Sir George Donaldson's donation to the Victoria and Albert Museum of French furniture displayed at the 1900 Paris Exposition. A letter to *The Times* in 1901 from Art Workers' Guild architects (including Blomfield, Prior and Macartney) considered the work of Majorelle, Gallé, Bagués and Gaillard to be badly executed and representing 'only a trick of design which, developed from debased forms, has prejudicially affected the designs of furniture and buildings in neighbouring countries'. Others joined in support, from Crane to government officials in the new Board of Education (the former Department of Science and Art). The incident illustrated the emphasis still placed on craftsmanship, the rejection of elaborate, non-structural ornament, and the high pitch of patriotism kindled during the Boer War. Not least it also helped publicize the Guild architects' new, elegant but expensive Neo-Georgian furniture, designed to harmonize with their buildings and compete with a growing trade in antiques.

Just as architectural priorities generally crystallized towards either social or artistic housing, so too designers worked to improve quality in either commercial and industrial design or the one-off studio crafts. Any split in the Arts and Crafts movement in the 1900–1914 period into designers and commercial manufacturers calling for better design and independent creative craftworkers was, however, never a clear-cut one of modernist versus traditionalist handworker. Whatever their own field of work, most designers supported both aspects of the movement and wanted, as Gleeson White had written in *The Studio*, simply to 'speak up for good things, whether made by an obscure amateur, or by manufacturers in a large way of business'. Industry and craft were regarded as complementary and not in direct competition with one another.

The crucial question of material appropriateness to object design was already a major issue. Lethaby had argued as early as 1890 in support of new, man-made fabrics: in 'Cast Iron and its Treatment', published in *The Journal of the Society of Arts*, he wrote that 'the easy

contempt we feel for iron is the direct result of our unworthy treatment of it'. Some Arts and Crafts designers, such as Gimson, stood firmly in favour of the continued use of natural materials and against involvement with industry, while others, for whom Lethaby was often the spokesman, held the view that to ignore technical advance was not only to maintain a blinkered attitude to manufacturing but also to endanger design progress.

Lethaby wanted an urgent re-assessment of the design reform initiated by Morris. He called for art and humanity to be restored to workmanship and also for designers to be motivated by a sense of social purpose and responsibility as much as commercial success. In 1913, in an essay on 'Art and Workmanship' in *The Imprint*, which was influential then and has been much quoted since, he wrote that 'although a machine-made thing can never be a work of art in the proper sense, there is no reason why it should not be good in a secondary order – shapely, smooth, strong, well fitting, useful; in fact, like a machine itself. Machine work should show quite frankly that it is the child of the machine; it is the pretence and subterfuge of most machine-made things which make them disgusting.'

The new wave of design reform was further stimulated by commercial competition from abroad and admiration for the principles and work of the Deutsche Werkbund, founded in Germany in 1907. The Werkbund had accepted the need to design not just for handcraft but also for mass production. It had a collective membership which included manufacturers as well as artists, architects, craftsmen and laymen and was successful not only in design and workshop practice but in contributing to the German national economy. The impact of the Werkbund in Britain was almost immediate: the Design Club was formed in 1909, and the Design and Industries Association (DIA) in 1915, following a Werkbund exhibition in London in 1914. The DIA was motivated by both government concerns and design reform. It sought to counter recent German design with original British work of quality and fitness for purpose. The declared aim was the encouragement of a public demand for 'what is best and soundest in design' and under Lethaby's guidance its council considered that 'machine work may be made beautiful by appropriate handling'. Hoping to spread its influence nationwide, the DIA council showed their inaugural exhibition in Liverpool, Leicester, Leeds and Edinburgh as well as in London.

The founders of the DIA included a variety of craftsmen, designers, artists and architects, among them Harold Stabler, the lithographer

Ernest Jackson (1872–1945), the printer Harold Curwen (1885–1949), a former bookseller and entrepreneur Harry Peach (1874–1936) and as honorary secretary an architect, Cecil Brewer (1871–1918). They were intent on quality and simplicity in design and the abolition not of machine goods but of those which were shoddy and imitative. Regular exhibitions of good design were organized (the first few were on the familiar subjects of typography, pottery, textiles and furniture) and pamphlets issued.

The DIA partly drew on Morris's aims: an alternative title suggested by Peach was the 'British Trade Guild for raising the standard of British Industry and adding dignity to labour and commerce'. It supported Lethaby's definition of art as simply 'the well-doing of what needs doing' and joy in work but at the same time avoided the 'politics of labour', a potentially explosive subject. Several commercial designers did succeed in reappraising manufacturing methods and standards by introducing craft directly into industry. Influenced by Lethaby and Ashbee, manufacturers such as Ambrose Heal, Peach and Gordon Russell, all leading members of the DIA, restructured the relationship between craft and machine.

Ambrose Heal (1872–1959), Brewer's cousin, and both a founder of the Design Club and treasurer of the DIA, was among the first British 'craft designers' to design, promote and sell inexpensive machine-made furniture. He had trained as a cabinet-maker, working as a bedding designer in his London family firm from 1893, and he designed cottage furniture for the showcase housing exhibition at Letchworth in 1905. Heal's furniture ranged from the cheap to the more expensive, made of cherry, walnut, chestnut or oak, but all was characterized by simple design and crafted details such as ebonized bandings and chip-carved plain handles. To meet the new public demand for the integrated 'designer' interior, Heal's London shop also opened new departments such as the embroidery and decorating studio.

Influenced by Lethaby's ideas, Peach founded the Dryad firm with Benjamin Fletcher, headmaster of the Leicester School of Art, in 1907. Dryad cane furniture was a deliberate imitation of contemporary Austrian and German types, including chairs designed by Richard Riemerschmid, a leading Werkbund member. Initially financed by Peach and using designs by Fletcher, the company united workshop skills with everyday objects, and art school ideas with local business acumen. Each piece of Dryad furniture was of 'sound construction' and hand-woven with 'special attention to design for comfortable

75

A COTTAGE ROOM

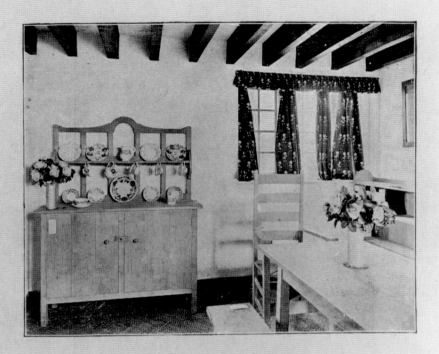

Plain Oak Dresser
No. 505. 4 ft. 6 in. wide
£6 15 0

HEAL
AND
SON

75 'A Cottage Room', from a Heal and Son catalogue. Oak furniture
designed by Ambrose Heal for the first Letchworth exhibition, 1905

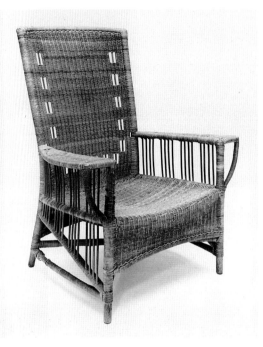

76 Dryad 'Traveller's Joy' armchair, *c.* 1907, designed by Benjamin Fletcher

use'. Even if made to a standard design this granted it a popular craft pedigree. The furniture appealed to a middle-class market not only on grounds of cheapness, utility and fashionable design, but also because of the nostalgic, comforting names chosen for models, from the 'Abundance' and the 'Ingle' to the Elizabethan 'Falstaff', 'Traveller's Joy' and the 'Virgin's Bower'.

Gordon Russell (1892–1980) served his cabinet-making apprenticeship in his father's Cotswolds antique business in Broadway, establishing the Russell Workshops in 1927 and the firm bearing his name in 1929. He shared with Lethaby the view that modern society was dominated unnecessarily by notions of 'great' art and 'genius' designers. Russell believed that craftworkers had now abandoned the vocational and ordinary in favour of high-minded education, academicism and experiment; in his youth he had been as interested in the work of the local craftsmen of Chipping Campden – the carpenters, harness- and basket-makers, the wallers and stonemasons – as that of Ashbee's imported silversmiths and cabinet-makers. At the same time Russell recognized that the machine used properly could provide goods previously unavailable and to a standard equal to the hand tool. While respecting tradition, he saw that it was 'a poor age

76

77

that makes no contribution of its own'. Russell believed, like other DIA members, that there could be just as much pride of craftsmanship in the engineering industries as in the studio workshops. In his designs for furniture, from unique commissions to mass-produced turned chairs with rush seats and his more European pieces, his abiding aim was quality construction and finish, whether by hand or machine.

The closest unions between craft and industry were usually achieved through the convictions and personal involvement of the company director. When James Morton (1867–1943), a friend and future client of Lorimer, founded the Edinburgh Weavers firm in 1928 his aim was not only to produce textiles suited to new mechanical methods and corresponding to a new 'restraint' in British architecture, but also to ensure that the designers obeyed the Arts and Crafts intuitive respect for materials. His son, Alastair Morton (1910–63), developed more intimate craft links: he researched fabric and fibre construction and trained as a loom weaver under Ethel Mairet.

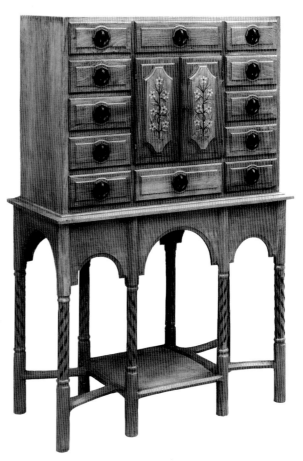

77 Cabinet designed by Gordon Russell at Russell & Sons, 1924, and awarded a gold medal at the 1925 Paris Exposition

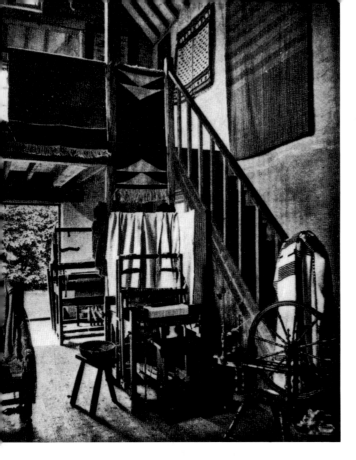

78 Ethel Mairet's
spinning and weaving
room, Gospels, Ditchling
photographed for
The Queen 1932

As progressive manufacturers pursued workmanship and redefined
industrial materials and thus design, so textile and ceramic craft-
workers abandoned formality in design in favour of intuitive
inspiration. Ethel Mairet (1872–1952) revolutionized the craft of
hand-loom weaving. With her first husband, Ananda Coomaras-
wamy, Mairet had travelled to Ceylon in 1903, teaching embroidery
and collecting local *objets d'art*, which she considered evidence of an
untouched culture. Her importance to twentieth-century craft was
twofold: she advocated the concept of craft and tradition as
complementary life-enhancing forces and she researched and popu-
larized natural vegetable dyes, publishing a treatise on the subject in
1917. Mairet was one of the first to abandon pictorial design in
weaving. Instead, she used natural fibres – wool and also, from the
early 1920s, silks and cottons – to explore, like furniture makers and

metalworkers, their inherent textural qualities. She was also an educationalist who had no time for the amateur. At her home, Gospels, in Ditchling, Surrey, in the 1920s and 30s she trained 78 professional craftswomen and teachers, for whom she became, like Jessie Newbery in Glasgow, a role model. Extending her influence worldwide, she published 'textile portfolios' for use in colleges and schools, and travelled to Scandinavia, Denmark and Yugoslavia to talk, learn and inspire.

The St Ives Pottery in Cornwall also taught the beauty and honest satisfaction of handcraft attained through respect for materials. Established by Bernard Leach (1887–1979) on his return from Japan in 1920 79 with Shoji Hamada, the Pottery used local clays and natural glazes. St Ives ceramics combined traditional English techniques with methods developed in Japan by Ogata Kenzan VI. Mairet, Leach and their pupils, including Katharine Pleydell-Bouverie (1895–1985) and Michael Cardew (1901–83), all used oriental aesthetics of simple forms and organic materials. Pleydell-Bouverie also learned Japanese glazing and firing techniques from Tsurunoske Matsubayashi who helped establish a pottery at her family home, Coleshill House in Berkshire. The subtle smoky green and grey glazes of her wares were produced from the ashes of trees and plants on her estate to create an intimate harmony with nature, an ethic which, with Leach's principles, has made ceramics a lasting craft of the twentieth century.

79 Vase, *c.* 1925, Bernard Leach

The notion of craft as a way of life shaped both manufacturing and craft studios in the 1920s. Dryad and a few firms such as the Curwen Press were run on democratic principles influenced by the Guild of Handicraft. The workforce of Dryad and its associate firm, Dryad Metal Works, enjoyed group social activities including cricket, football and fishing. The firm's guiding principle was 'the prosperity and efficient working of the business', based on a partnership of employer and employee. When Harold Curwen took over the family firm he granted each employee artistic freedom and urged technical excellence and 'fitness for purpose'. Curwen placed great importance on work satisfaction and cared for his employees. He was, moreover, a master craftsman, a printer regarded with a mixture of awe and affection by his men. Curwen was also one of the first to employ artists, as opposed to craftsmen, to design for industry, recruiting in the 1920s Claud Lovat Fraser, Paul Nash, Edward Bawden and Eric Ravilious.

As typographer, letter-cutter, wood-engraver and sculptor Eric Gill (1882–1940) carried the banner for individualistic creation and for a union of art with craft. He condemned industrialism as an evil, degenerative power which reduced workers to 'intellectual irresponsibility'. He did, however, support the introduction of art to industry, designing, for instance, typefaces for the Monotype Corporation between 1925 and 1929. Gill first settled in Ditchling in 1907, seeking a life where hand, heart and head could be uniquely integrated, which in his *Autobiography* he was to refer to as a 'cell of good living'. Roman Catholicism formed the spiritual basis of his inspiration. The Guild of St Joseph and St Dominic, founded in 1921 by Gill and Pepler, a fellow Catholic convert who had taken the name Hilary, absorbed Pepler's St Dominic's Press of five years earlier.

The Gill community was consciously male-dominated and Gill's second daughter Petra worked instead with Ethel Mairet at Gospels. However, as women assumed new social and political responsibilities in society, so their role in both the professional and amateur crafts broadened. No longer confined to working at home or in craft studios or directing amateur craft classes, upper- and middle-class women also owned and managed craft shops or led an interclass boom in handcraft as a leisure activity. In London the Three Shields (1922–45), exhibiting work by Leach, Cardew and Mairet, was run by Dorothy Hutton with Muriel Rose, who opened her own Little Gallery in 1928. The Little Gallery sold both the new and traditional country crafts from home and abroad. Ethel and Philip Mairet set up the New

The inscription within the relief reads:

QVID
EST
VERI
TAS

RE S
NIVE
DIXI
SVPER
FILIOS
DIMI
BAM;
FLAG
DIT
GE

PONDENS·
RSVS·POPVL
T·SANGVIS·E
NOS·ET·SVP
NOSTROS·T
SIT·ILLIS·BA
JESVM;AVT
ELLATVM·TR
EIS·VT·CRVC
RETVR

V·
VS
IVS
ER
VNC
RAB
EM
ADI
IFI

NATVS
LVSQVE
MANVS

I. JESUS IS CONDEMNED TO DEATH

80 Eric Gill, first of the fourteen 'Stations of the Cross', 1913–18, Westminster Cathedral

Handworkers' Gallery in London in 1927 and their friend Margaret Pilkington founded the Red Rose Guild of Artworkers in Manchester in 1920.

As earlier Home Arts leaders had sought to give the working classes an alternative to unemployment and the temptation of the public house, their successors countered the Depression of the 1930s with cheap, creative crafts. For women the crafts were both a means of work fulfilment and economical home furnishing. Central to the craft movement was the National Federation of Women's Institutes, founded in 1915 and much admired by Lethaby and Peach. It encouraged skills and high standards, protected traditional crafts and educated through a programme of travelling exhibitions of members' work. Peach established the other major influence on amateur work of the inter-war years. In 1917, the year of the Federation's first public

display during London's National Economy Exhibition, he set up Dryad Handicrafts. It provided juvenile and adult classes across Britain with materials, tools and, from 1923, Dryad Press instructional leaflets written by art school teachers on subjects from leather-craft and basketry to upholstery.

Art school directors also responded to the changing face of adult craft education. Recognizing the shift towards democracy in handcraft, they started evening classes for amateurs, in popular subjects such as painting and dress-making, which were often over-subscribed. Professional teaching in the 1930s still included the one-off crafts employing expensive materials but their products were generally regarded as luxury items in practice made only to commission. Teachers, encouraged by the government and the DIA, were placing increasing emphasis on design for industry. Efforts were made to meet the needs of national and local manufacturers in metalwork and furniture, to incorporate the processes engendered by European functionalism as well as by Arts and Crafts principles. In the inexpensive crafts of handloom weaving and pottery students were still encouraged to work out ideas by handling materials rather than observing the restrictive discipline of the drawing-board. As part of a continuing dialogue between art schools and craft studios this intuitive method was one of the principal legacies of the movement to twentieth-century design.

Regionalism in American Architecture

The idea that every country should have an architecture that reflected its own particular history, geography and climate was central to the Arts and Crafts movement. England had issued the call for reviving the vernacular and no country heeded it more fervently than the United States. The goal was an 'organic' architecture – one where the 'honest' expression of structure, responsiveness to site and the use of local materials would replace stale academic conventions.

The interpretation of the vernacular varied widely in different areas of the country. Design reformers on the west coast looked to Spanish missions and their own balmy climate; in the mid-west, the Prairie served as inspiration; the east coast was most conscious of English precedent and the colonial past. These preferences, however, were not exclusive – every area of the country had Mission-style bungalows, horizontal Prairie houses and half-timbered cottages.

The anti-academic stance of the Arts and Crafts movement was not a rejection of all past styles; rather, it was a search for images appropriate for contemporary America. The past could be mined for inspiration but only for styles that were seen as evolving from local tradition or as a response to the landscape. The prescriptive literature of the period is replete with calls for 'genuine architecture' and 'unpretentious buildings' made with 'materials of the countryside'. Such straightforward, 'common sense' structures would be designed according to the needs of the inhabitants and therefore would provide the best domestic architecture for modern America. Embracing the principles of Ruskin and Morris, reformers condemned as artificial the symmetry and proportion characteristic of classical architecture and they rejected as unresponsive to human needs the academic styles developed for grand public building. Theirs was a domestic architecture, designed not to awe but to protect and provide the proper atmosphere for the pursuit of the simple life.

The British concept of the domestic vernacular had two manifestations in America. One was the doctrine of fidelity to place, which encouraged designers to look to the American landscape and past. The

81 Cram, Goodhue & Ferguson, St John's Church, West Hartford, CT, 1907–09. Perspective

other was the adaptation of indigenous British styles themselves – the Gothic, Tudor and Queen Anne revivals. Although the latter might seem to contradict the insistence on a uniquely American identity, many Americans believed that the United States was fundamentally English in its cultural traditions. In New England and the mid-Atlantic states, regions where identification with Britain was strongest, architects were especially drawn to British precedent.

The Gothic was seen as particularly appropriate for church architecture and after the architect Bertram Grosvenor Goodhue (1869–1928) joined the Boston firm of Cram and Ferguson in 1891, they became the most important practitioners of the Gothic Revival in New England. A convert to the High Episcopal church, Ralph Adams Cram (1863–1942) was committed to the Anglo-Catholic Oxford movement, including its belief that reformed rituals should take place in Gothic-style churches. Goodhue, although not as religiously motivated, was an anglophile who deeply admired the architectural theories of Lethaby. The architects' English inspiration is clearly seen in commissions ranging from the modestly scaled 81 St John's Church in West Hartford, Connecticut (1907–09), to the 82,83 enormous St Thomas's Church in New York (1905–13), for which Goodhue designed the largest reredos in any Gothic church. Following George Frederick Bodley and other English architects of

the 1880s and 90s, Cram and Goodhue adopted the fifteenth-century Perpendicular, a lighter, later Gothic style than those revived by earlier High Victorian architects.

Leaders of design reform in Boston, Cram and Goodhue helped found the Society of Arts and Crafts (SACB) there in 1897. Modelled after the Arts and Crafts Exhibition Society in London, the Boston organization disseminated craft ideals through its exhibitions and salesroom and established the precedent for hundreds of similar organizations throughout the United States. For the interior decoration of their churches, Cram and Goodhue repeatedly employed the talents of SACB member craftsmen who were leaders in the revival of superb woodcarving, ironwork, silver and stained glass. For example, Johannes Kirchmayer did woodcarving for All Saint's Church in Dorchester, Massachusetts, and for St Thomas's; Frank Koralewsky executed the ambitious handwrought ironwork for St Thomas's; George Germer, who was considered America's foremost creator of ecclesiastical silver, executed many pieces for Cram and Goodhue churches. The craftsmen's involvement with the SACB and their repeated commissions demonstrate the close-knit nature of the crafts community in Boston. While Goodhue himself designed most of the interior decoration for the firm's churches, these craftsmen did play a creative role and all were noted for their work independent of architects' commissions.

Cram had a particularly close relationship with Charles Connick (1875–1945), whose studio produced some of the finest stained glass in America. The two men collaborated on several major commissions, including Cram's Proctor Hall at Princeton University (1919–22). Connick's windows for the college tell Sir Thomas Malory's story of 84 the search for the Holy Grail. Both in imagery and technique, Connick worked in a Gothic manner. Rejecting as inauthentic the opalescent stained glass popularized by John La Farge and Louis Comfort Tiffany, Connick would use only clear 'antique' glass similar to that of the Middle Ages. In addition, his studio was organized along medieval lines. Apprentices trained for four to six years and, regardless of their ultimate area of specialization, Connick insisted that they learn all aspects of glass making, so they would appreciate the entire process and render the final product a communal effort.

Although Cram claimed that he aspired to a 'medieval spirit vitalized by modern conditions', most of his writing suggests that he preferred to avoid the modern world altogether. The purpose of his short-lived publication *The Knight Errant* (1892) was 'to assail the

dragon of materialism . . . to ride for the succor of forlorn hopes and the restoration of forgotten ideals'. From Cram's many publications, one would think the firm's output consisted only of Gothic churches; in reality, the partners received commissions for houses, schools, and public buildings as well, and executed them in a wide variety of styles. After the firm was dissolved in 1914, however, Cram pursued a career as a church architect and became even more faithful to English Gothic models. He continued to work closely with craftsmen in an attempt to recreate a community bound together by a common religion and devotion to handwork. In his attacks on modern civilization and idealization of the medieval world, Cram represented the regressive, conservative side of the Arts and Crafts movement. Like Ruskin, Cram promoted co-operation but was against democracy. As he wrote in *Walled Towns* (1919), he longed to establish small communities where people joyfully completed work assigned by a benevolent master who knew which tasks were best suited to their skills. The 'just businessman' would be responsible for the common good and all would profit accordingly.

82 Bertram Goodhue, St Thomas's Church, New York, 1914–20. Reredos wall, chancel and organ case

83 Cram, Goodhue & Ferguson, St Thomas's Church, New York, 1905–13. 1913 view from the south-east

Goodhue was not a prolific writer like Cram, nor was he a passionate conservative. His work represents instead a more progressive aspect of the Arts and Crafts movement. He wrote in 1893 that he desired a 'return to greater simplicity – subtler simplicity is a better term – and directness of method'. He had always been interested in a variety of vernacular styles, including Spanish and Byzantine, and after the firm's break-up his domestic work continued to be inspired by regional expression. His public buildings were more monumental and contained rich symbolic ornament. By the end of his career he no longer resisted classicism, and designed such important early Art Deco buildings as the Los Angeles Library (1921–26) and the Nebraska State Capitol (1920–32).

The demands of his practice forced Goodhue to abandon what had been a second career, that of book designer. Goodhue created title pages, decorations and initials, as well as typefaces, working in a Gothic tradition heavily influenced by Morris's Kelmscott Press. Not only did Goodhue provide the graphic design for *Knight Errant*, he also worked for all the presses that made Boston a centre for the revival of fine printing and book design: Copeland and Day, Stone and Kimball, Small and Maynard and the Merrymount Press.

In addition to the Gothic, New England architects appropriated the English Queen Anne style in the 1870s and 80s. Architects fused the red brick, sunflower motifs, Palladian windows and broken pediments of the Queen Anne with the half-timbering of Old English to form their own expression of the style. Architects like H. H. Richardson (1838–86) adopted the half-timbering used by Norman Shaw, but substituted shingles, a roof and wall covering used in New England during the colonial period, for hung tiles. The reasoning seemed to be that since the Queen Anne in England was an eclectic re-examination of the country's architectural past, especially the Georgian, Americans also should look to their seventeenth-and eighteenth-century precedents.

The colonial revival extended beyond pre-revolutionary furnishings to include all objects made before 1840 when handwork was perceived to have been replaced by machine production. This period was regarded as a time when Americans had greater mastery of their environment; therefore, products of colonial craftsmen became symbolic of control over impersonal forces. A generation overwhelmed by technology found solace in the values assigned to the hand-made object: simplicity, integrity and joy in labour. Just as Ruskin, Morris, and their followers had idealized the medieval past, so too did Americans idealize the colonial past as a time when craftsmen took pride in their work, buildings and their furnishings were beautifully made and the fabric of society was cohesive.

New England's architectural heritage appealed to the moral aesthetics of Arts and Crafts movement enthusiasts. They saw in colonial styles the 'naturalness' and straightforward use of materials they were advocating for modern buildings. Since a national style was sought, what could be more American than architecture inspired by indigenous buildings of the seventeenth and eighteenth centuries? At the same time, what could be more English, since the early settlers derived their building vocabulary from the mother country? Thus the colonial revival had a wide appeal – it attracted the patriot, the anglophile, the conservative who found solace in an idealized past as well as the modernist who admired the direct, unadorned expression of natural materials.

The fact that most eighteenth-century buildings were characterized by symmetry, a quality that most Arts and Crafts adherents rejected, did not present a problem. In the early years of the revival, more informal seventeenth-century buildings provided the greater inspiration, and even when Arts and Crafts architects turned to the

84 Model of the Holy Grail window *Sir Bors Sucoures the Mayde*, c. 1919, by Charles Connick Associates, for Proctor Hall, Princeton University >

sir Bors svcovres the Mayde

Georgian, their models tended not to be perfect Palladian high-style examples but rather a combination of homestead and Georgian forms. Before its final emergence as an academic, historicist style in the 1920s, the colonial revival continued to have many interpretations.

John Calvin Stevens (1855–1940) was one of the many architects at the turn of the century who took the colonial from a vernacular expression to a more formal revival style. Working mostly in Maine, he began his career in partnership with Albert Winslow Cobb (1858–1941). Together they produced the influential *Examples of American Domestic Architecture* (1889), one of the earliest design reform books to call for social change through a more democratic, rational architecture free from the 'moral corruption' of European styles. The architects described a house they built in 1889 on the shore of Cape Elizabeth, near Portland: 'The underpinning of this house . . . is of weathered field stone, the very color of the ledges out of which the building grows. The walls above the stone work are of shingles, untouched by paint, but toned a silvery gray by the weather.' Their rhetoric is pure Arts and Crafts: local materials are best and ought to be left in their natural state so they harmonize with the environment. Stevens and Cobb used colonial details in a free way: the gambrel roof, gable dormers, small rectangular panes and the suggestion of a Palladian window are derived from the eighteenth century but are not exact copies. After the partnership was dissolved in 1891, Stevens began to work in a more academic Georgian mode, although he never completely abandoned the construction of houses with vernacular features.

86

87

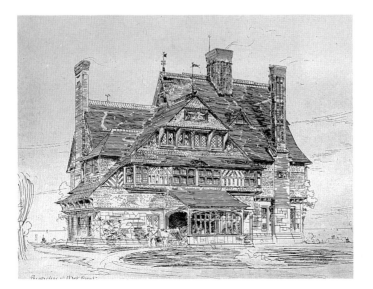

85 H. H. Richardson, William Watts Sherman house, Newport, RI, 1874–76. Perspective rendered by Stanford White, 1874

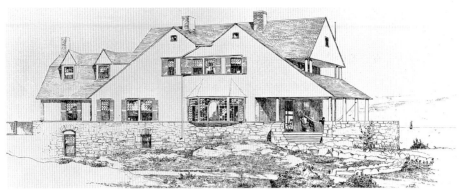

86 Stevens and Cobb, 'House at Delano Park', Cape Elizabeth, ME, 1889. Perspective

87 John Calvin Stevens, Richard Webb house, Portland, ME, 1906–07

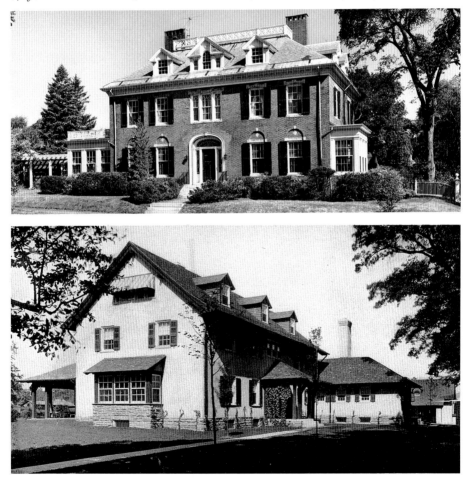

88 Wilson Eyre, William Turner house, Philadelphia, 1907

89, 90 Greene and Greene, David B. Gamble house, Pasadena, CA, 1908–09.
Garden view; living-room

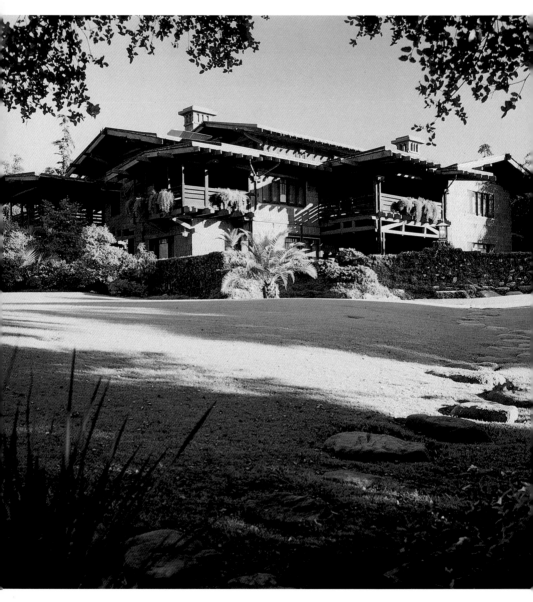

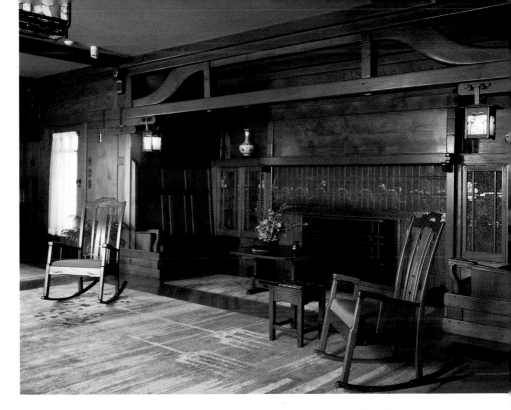

In the mid-Atlantic states, as in New England, emphasis on locality was stressed in the 1890s and early 1900s. As the new century progressed, there too the vernacular tended to be absorbed into more 'accurate' classicizing styles. Nowhere was the Arts and Crafts movement more closely intertwined with the colonial revival than in Philadelphia. The city's heritage as the largest metropolis in Britain's eighteenth-century colonial empire prompted one critic to observe that it had 'remained Anglo-Saxon and . . . many of her architects have English leanings.' Fuelled by the Philadelphia Centennial celebration of 1876, a new pride in American achievement was added to the strong identification with Britain. One result was a domestic architecture, led by Wilson Eyre (1858–1944), that combined British and rural Pennsylvania building traditions. Using local stone and stucco, Eyre created suburban idylls on Philadelphia's main line. In buildings such as the William Turner house of 1907, he drew on 88 Pennsylvania farmhouses to create a picturesque composition. He combined Georgian fenestration and gable roofs with informal Arts and Crafts idioms of verandas, sleeping porches and patios.

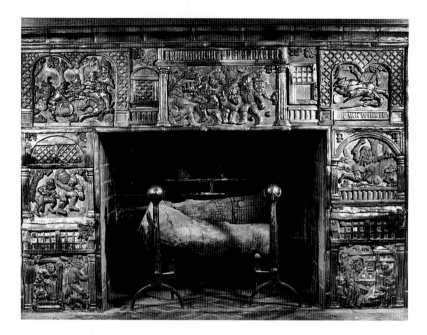

As in Boston and other centres, the Arts and Crafts community in Philadelphia was nourished by the activities of clubs and societies. Eyre was one of the founding members of the T–Square Club, a group of architects who sponsored exhibitions, lectures and a journal. Like their counterparts in Boston, the architects of the T–Square Club worked closely with local craftsmen committed to the highest standards of design and workmanship. One of the most prolific craftsmen was Samuel Yellin (1885–1940), who championed the revival of architectural wrought iron. He received many commissions from Eyre and other T–Square Club architects such as Will Price and the firm of Walter Mellor and Arthur Meigs. From his monumental gates and grilles to marvellously intricate door handles and locks, Yellin's work demonstrates the individuality, variations in colour and texture, and diversity of decoration that result when a master craftsman works with hammer and anvil. Yellin was eclectic in his design sources: for his own workshop in Philadelphia (designed by Mellor and Meigs), he created a gate inspired by the ironwork of medieval France and Germany as well as Florentine grillwork. The gate is a vocabulary piece of forged iron: each rosette and quatrefoil has a different design motif and the joints are characterized by a variety of historic construction techniques.

92

91 OPPOSITE *Rip Van Winkle* fireplace, 1915, Henry Chapman Mercer, Moravian Pottery and Tile Works

92 Interior gate, 1926, Samuel Yellin for his workshop, Philadelphia

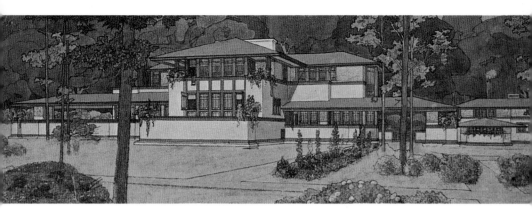

93 Frank Lloyd Wright, Ward W. Willits house, Highland Park, IL, 1902. Presentation drawing

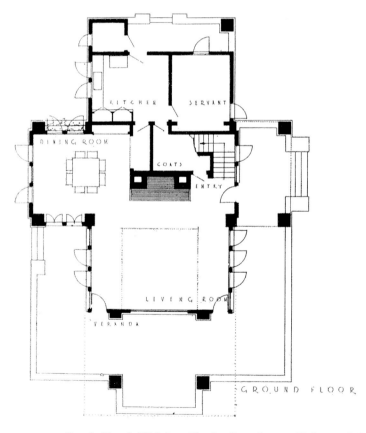

94 Frank Lloyd Wright, Charles Ross house, Delavan Lake, WI, 1902. Ground-floor plan

Philadelphia architects often incorporated the tiles of Henry Chapman Mercer (1856–1930), who in 1900 established the Moravian Pottery and Tile Works in Doylestown, Pennsylvania. An archaeologist, folklorist and museum curator, Mercer found in the manufacture of tiles a way to combine all his interests. His style sources ranged from pre-Columbian Mayan to medieval English patterns and he was particularly interested in images derived from American folk tales and songs. Although made with moulds, the tiles still required much handwork and their rough, earthy effect appealed to Arts and Crafts adherents. Wilson Eyre often used Mercer tiles in his buildings; Cram, Goodhue, and Irving Gill were only a few of the many architects outside Philadelphia who chose Mercer tiles for walls, floors, and fireplace surrounds.

The colonial revival was largely English in derivation except for the Dutch variation, which was most popular in the mid-Atlantic states colonized by Holland in the seventeenth century. The architect Aymar Embury II (1880–1966) popularized this style, characterized by broad gambrel roofs, large chimneys and fireplaces and stone walls for the lower stories with shingles for the upper. However, just as colonial revival architecture was often a free adaptation of past styles, so too were the labels assigned to these buildings in period literature. A house three bays long with a gambrel roof and continuous dormer was widely referred to as Dutch colonial, but there is nothing particularly Dutch about this design, and it was found throughout the eastern seaboard.

The attribution of stylistic sources was fairly arbitrary and continues to be so today. The source of an Arts and Crafts building's horizontality is often unclear – it could be ascribed with equal plausibility to, for example, the influences of Voysey, the Prairie School, or Pennsylvania farmhouses. Regardless of its origin, the important point about horizontality is that, together with the use of local materials, craft traditions and the vernacular, they were the key elements of Arts and Crafts architecture. That a building could be designated Dutch colonial, mission, Olde English, or simply 'a cozy home' is less important than the fact that it was perceived as a regional expression, evolving from unique circumstances of landscape and history.

Although the concept of regionalism was often subjective, California truly possessed a distinct local architecture. Sleeping porches, pergolas and patios (features almost unknown in Great Britain) were certainly used elsewhere in America, but never more

often or to greater effect than in California, where the benign climate and lush vegetation were most conducive to the Arts and Crafts ideal of living close to nature.

The work of Charles Sumner Greene (1868–1957) and Henry Mather Greene (1870–1954) offers an outstanding example of Arts and Crafts architecture in California. On one of his many visits to the United States, Ashbee admired the work of the Greene brothers as 'among the best there is in this country'. He compared it favourably to the work of Frank Lloyd Wright, noting 'it is more refined and has more repose' and attributed these qualities to the region: 'Perhaps it is California that speaks rather than Illinois. . . .' Ashbee probably preferred the Greenes' work to Wright's because he could never completely reconcile himself to Wright's championing of the machine and empathized more with the Greene brothers' devotion to rich materials and craftsmanship.

The Greenes were first exposed to crafts at Calvin Milton Woodword's Manual Training High School in St Louis, the first non-vocational institution to consider handwork to be as important as the liberal arts. This experience was more influential than the Beaux-Arts architecture training they later received at the Massachusetts Institute of Technology. Establishing an architecture practice in Pasadena in 1893, they spent the next several years experimenting with a variety of styles before encountering two other major influences on their work: *The Craftsman* magazine which, published by Gustav Stickley from 1901 to 1916, was the greatest disseminator of Arts and Crafts beliefs in America, and the arts of the Orient. They began to collect Japanese prints and books about Oriental gardens, buildings and furniture and to see the spare, asymmetric design and superb craftsmanship of the East as the ultimate aesthetic ideal.

All these influences came together in Greene and Greene's most significant group of buildings – the 'ultimate bungalows' they designed between 1907 and 1909. The language of the Greenes was wood – native redwood for beams and shingles, mahogany for furniture. They delighted in structural revelation, in demonstrating how wood could be joined, interlocked and sculpted. Both the exterior and interior of the Gamble house (1908–09) show this passion: the roof rafters protrude over the shingled walls, their elaborate bracket supports providing further accents; the second floor projects over the first, and the sleeping porches provide other intricately sculpted extensions. Although far more detailed than necessity would dictate, these projections served a practical function.

89,90

Inspired by Japanese brackets, the broad overhangs offered protection from the strong California sun; the sleeping and sitting porches encouraged open-air living and shaded the terraces below. All served to integrate the outside of the house with the inside, as did the fact that the Greenes also designed the garden and the furniture, lighting fixtures and stained glass for the Gamble house and many other commissions.

Of the brothers, Charles was particularly devoted to handcraftsmanship. No detail was too small for Charles's rapt attention: he searched the Pasadena *arroyo* (ravine) for the perfect boulder for a wall or fireplace, carved many of the beams himself and worked closely with another pair of brothers, the cabinet-makers Peter and John Hall, who executed all the Greenes' custom-made furniture.

The Gamble house living-room, in the exposed structure of the brackets and ebony pegs; the exquisitely carved redwood frieze highlighting the grain of the wood; the rugs, furniture and fixtures unified by the repetition of geometric motifs; and the inglenook with its built-in settle and cabinets demonstrate why the Greenes are considered to be the quintessential Arts and Crafts designers. The virtuosity that distinguishes their work, however, does separate them from certain Arts and Crafts ideals: their use of mahogany for furniture that was frequently inlaid with mother-of-pearl and silver violated the Arts and Crafts principles of native materials and accessibility to a broad clientele. Furthermore, the Greenes' obsession with an exquisite appearance could sometimes run counter to reform ideals about exposed construction; for example, the ebony pegs on all their furniture conceal metal screws that are actually doing the fastening.

While the Greenes represent Arts and Crafts at its most refined and elite, California also provided the movement with its most potent symbol of the democratization of art – the bungalow. Although built throughout the country, the bungalow was always associated with California; its open interior, one-storey plan, wrap-around porch and low-pitched, overhanging roof offered the ventilation and protection from the sun suitable to the state's climate, and its rapid assembly, affordability and informality made it particularly suited to the state's mobile, transient society. Costing as little as a few hundred dollars, the bungalow was accessible to working- and middle-class Americans. To own a bungalow soon became part of the American dream of a home of one's own in a bucolic setting. A popular song of the 1920s sums up these aspirations: 'I just can't keep my tho'ts away from

90

California's shore . . . to the land of fruit and honey, Where it does not take much money, To own a little Bungalow.'

Articles extolling the virtues of bungalows fill the pages of Stickley's *Craftsman* and other popular shelter magazines like *The Ladies' Home Journal*. Whole journals, such as Henry Wilson's *Bungalow Magazine*, were devoted to publishing plans and elevations. People could order sets of drawings from Wilson or from the contractors and builders who produced 'bungalow books' containing photographs and floor plans. Those too impatient or impecunious to hire a builder could purchase a prefabricated bungalow from the California Ready-Cut Bungalow Company or from the Aladdin Company, which had distribution centres throughout North America.

By their very nature bungalows were non-professional and part of popular rather than high culture. Many architects, however, did specialize in the construction of bungalows: Alfred Heineman (1882–1974) was among the most notable. He and his brother Arthur designed and built hundreds in Pasadena, where they often resemble smaller, inexpensive versions of houses by the Greene brothers. The cover of *Sweet's Bungalows*, published in Los Angeles about 1915, features one of Alfred Heineman's most popular designs. At a cost estimated between three and four thousand dollars (the plans were available for $5), the client would get what was described as 'the artistic chain-supported porch roof, the wide overhang, the low, rambling classy lines, the inviting pergola and its restful porch'. Executed many times, Heineman's design represented one of the most popular bungalow types. Resembling a Swiss chalet, with a suggestion of the Orient, the style was often called 'Japo-Swiss'.

Most people could not afford a Greene and Greene custom-designed house, but with a 'simple but artistic' bungalow they could still buy into the Arts and Crafts ideal. The wood-framed bungalow was one manifestation of the local vernacular in California; the other was architecture inspired by the Spanish *adobe* (mud-built) missions of the colonial period.

On the west coast, the Spanish colonial past was idealized in much the same way as was the English colonial past: as a simpler time when a spirit of community prevailed, people lived in harmony with nature and took pride in working with their hands. Not only did the life of the Franciscan brothers and their Indian converts seem in accordance with Arts and Crafts principles, but mission architecture (constructed between 1769 and the 1820s) did as well. The *adobe* bricks had been

95

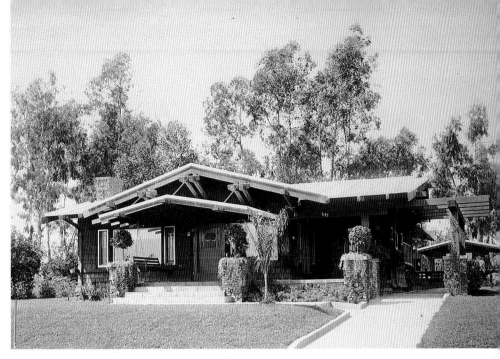

95 Arthur S. Heineman, bungalow, Pasadena, CA, *c.* 1911

locally made; the missions' patios, courtyards and projecting eaves were suited to the climate; and their arcaded corridors, arches and unadorned walls conformed to the principles of geometric simplicity.

Arts and Crafts publications supported the revival of mission architecture that swept across California and to a lesser extent the rest of the country. A 1902 article in *The Craftsman* praised Mission revival buildings in Ruskinian terms, admiring the way they evoked the 'patient handicraft' and 'loving sincerity' of the 'unskilled builders who had joy and faith in their work'.

The greatest proselytizer of the style was the magazine *Land of Sunshine* (later *Out West*), edited by Charles Fletcher Lummis (1859–1928), a transplanted Easterner who championed the preservation of both missions and American Indian artefacts. *Land of Sunshine* published innumerable articles about Indian and Hispanic cultures. While fostering appreciation of their contributions, all depicted a highly idealized past that ignored the harsh reality of the Indian's exploitation by white settlers.

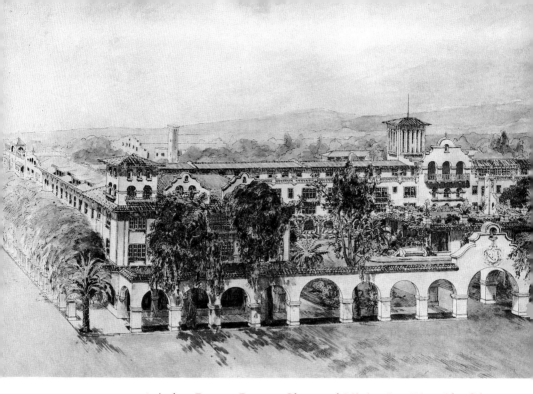

96 Arthur Burnett Benton, Glenwood Mission Inn, Riverside, CA,

The symbolic value of the missions was recognized by Lummis in his 1929 book *The Spanish Pioneers* when he wrote: 'Plymouth Rock was a state of mind. So were the California Missions.' Not above using the mission 'state of mind' to promote California's economic development, Lummis has been called 'the impresario of the Southern California tourist renaissance'.

96 Lummis certainly was not alone. The Mission Inn in Riverside exemplifies the romantic view of California as a land of perennial sunshine, peace and goodwill that helped the state sell its products and become a mecca for vacationers and retirees. All the elements of the old missions are present in this resort hotel: bell-towers, arches, cloisters, white walls, red-tile roofs. Stucco and cement were used instead of *adobe*, but this was considered to be a reasonable substitution even by purists. The Inn was decorated with Spanish and Mexican artefacts and simple, rectilinear furniture that became known as 'mission' style (see Chapter 5). Arthur Burnett Benton (1857–1927), the architect of the Mission Inn, was proud of the commercial value of

126

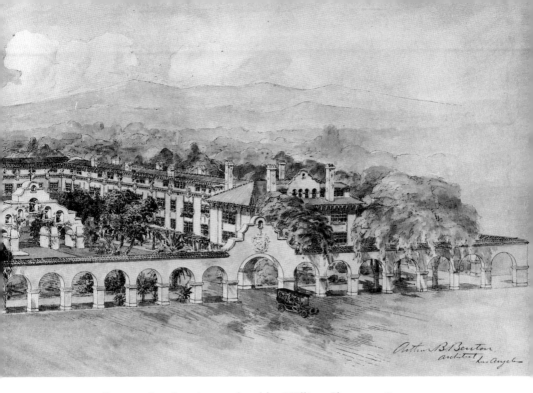

c. 1902–27. Presentation drawing rendered by William Sharp, 1908

revival buildings: 'They advertise the state as nothing else can. . . . Our railroads, [in] whom we have no better advertisers, have their Mission folders, Mission stations and now their Mission Cars. Our Mission hotels are proving how great [is] the demand by tourists for something "different".'

If Benton represents the Arts and Crafts movement at its most commercial and romantically conservative, then the architect Irving John Gill (1870–1936) represents the movement at its purest and most progressive. After training for two years with Louis Sullivan in Chicago, Gill moved to San Diego in 1893 for health reasons. He became enamoured with the missions, seeing in their architecture ideal geometric forms: 'the straight line, the arch, the cube and the circle'. He also wrote: 'If we, the architects of the West, wish to do great work we must dare to be simple, must have the courage to fling aside every device that distracts the eye from structural beauty, must break through convention and get down to fundamental truths.'

The Spanish missions provided Gill with a model for reductive geometry. He used much of their design vocabulary, as in the arcades and courtyards for the Women's Club in La Jolla (1912–14), but took their plain, undecorated surfaces even further. For example, Gill had always kept his wooden mouldings simple and without finishes, but after 1904 he often eliminated mouldings entirely. He considered such minimalism to be both aesthetically and ethically correct. Gill was deeply concerned with low-cost housing and believed it would be more viable with less attention to useless ornament and more to structure. Furthermore, he was passionate about hygiene, so his interiors also made sense on a pragmatic level. In an article for *The Craftsman* Gill wrote that in his houses 'walls are finished flush with the casings and the line where the wall joins the floor is slightly rounded, so that it forms one continuous piece with no place for dust to enter or lodge, or crack for vermin of any kind to exist. There is no molding for pictures, plates or chairs, no baseboards, panelling or wainscoting to catch and hold the dust.'

The Dodge house (1914–16) is Gill's masterpiece. Like the La Jolla Women's Club, it is made with his favourite material – reinforced concrete. As did many American Arts and Crafts architects, Gill not only accepted technological innovation, he enthusiastically embraced it. He developed a tilt slab system of construction that enabled him to

97 Irving Gill, La Jolla Women's Club, La Jolla, CA, 1912–14

98 Irving Gill, Walter Luther Dodge house, Los Angeles, 1914–16

pour out concrete for a wall and then erect it as a single unit. The Dodge house illustrates why he is considered to be the most modern of the Arts and Crafts architects. Although Gill was clearly inspired by indigenous Spanish architecture, the house's stripped walls, frameless windows and volumes linked by balconies and terraces create a purely abstract composition.

Arts and Crafts purists approved of the Mission style only when it was indigenous to the region. The poet, naturalist and philosopher Charles Keeler (1871–1937) rejected its use in the San Francisco area because colonial missions had rarely been constructed so far north. Founder of the Hillside Club, a civic improvement society in Berkeley, Keeler preached a new kind of architecture and a way of living closer to nature. Keeler's book, *The Simple Home* (1904), glorified handcraftsmanship and wooden architecture. It was dedicated to 'my friend and counselor Bernard Maybeck', an architect who contributed much to the San Francisco Bay regional style of weathered shingled houses with informal plans. Beginning with a

99 Bernard Maybeck, Guy Hyde Chick house, Berkeley, CA, 1914. Entrance pergola

home for Keeler in 1895 and later the design for the Hillside Club (1906), Maybeck (1862–1957) developed an eclectic style of wood-framed houses that nestle into the Berkeley Hills. Influenced by Swiss chalets, English half-timbering and Gothic churches, Maybeck strove to produce houses suited to specific sites and particular clients – he was not concerned with the promulgation of a single coherent style. Since he believed 'the house after all is only the shell and the real interest must come from those who are to live in it', he was not averse to designing Neo-classical buildings when the situation warranted it. With his Ecole des Beaux-Arts training coupled with an inventive, iconoclastic personality, Maybeck could produce with equal facility a

99 pure Arts and Crafts structure like the Chick house (1914) and a full-blown Neo-classical building such as the Palace of Fine Arts for the San Francisco Exposition (1915).

The most ahistorical of American regional styles was the architecture of the Prairie School in the Midwest. With Louis Sullivan (1856–

1924) and Frank Lloyd Wright (1867–1959) as its leading spokesmen, the Prairie School was a group of architects united, as one contemporary critic observed, by the 'search for an original vehicle of expression'. The architect Irving Pond wrote about this quest for indigenous American design, stating that 'the horizontal lines of the new expression appeal to the disciples of this school as echoing the spirit of the prairies of the great Middle West, which to them embodies the essence of democracy.' These architects shared the conviction that a building must respond to its surroundings; that it be horizontal, like the prairie, and linked to the earth through low-hipped roofs, broad eaves and extensions that would unify the interiors with the exterior – porches, terraces, and pergolas.

The ideal of an organic architecture originated with Sullivan who, beginning in the 1880s, advocated the creation of a new American architecture through the simplification of mass and ornamentation 100 based on the growth of plants. He believed an 'architecture of democracy' would emerge by casting off the shackles of classicism and returning to nature. Through his voluminous writings as well as his innovative buildings, Sullivan became the philosophical leader of the Prairie School in Chicago. Many members of the group shared office

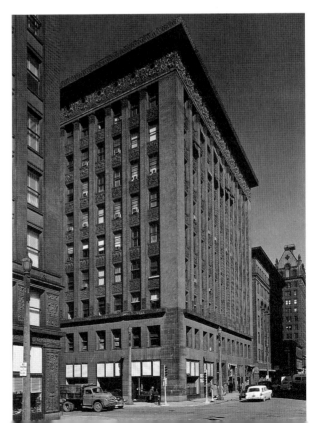

100 Adler & Sullivan, Wainwright building, St Louis, 1890–91

space in the 1890s at Steinway Hall, among them Wright, Myron Hunt, Dwight H. Perkins and Robert Spencer. The group was linked in other ways as well: the Steinway Hall architects met with other reform-minded colleagues for monthly discussions over lunch, becoming known as 'the Eighteen', and many were instrumental in founding organizations such as the Chicago Architectural Club, the Architectural League of America and the Chicago Society of Arts and Crafts.

While Sullivan provided the philosophical underpinnings of the Prairie School, it was Wright who, after leaving his position as a draughtsman in Sullivan's office in 1893, evolved a design language which made him pre-eminent. As the historian H. Allen Brooks has pointed out, Wright's major innovation was to design interior spaces that were not enclosed in the traditional sense. In the Ward Willits and Charles Ross houses of 1902, the corners between the dining- and living-room were abolished, which created interpenetrating spaces and 'freed the wall' to define an area rather than enclose it. The houses were not only opened from within: their long horizontal lines, low-pitched roofs, overhanging eaves and porches tied them to their surroundings.

The Robie house (1906–08) provides another illustration of Wright's assertion that the building must 'begin to associate with the ground and become natural to its prairie site'. Although his Prairie houses are horizontal, they are balanced and anchored by massive vertical chimneys. A dominant fireplace was part of Wright's desire to 'give a sense of shelter in the look of a building'. In the Robie house, the fireplace not only performs this function but also serves as the symbolic centre of family life. It demarcates but does not rigidly separate the living- and dining-room areas, which are united by open corridors and shared banks of windows.

Although not many Prairie architects went as far as Wright's 'destruction of the box', all shared with him the Arts and Crafts goal of design unity. Just as the building needed to be in harmony with the landscape, so too all the furnishings needed to be part of the totality of conception. Their clients permitting, Wright and the other Prairie architects designed the furniture, stained glass, light fixtures and textiles for their houses.

The Robie house dining-room exemplifies the ideal of design unity. It is the antithesis of cluttered Victorian interiors: Wright's furnishings for the room are harmonious; their form and decoration reduced to fundamental geometric components. One source of

132

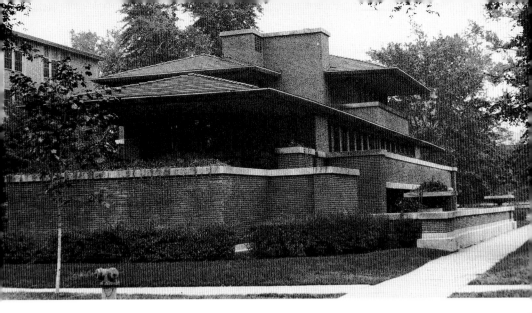

101, 102 Frank Lloyd Wright, Frederick C. Robie house, Chicago, 1906–08. Exterior; period photograph of the dining-room

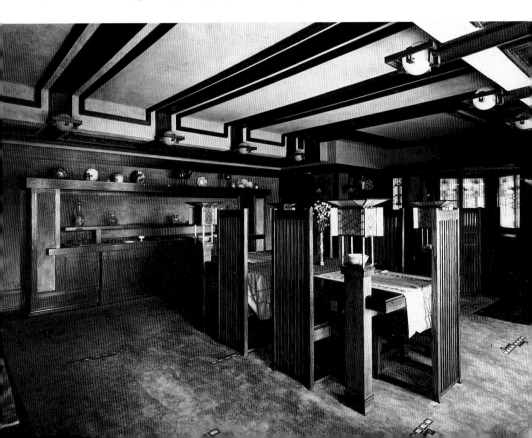

Wright's affinity to geometry was his passion for the stylized arts of Japan; another was his childhood fascination with Froebel blocks to which he ascribed 'the awakening of the child–mind to rhythmic structure in Nature . . . I soon became susceptible to constructive pattern *evolving in everything I saw.*' These patterns provide unity in Wright's designs; in the Robie dining-room, diamond shapes in the stained-glass windows are echoed in the table lamps and scarves (runners), the rectangle is the dominant form for furniture and textiles, and the horizontal lines of the mouldings, cornice, inglenook and table define the space.

While maintaining their traditional protective functions, the walls also serve as screens, open at the corners to allow a continuous flow of space. Wright's frequent use of straight, tall-back chairs is analogous: in the Robie dining-room, their height creates a room within a room, while the chairs' slatted backs link them with the other furnishings.

The use of built-in furniture enabled Arts and Crafts architects to realize two of the principal aesthetic goals of the movement – simplification and integration. Built-ins such as the sideboard and table lamps in the Robie dining-room gave the architect more control over design unity: the more furnishings that could be integrated into the fabric of the building, the less opportunity the client had to instal unsympathetic elements which would interfere with the overall composition.

In 1898, Wright opened a studio in his suburban Oak Park home, where many of the most talented young reform–minded architects soon joined him. Walter Burley Griffin, Marion Mahony, William Drummond and Barry Byrne were among the most significant architects to have trained with Wright from 1898 until 1909, when the studio closed on Wright's departure for Europe.

Given Wright's dominant personality, his associates did not evolve readily identifiable personal styles of their own until they left his employment. Work in a studio as prolific as Wright's, however, was by nature collaborative, and the contributions of more than a dozen young architects, who later went on to distinguished careers, have often been overlooked. For example, Griffin (1876–1937), Wright's site supervisor and office manager, often planned the landscapes that complemented Wright's designs. Receiving numerous commissions after leaving the studio in 1905, Griffin gradually changed his style, which became, as in the Comstock houses, more vertical, closed and massive, and is characterized by split-level rooms and corner piers that extend to the second floor. Mahony (1871–1962) was a superb

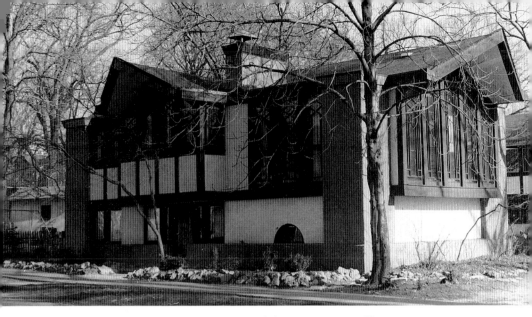

103 Walter Burley Griffin, Hurd Comstock house, Evanston, IL, 1912

draughtswoman responsible for hundreds of drawings in Wright's studio as well as designs for furnishings and such architectural features as the fountain setting for the Dana house interior hall (1902–04) in Springfield, Illinois. After marrying Griffin in 1911, Mahony confined her rendering skills to preparing her husband's designs. In 1912 she executed the drawings for Griffin's prize-winning plan for Canberra, Australia, after which the couple emigrated there.

Wright is considered to be the most significant American architect of the early twentieth century. Through the publication of his work abroad, his influence extended to Europe, affecting young modernists there such as Ludwig Mies van der Rohe and Walter Gropius. The Arts and Crafts movement created the climate in which Wright's work could flourish. His belief in fidelity to the inherent nature of materials, unity of design, responding to the landscape and creating a democratic art were all touchstones of the movement. By the turn of the century, the Midwest had enough progressive businessmen sympathetic to these ideals to become the clients of Prairie School architects. A critic noted in 1903 that 'the well-to-do western gentlemen for whom the houses are built, do not seem to demand the use of European styles and remnants to the same extent as do the eastern owners of expensive buildings.' Just as important, the region

had talented designers, craftsmen and manufacturers who could execute the architect's plans.

One such designer was George Niedecken (1878–1945), founder of the interior decorating firm of Niedecken-Walbridge in Milwaukee. Niedecken had begun to work with Wright by 1904, when the architect commissioned him to design and paint a mural for the Dana house. He soon began to collaborate with Wright on furnishings for many of his Prairie houses, sometimes transforming Wright's rough sketches into more complete designs. At first Niedecken arranged for the furniture to be provided by the F. H. Bressler company but in 1909 he and his partner Walbridge established their own cabinet-making shop.

Niedecken's firm offered a complete interior design service; he would execute architects' plans, modify them or provide his own original custom-made furniture, textiles and lighting fixtures. Insisting that 'the fitness of a thing is quite as important as the design', he championed the new profession of 'interior architect' and insisted that decorators collaborate with architects to provide furnishings of the same natural materials as the house, thereby harmonizing interior and exterior. Niedecken worked with many other Prairie architects, for example, Robert Spencer and the firm of Purcell, Feick and Elmslie (after 1913, Purcell and Elmslie).

William Gray Purcell (1880–1965) and George Grant Elmslie (1871–1952) were the most popular Prairie School architects; between 1910 and 1920, their firm, with offices in Minneapolis and Chicago, executed over seventy commissions. The majority were for small urban residences, although they designed many banks and large houses for wealthy clients. Their work is characterized by compact plans and simple massing, with tinted stucco walls and bands of

104 George Niedecken, design for table/desk and chair, c. 1912. Henry B. Babson house, Riverside, IL

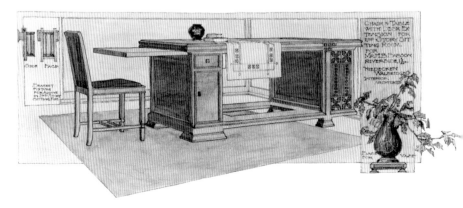

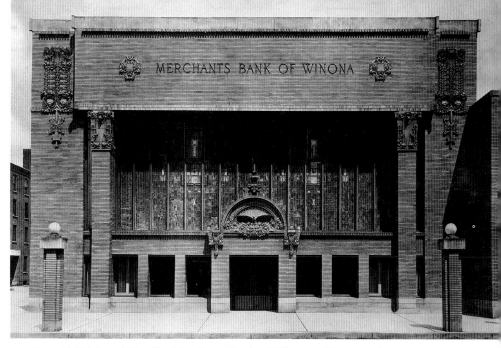

105 Purcell, Feick and Elmslie, Merchants Bank of Winona, Winona, MN, 1911–12

casement windows. Since most of their clients were of moderate means, they became known for achieving artistic effects with inexpensive materials.

Unlike many Prairie School designers, Purcell and Elmslie made ornament a focus of their work, a legacy of the twenty years (1890–1909) Elmslie spent as Sullivan's chief draughtsman. Highlighting a corner pier, an entrance or the back of a chair, ornament served to link the furnishings with the building. As the architects explained, the 'motifs are designed as an organic part of a structure, an efflorescence of the idea represented in the building itself.'

In the 'writing nook' designed for Purcell's own home (1913) the space is integrated by the repetition of floral and geometric motifs in the furniture, stained glass and textiles. Elmslie designed all the furnishings and, in the home-craft tradition so dear to design reformers, the tablescarf was embroidered by Elmslie's wife Louise; Mrs Purcell executed the curtains. The frieze was stencilled, the wood-trim stained instead of painted and the walls were a 'natural' light brown. Floral motifs, potted plants and stained glass helped unite house and garden.

106

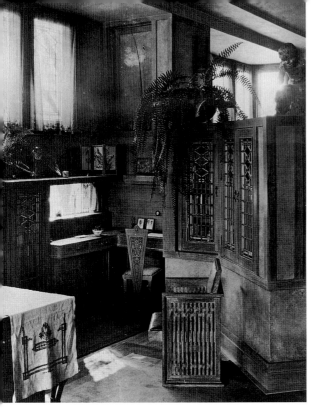

106 Purcell and Elmslie, Purcell house, Lake Place, Minneapolis, 1913. Writing nook

The Purcell house interior demonstrates the close connection between the Prairie School architects and the Arts and Crafts movement. The Prairie architects, however, differed in their lack of concern with the hand-made. Since they wanted to exercise complete control over interiors as well as exteriors, they could not subscribe to the Ruskinian ideal that the craftsman should also be the designer. Furthermore, they were greater advocates of machine production than most Arts and Crafts proponents. It was in fact at a meeting of the Chicago Society of Arts and Crafts in 1901 that Wright publicly declared his allegiance to the machine as the natural extension of the movement's principles: 'William Morris pleaded well for simplicity as the basis of all true art. Let us understand the significance to art of that word – SIMPLICITY – for it is vital to the Art of the Machine.' Wright maintained that if machines were used correctly they would be agents for the promotion of a democratic art as well as the simple life: 'The machine, by its wonderful cutting, shaping, smoothing, and repetitive capacity, has made it possible to so use it without waste that

the poor as well as the rich may enjoy to-day beautiful surface treatments of clean, strong forms. . . .'

Other Prairie architects need not have subscribed to Wright's philosophy of machine superiority in order to embrace technological advances. While Purcell and Elmslie did use the custom services of Niedecken, more often their limited budgets demanded they also contract out to firms that used commercially available stained glass and to furniture factories that used mill-worked oak and machine production.

That individual craftsmanship often precluded a democratic art was a central paradox of the Arts and Crafts movement. Those who advocated the use of machinery to ensure a more democratic art seemed at odds with the Arts and Crafts concern for the craftsman's joy in labour. Those who eschewed cost-cutting and time-saving machinery were only able to offer their services to a restricted elite. The Prairie School architects, more than their counterparts on either coast, turned to machine production as the most practical way to maintain control of the design process while keeping within a budget and could thus reach a middle- as well as an upper-class clientele.

Resort architecture provides yet another regional variation of the Arts and Crafts movement. With increasing urbanization and industrialization in America came the need to get away from it all. Many who would not have wanted an Arts and Crafts house in the city found the idea of a house integrated with its natural surroundings appealing as a second home in a rural setting.

From the forests of Maine to the Rockies, wealthy people commissioned vacation houses in order to pursue 'the strenuous life', a concept akin to Arts and Crafts ideals. For at least part of the year, one could live in bucolic splendour, engage in rugged sports and escape from the overcrowded, soul-deadening city. The lodges, or camps, of the Adirondacks epitomize a romantic view of the rustic that resulted in extremely elaborate simplicity. For example, Knollwood Club in 107 Lower Saranac Lake is a complex of buildings designed by William Coulter in 1899 for six New York families. Typical of Adirondack architecture, the camp was built of logs and shingles with two-storeyed log porches. The rough-hewn beams of the living-room retained their original bark, a moosehead – a trophy of the strenuous life – adorned the massive fireplace and Arts and Crafts and wicker furniture filled the room. The materials suggested a life close to nature; the medieval-inspired diamond-paned windows, a link with the distant past.

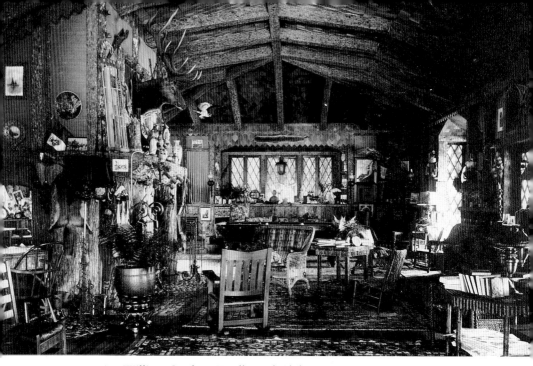

107 William Coulter, Knollwood Club, Lower Saranac Lake, NY, 1899

Although the studied rusticity of resort architecture was available only to those who could afford second houses or vacations, Arts and Crafts architects reached a broader clientele by designing model houses published in mass-market journals. The best-known was the series sponsored by Edward Bok (1863–1930), the progressive editor of *The Ladies' Home Journal*. A supporter of the Arts and Crafts movement, Bok was determined to make good design available to the average American. In 1895 he began to commission architects to publish plans and elevations for houses costing no more than $7000 (some were as little as $3500). By 1910, many major American architects had published house plans in the *Journal*, including Wright, Cram and Elmer Gray. Wright's 'Fireproof House for $5000' (1907) was one of the most popular, perhaps because the design was inspired by the vernacular architecture of the Midwest – the four-square, balloon-frame houses that became ubiquitous in the region in the mid-nineteenth century. Scores of houses were built following Wright's model not only in the Midwest but as far from the prairie as Berlin.

108

Gustav Stickley's *The Craftsman* magazine was the main promoter of Arts and Crafts houses for the middle class. Stickley (1858–1942) was a manufacturer whose Craftsman Workshops produced furniture appropriate for the simple life (see Chapter 5). Although not an architect himself, he was committed to the ideal of design unity and wanted his Craftsman furniture to adorn sympathetic spaces. Not surprisingly, the low-cost bungalows and modest, two-storey residences he began to publish in every issue of *The Craftsman* were called 'Craftsman Homes'. Complete working plans and specifications could be ordered free from Stickley's company, or a client could actually have the company build the house.

The Craftsman, however, did not only serve as an advertising vehicle for Stickley's houses and furniture. In its pages Stickley shows himself as a uniquely American leader of the Arts and Crafts movement in his combination of passion and commerce. Although devoted to the ideals of the movement (the first issue of *The Craftsman* was a panegyric to Morris, the second was devoted to Ruskin), he was also a pragmatic businessman who mass-produced his Arts and Crafts furniture with the latest machine technology and quickly abandoned his profit-sharing plans when they proved not to be economically viable. The changing subtitles of the journal indicate the dilution of Morrisian ideals, despite the fact that Stickley continued to promote education, labour, art and social reform. For the subtitle of the opening issues, 'In the Interests of Arts Allied to Labor', Stickley soon

108 Frank Lloyd Wright, 'A Fireproof House for $5000', published in *The Ladies' Home Journal* April 1907. Perspective and plans

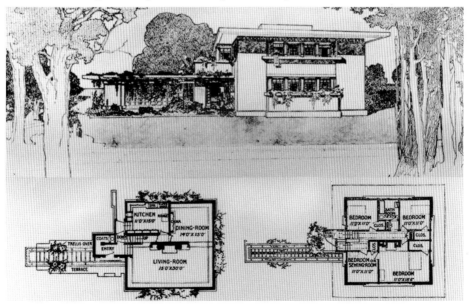

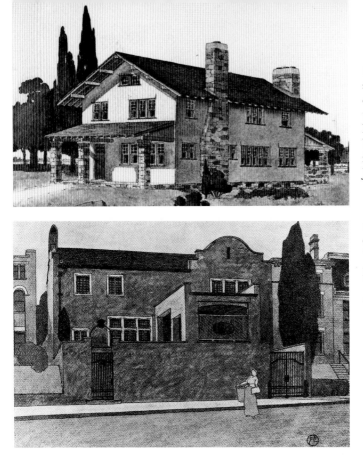

109 'A simple straightforward design from which many homes have been built', published in *The Craftsman* January 1909

110 Harvey Ellis, design for an 'urban house', published in *The Craftsman* August 1903

substituted 'For the Simplification of Life', and finally in 1906, 'Better art, better work, and a better and more reasonable way of living'.

As has been seen, Stickley published articles by or about most of the leading practitioners of design reform on both sides of the Atlantic. Advocating designers from Baillie Scott, Voysey and Barry Parker to Eyre, Greene and Greene and Gill, the magazine became a forum not only for architecture but also for garden suburbs and urban planning.

Stickley chose better architects to write about than he did designers
110 of his Craftsman Homes. With the exception of plans by Harvey Ellis (1852–1904), an immensely talented architect who worked for
109 Stickley briefly in 1903–04, the Craftsman Homes are fairly undistinguished. Their presence across the country, however, and their diversity of stylistic expression, ranging from mission bungalows to New England farm houses, embodies the American popularization of the Arts and Crafts ideal to the broad middle class.

142

Arts and Crafts Production in America

Arts and Crafts reformers' designs for buildings and furnishings were shaped by moral convictions and often conveyed prescriptions as to how people ought to live. The goals were the revival of hand-craftsmanship, the creation of more satisfying working conditions and the promotion of simple, uncluttered houses and interiors achieved through a unification of all art forms.

The moral aesthetics of American reformers developed from British precedent, most notably Ruskin and Morris. Their writings were bestsellers in America; for example, Ruskin's only book devoted to the decorative arts, *The Two Paths*, was reprinted nineteen times in America between 1859 and 1892. Reading groups to study their work were established across the country: one designer, Joseph Twyman of the Tobey Furniture Company in Chicago, established a William Morris room in the company's showrooms and founded a William Morris Society.

Although neither Ruskin nor Morris visited the United States, many other British leaders made the journey, among them Walter Crane, Ashbee and Morris's daughter May. All gave numerous lectures, met American reformers and toured exhibitions of their work. American craftsmen came to Britain not only to study the work of bookbinders, silversmiths, and furniture makers but also to learn about societies, settlement houses and utopian communities. Americans subscribed to the latest British journals and published their own, featuring British designers. International expositions held in Philadelphia (1876), Chicago (1893), Buffalo (1901), St Louis (1904) and San Francisco (1915) displayed the work of leading British craftsmen and manufacturers.

Arts and Crafts ideals and designs were also transmitted and then disseminated via organizations such as the SACB, which was founded in 1897 with Charles Eliot Norton (Harvard professor of fine arts and close friend of Ruskin) as its president. The SACB offered lectures, classes and social gatherings to bring together craftsmen, architects and enthusiastic amateurs. Seeking to elevate taste and assist members

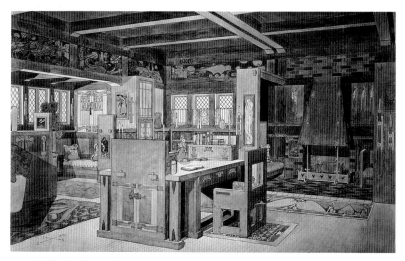

111 Will Bradley, drawing for a library, published in *The Ladies' Home Journal* 1902. Bradley, one of the most influential graphic artists at the turn of the century, also designed interiors, furniture and fittings.

to market their products, the SACB maintained a salesroom where work could be sold only after being selected by a jury.

The SACB's *Handicraft* (1902–04) was one of the many small journals founded as part of the movement. Although these publications were influential, with their combination of inspirational essays, quotes from Ruskin and Morris and practical guidance to craft services, it was the more general 'shelter' magazine such as *The Ladies' Home Journal* that carried the Arts and Crafts message into millions of homes. Dedicated to promote, in the words of the *House Beautiful* motto, 'Simplicity, Economy and Appropriateness in the Home', they made Arts and Crafts a recognizable and desirable style to middle-class people.

Neither the shelter magazines nor the SACB, however, advocated one particular style; rather, they shared assumptions about good design that resulted in an Arts and Crafts 'look'. Decoration inspired by motifs found in nature, especially local nature, always received approbation. According to the director of the Newcomb Pottery, which was part of a woman's college in New Orleans, Louisiana, the ceramics were to be 'a southern product, made of southern clays, by southern artists, decorated with southern subjects!' Thus magnolias, live oaks, hanging moss, cypress trees and other southern vegetation were the primary motifs on the pottery.

As in architecture, the use of local materials in the decorative arts was advocated: the more modest and unadorned the better. The beauty of the object was to be found in the way it was made and the inherent nature of the material rather than in its monetary worth. Therefore, in furniture, native oak was preferred to imported mahogany, simple fumed wood to elaborate veneers, and rectilinear forms derived from the wood's structure preferred to ornate curves. In metalwork, the use of copper was encouraged, semi-precious stones were chosen over precious ones, and found materials such as pebbles were incorporated in many designs.

The Kalo Shop of Chicago often used semi-precious green cabochons on the handles of silver pieces, especially in the company's early years. Their creamer and sugar bowl indicate another important aspect of the Arts and Crafts aesthetic – 'honest' construction. Unlike eighteenth-century practice, where the objective was to make silver look as smooth and perfect as possible, a goal of Arts and Crafts production was to show the imprint of tools and hand processes. Hammer marks were left to illustrate construction techniques and to demonstrate that the silver was fashioned by a craftsman and not by a machine. The philosophy behind the creamer and sugar's manufac-

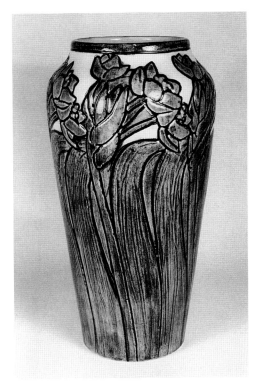

112 Vase, 1903, decorated
by Harriet Joor for
Newcomb Pottery

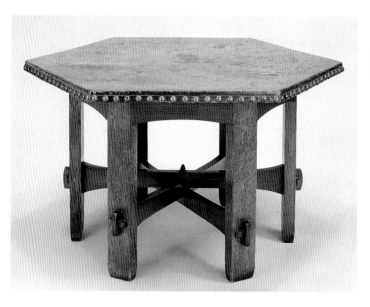

113 Library table, c. 1906, Craftsman Workshops

ture was inherited from Ruskin and Morris; the actual forms were derived from Ashbee's designs at the Guild of Handicraft.

120 Hammered surfaces also characterized the copper lamps produced by Dirk Van Erp (1859–1933) in San Francisco. Construction was further celebrated in the shades, where the riveting became part of the decoration. Exaggerated hammered copper hinges on furniture were another manifestation of an aesthetic of revealed construction.

113–15 The most oft-repeated Arts and Crafts objectives were simplicity, utility and the democratization of art. The furniture made by Stickley's Craftsman Workshops became known as 'mission', partly because it was associated with the furnishings of eighteenth-century Spanish colonial churches, but also because of Stickley's repeated statements that 'a chair, a table, a bookcase or bed [must] fill its mission of usefulness as well as it possibly can. . . . The only decoration that seems in keeping with structural forms lies in the emphasizing of certain features of the construction, such as the mortise, tenon, key, and dovetail.' ('Mission' was soon used to describe Arts and Crafts furniture by any maker.) Most Stickley furniture exhibited such 'honest' construction and was, in general, made of quarter-sawn oak, with the grain emphasized by a finish of fumed ammonia. Seats and upholstery were of other natural materials – leather or rush. His rectilinear forms were often derived from seventeenth- and eighteenth-century prototypes such as settles and trestle tables. In homage

146

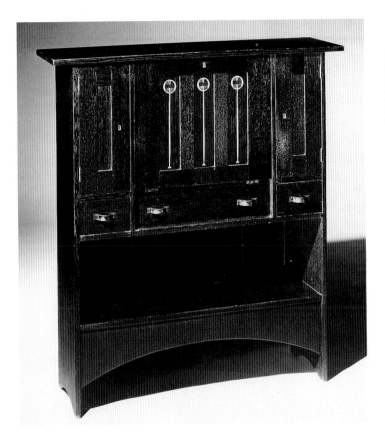

114 Fall-front desk, *c.* 1903–04, designed by Harvey Ellis for Craftsman Workshops

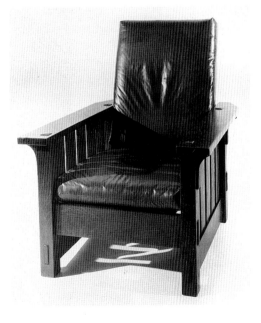

115 Morris Chair, *c.* 1903, Craftsman Workshops

to his English hero, he also made many versions of the Morris chair.

Stickley's company produced metalwork and needlework as well, but for ceramics he recommended that Grueby pottery be purchased to complement a 'Craftsman Home'. William Grueby (1867–1925) developed the company's characteristic matte green glaze; its texture was described in 1904 as 'like the smooth surface of a melon, or the bloom of a leaf, avoiding the brilliancy of high glazes'. Perceived as more natural, matte glazes became popular in the mid-1890s; Grueby's were the most widely imitated both for tiles and vessel forms. A Grueby pot or fireplace surround was ideal for an Arts and Crafts interior. Their best-selling colour was green, considered to be the colour of nature; their designs were based on leaf and flower motifs; and they clearly were hand-made.

Although Arts and Crafts proponents did not espouse any single style, they were united in what was opposed – revivals such as Rococo or Louis XIV were rejected as being artificial, too elaborate and unresponsive to human needs. In keeping with the idealization of the pre-industrial past, they embraced medieval, oriental, folk and colonial styles. American design reformers saw no contradiction in

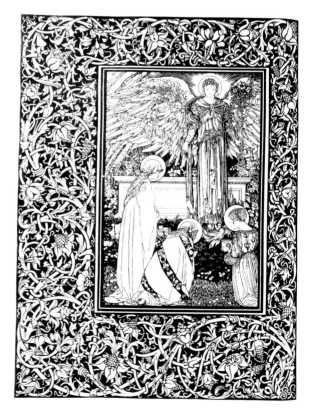

116 *The Altar Book* 1896, decorations designed by Bertram Goodhue for the Merrymount Press

looking to Britain, Europe and the Orient for sources to create a distinctly American art.

More often seen in buildings, the medieval style was also applied to furniture, metalwork, ceramics, books and textiles. At the Merrymount Press in Boston, Daniel Berkeley Updike (1860–1941) published *The Altar Book* (1896) in a limited edition of 350 copies. Its 116 floral border design and decorated initials resembled fifteenth-century incunabula – the efforts of early printers to continue the tradition of medieval manuscripts. *The Altar Book* closely followed examples produced at Morris's Kelmscott Press, an unusual example in America of Morris's actual designs being an inspiration as well as his ideas.

Oriental art was admired for many of the same reasons as the Gothic. Both were asymmetrical and thus 'natural', uncluttered in design and associated with traditional craft production. Japanese and Chinese art embodied the qualities of harmony, unity, simplicity and reverence for the natural world that Arts and Crafts reformers extolled. Ceramics were especially influenced by Oriental art. Reacting against what they considered unnecessary surface decor-

117 *Sang-de-boeuf*
vase, *c.* 1886–88,
Hugh Robertson at
the Chelsea Keramic
Art Works

ation, potters embraced the Chinese emphasis on glazes and form. At
the Chelsea Keramic Art Works outside Boston, Hugh Robertson
117 (1845–1908) spent years perfecting his version of the Chinese red glaze
called *sang-de-boeuf*. His is a story of Arts and Crafts idealism and
compromise. He spent so many years refining his glazes that the
company went bankrupt in 1889. (His own term for the Chinese red
glaze was 'Robertson's blood'.) Backers gave him the money to re-
open two years later on the condition that the pottery be made
commercially viable. With the success of a blue-decorated white
Chinese crackle glaze Robertson had developed and his willingness to
apply it to multiple-production table wares, the company, re-
organized as the Dedham Pottery, became profitable and remained in
operation until 1943.

The previous chapter discussed the importance of regionalism, the
idea that buildings should be integrated with their environment and
use indigenous materials. The nation's landscape and history provided
design sources for decorative art as well. Nostalgia and the yearning
for a simpler past led to the revival of colonial designs. In Deerfield,
Massachusetts, the Society of Blue and White Needlework was
founded (1896) to preserve eighteenth-century embroidery tech-

118 Embroidered mat, *c.* 1896–1900, Society of Blue and White Needlework

niques of the Connecticut River Valley. Ellen Miller and Margaret Whiting trained a group of local women to execute the designs for coverlets, bed curtains and table cloths they adapted from examples in the local historical society. The earliest work of the Society used only blue and white linen yarns but within a year Miller and Whiting were experimenting with natural dyes – indigo, madder and butternut – to produce coloured yarns and fabrics (man-made aniline dyes were strictly forbidden).

118

Throughout the country, textile craftworkers were reviving other traditional techniques and materials, among them patchwork, netting and candlewick. Often their original purpose was lost; for example, in the eighteenth century rag rugs were made so that no scrap of old fabric was wasted. One hundred years later weavers made them by cutting up new material in order to achieve greater control over the process. What had been a necessity became a stylistic choice.

New England was the centre for the Colonial Revival. Wood-workers made furniture inspired by seventeenth- and eighteenth-century precedent: Windsor chairs, Hadley chests, gate-leg and trestle tables. At Boston's Handicraft Shop (1903–*c.* 1940), an outgrowth of the SACB, silversmiths created metalwork derived from panelled

119 Punch bowl, 1910,
Robert Jarvie

bowls, porringers and beakers. These are only a few of the forms mined from the colonial past that Arts and Crafts advocates admired as expressing the frank exposure of construction and honest use of materials.

Since the Arts and Crafts movement idealized the rural and the primitive, folk crafts were seen as contributing to a national identity. A continuation of the hand-weaving tradition, coverlets made by Appalachian mountain women were marketed successfully in the north. Although not native, immigrant crafts were admired as well, with Italian embroideries and laces finding a ready audience. After the confinement of the western tribes to reservations in the 1870s and 80s, Native Americans were romanticized as the embodiment of 'the simple life' and objects produced by them were among the most popular domestic accessories. The geometric patterns of Indian pottery, baskets and blankets were also compatible with the Arts and Crafts aesthetic of stylization, so much so that many commercial companies as well as Arts and Crafts societies began to produce Native American designs. These ranged from forms inspired by Indian 119 designs, such as a silver bowl crafted by the Chicago metalsmith Robert Jarvie (1865–1941) that he adapted from a Native American basket at the Field Museum of Natural History, to fairly archaeologically correct imitations, such as those produced by the Clifton Art Pottery of New Jersey (1905–14).

The revival of native craft traditions was closely allied to Arts and Crafts efforts towards social reform. As in Britain, upper- and middle-class women formed organizations to teach and market crafts, usually

120 Table lamp,
c. 1910, Dirk Van
Erp Studio

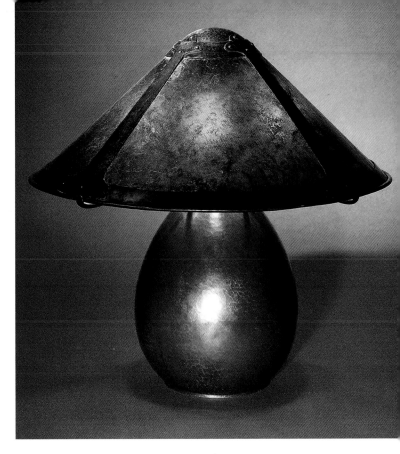

121 Creamer and
sugar bowl,
c. 1908, designed
by Clara Pauline
Barck Welles at
The Kalo Shop

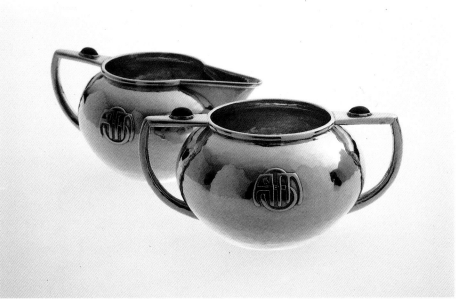

PARADISE LOST

JOHN MILTON

122 Binding on John Milton's *Paradise Lost*, by Ellen Gates Starr at Hull House, 1902

for the benefit of less fortunate members of their sex. With London's Toynbee Hall as the model, crafts programmes at settlement houses such as Jane Addams's Hull House in Chicago provided an escape from the tedium of factory work. In addition, settlement houses offered immigrants a chance to affirm and express their native heritage. With classes and salesrooms, the South End House and Denison House in Boston helped immigrant women to refine their manual skills and market their embroideries and laces. The Arts and Crafts movement was seen as a way of preserving the 'immigrant gift' of handwork. One settlement house resident warned that Americans must guard 'against the "melting-pot" melting out the best and leaving the dross to be fused into our national character – let us help to save as much as possible of this quality by actively interesting ourselves in this Arts and Crafts movement.'

Settlement houses and other philanthropic enterprises like them not only encouraged immigrant crafts. Many also tried to help economically disadvantaged groups develop new skills by offering classes in bookbinding, metalwork, woodwork and pottery. After

training with Cobden-Sanderson, Ellen Gates Starr established a hand
bindery at Hull House in 1898. The Paul Revere Pottery (1911–42),
which produced and sold breakfast and tea sets, lamps, tiles and vases,
grew out of the Saturday Evening Girls' Club at the North End
Branch of the Boston Public Library. The pottery provided the
daughters of Italian and Jewish immigrants with an alternative to
factory work and an opportunity to earn money while receiving
artistic instruction.

Design training was essential to the dissemination of the Arts and
Crafts movement and the settlement houses were but one of the many
new avenues for art education. Just as the Great Exhibition of 1851
inspired the development of art education in Britain, the 1876
Philadelphia Centennial had awakened Americans to the need for
design reform in their own schools.

Ideals were combined with economic necessity; good design was
not only morally uplifting, it would better enable American goods to
compete with European imports. While Arts and Crafts rhetoric
concerning individuality permeated the language of educational
reformers, most recognized that the needs of mass production had to
be met. As the teacher and ceramicist Ernest Batchelder pointed out:
'The evil of machinery is largely a question of whether machinery
shall use men or men shall use machinery.'

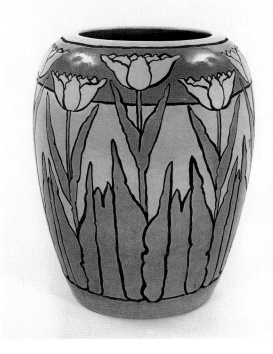

123 Vase, 1915, Paul
Revere Pottery of the
Saturday Evening Girls'
Club

Americans followed the London South Kensington model of establishing new museums to provide industrial designers with inspiration from the best objects of the past, and schools became affiliated with the museums to teach the importance of good design in basic household objects. Independent schools such as the Pratt Institute in Brooklyn (founded 1887) and university-based programmes such as the New York School of Clay-Working and Ceramics at Alfred University (1900) were only two of the many types of educational institutions founded in response to the need for training in the crafts.

By the turn of the century, manual training classes were widespread in American elementary and high schools, and hundreds of vocational, industrial arts and design schools had been established. The Arts and Crafts concepts of the joy in labour, dignity of work and utility in design were incorporated at all levels of instruction. One of the most influential teachers was the painter Arthur Wesley Dow (1857–1922).

125

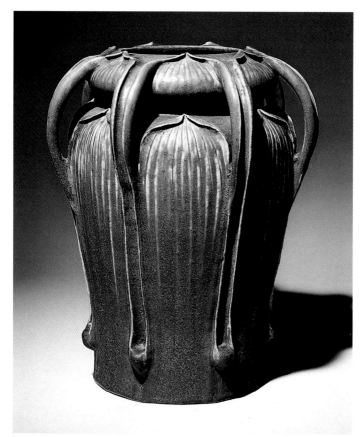

124 Vase, c. 1898–1902, designed by George Prentiss Kendrick for the Grueby Faience Company

125 OPPOSITE Poster, 1895, Arthur Wesley Dow for *Modern Art*

modern Art

EDITED BY J. M. BOWLES
PUBLISHED BY L. PRANG & CO.

Arthur W Dow

With the arts of Japan as his inspiration, Dow championed an aesthetic of 'rhythm and harmony, in which modeling and nature imitation are subordinate'. Nature should be the source of inspiration, but it should be abstracted into the basic elements of design – line, colour and *notan* (the Japanese term for 'light, dark'). His ideas were not only applied to painting and prints, but also to metalwork, pottery, textiles and woodcarving. Through his book *Composition* (reprinted twenty times between 1899 and 1938) and as Director of Fine Arts at Teacher's College, Columbia University (1904–22), Dow championed the principles of conventionalized design throughout the country.

The Marblehead Pottery was one of many companies whose work featured the stylized depiction of nature dictated by teachers such as Dow. The pottery was founded in 1904 to provide occupational therapy for 'nervously worn-out patients' recovering from tuberculosis. The work proving too onerous for the patients, the pottery was separated from the sanatorium the following year. With its simple, pleasing shapes and subdued, geometric decoration, Marblehead achieved a formula for success that enabled much of the pottery to be sold from catalogue orders. Arthur E. Baggs (1886–1947), who had studied at Alfred before becoming the supervisor and then owner of Marblehead Pottery, was not satisfied with multiple production however well executed and about 1910 started to create more individualistic pieces at the wheel. A forerunner of the studio pottery movement of the 1920s and 30s, Baggs ended his career as a professor of ceramic art at Ohio State University.

The development of the art pottery industry in America serves as a guide to the multiplicity of processes that can still be considered Arts and Crafts. The ceramics industry was one of the first to respond to the new demand for more individual, hand-made objects. Art pottery evolved in two ways – from amateur and professional china painting and from established commercial potteries that, recognizing a market for a hand-crafted line, added it to their regular production.

The vogue for china painting as a hobby for women emerged in the early 1870s. It was considered delicate work that would not tax the 'fairer sex' and could be executed at home or in a small studio. Most china painters were amateurs; many used their skills to generate income; a few used china painting as a stepping stone to careers in the arts usually restricted to men.

At the Philadelphia Centennial Exposition a display of china painting by a group of Cincinnati women won what little acclaim could be garnered for American art products. (American technologi-

cal and engineering achievements received world attention, but the country's art industries were considered negligible.) Aware of their deficiencies, potters looked to the foreign ceramic displays for processes they could adapt: the Japanese and French wares particularly captured their imaginations. It was two women from Cincinnati – Mary Louise McLaughlin and Maria Longworth Nichols (later Storer) – whose experiments with French underglaze techniques would most influence American art pottery and make Cincinnati its centre.

McLaughlin (1847–1939) was one of the women whose overglaze decoration received praise at the 1876 Centennial. She spent the following year trying to duplicate the more sophisticated underglaze painting with coloured slips (called barbotine ware) that the Haviland factory of Auteuil had displayed. She succeeded in adapting an old pottery technique that produced the same effect and in 1879 organized the Cincinnati Pottery Club to share it with other enthusiasts.

The invitation to join never reached Maria Nichols (1849–1932) who then formed her own pottery, Rookwood, in 1880. She hired full-time decorators to further develop McLaughlin's process and in 1883 a business manager, who selected which shapes and decoration were the most profitable and forced any amateur potters to leave.

Rookwood became the most renowned and successful art pottery. 127
The ceramic historian Edwin AtLee Barber wrote in 1893: 'The Rookwood Pottery was the first in this country to demonstrate the

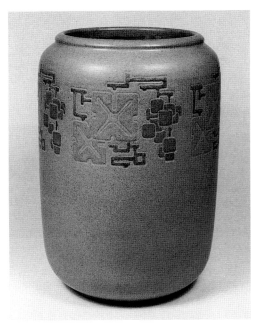

126 Vase, c. 1908–20,
Arthur E. Baggs at
Marblehead Pottery

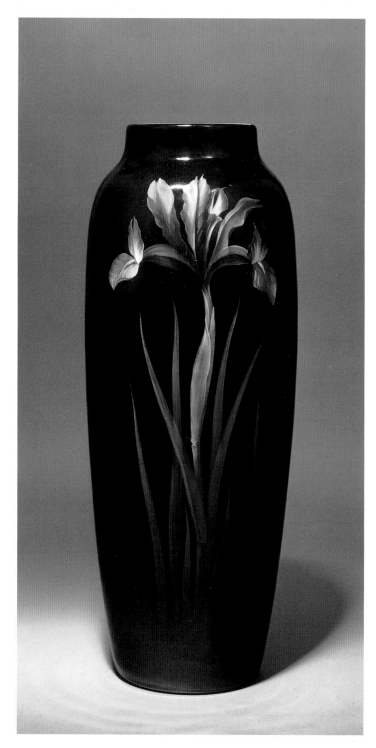

127 Vase, 1909, decorated by Carl Schmidt for Rookwood Pottery. The Pottery first became known for its subdued, earth-toned Standard ware, introduced in 1884. This example was part of the Iris line, very similar in palette to that at Royal Copenhagen in Denmark

128 OPPOSITE
Scarab Vase 1910, Adelaide Alsop Robineau

fact that a purely American product . . . can command the appreciation of the American public.' The pottery was the first to receive widespread international acclaim as well, winning major awards at international expositions such as Paris in 1900 and Turin in 1902.

The socialist Oscar Lovell Triggs described Rookwood as 'An Ideal Workshop' in his book *Chapters in the History of the Arts and Crafts Movement* (1902) because 'the fullest possible freedom is given to the workmen; they are encouraged to experiment, to express their own individuality, and to increase their culture by study and travel. The spirit of the factory is that of cooperation and good fellowship.' The decorators were responsible for complete designs and each piece was uniquely decorated. Rookwood, however, like all large-scale Arts and Crafts manufactories, could not meet the Arts and Crafts ideal. Shapes were standardized and division of labour specialized. (By the 1890s, a piece of pottery could pass through twenty-one different hands before completion.) Furthermore, Rookwood was not progressive in its designs. Even after a second generation of art potteries, established in the mid-1890s, moved the design emphasis from applied decoration to rich glazes and simplified forms, Rookwood tended to retain conservative, naturalistic landscapes and flower-painting on its pottery.

The Arts and Crafts ideal that a craftsman should control the entire design process from conception to finished product was best realized in small craft studios. Adelaide Alsop Robineau (1865–1929) began her career as a china decorator and teacher. Realizing that no quality periodical existed to serve the needs of china painters, she and her husband founded the influential magazine *Keramic Studio* (1899) in Syracuse, New York. A few years later, she progressed from china decoration to designing and throwing her own porcelain pieces. The 128 *Scarab Vase*, one of her masterpieces, exhibits both the delicate perforation and exquisite carving for which she became renowned. Decorated with an excised design of scarabs, the vase required at least a thousand hours of patient labour, explaining why the work is also known as *The Apotheosis of the Toiler*. Content with nothing less than perfection, Robineau limited her output and completed every stage of manufacture herself. She received world-wide acclaim, but since only about six hundred pieces were ever sold, she supported herself by teaching and publishing.

Robineau was not the only woman to move beyond china decorating. Mary Chase Perry (later Stratton, 1867–1961) founded

the Pewabic Pottery, an architectural tile company in Detroit. In 1911, the three Overbeck sisters, Elizabeth, Mary Frances and Hannah, established the Overbeck Pottery, where each pursued a specialty: Hannah was responsible for the designing, Elizabeth the throwing, and Mary Frances the decorating. Twenty years after developing her underglaze slip technique on earthenware, Mary Louise McLaughlin created the 'Losanti' line of porcelain.

Far more American women than British were able to establish independent studios or at least participate more fully in all stages of production. The Arts and Crafts movement led to new opportunities for women: for example, Robineau, Perry and Elizabeth Overbeck all studied at Alfred with the most revered ceramics instructor in America, Charles Fergus Binns. However, opportunities were limited by old stereotypes. Women were either confined to traditionally 'feminine' crafts, such as textile production, or to those branches of craft activity thought appropriate for the 'weaker sex'. A rigid sexual division of labour prevailed in the ceramics industry: men threw the pots and fired the kilns while women did the decorating. Only by working in their own shops were women able to pursue careers as potters, metalsmiths and bookbinders.

The Grueby Pottery is representative of this sexual division of labour. Young women graduates of the Boston Museum of Fine Arts, Cowles Art School and Massachusetts Normal School decorated the Grueby Pottery's forms. Male architects designed the pottery

129 Vase, c. 1915,
Overbeck Pottery

130 Teco vase, 1904–05, designed by Fritz Albert for Gates Pottery

131 OPPOSITE Desk and chair, *c.* 1900, Charles Rohlfs. Rohlfs created imaginative furniture that combined the rectilinear Arts and Crafts shapes with sinuous Art Nouveau ornament. His lack of formal training in cabinet-making, however, led to poor craftsmanship, as seen in his use of screws (concealed by pegs) to hold the furniture boards. The screws usually do not provide enough structural support and make the wood vulnerable to splitting.

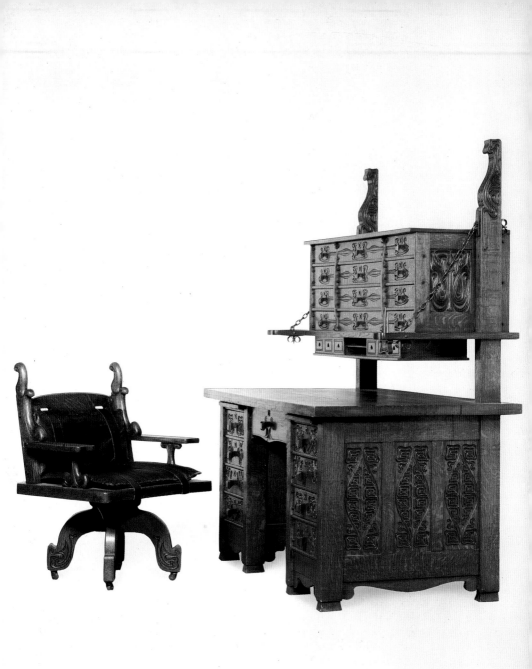

(George Prentiss Kendrick from 1897 to 1901; Addison LeBoutillier thereafter) and male potters threw it. Grueby's production is also typical of mid-size shops – the vases were not one-of-a-kind designs, but each piece was thrown, not moulded, and the prescribed patterns allowed for individual variation.

Not all potters believed that ceramics had to be thrown on a wheel to have artistic merit. Artus Van Briggle (1869–1904) began his career as a decorator at the Rookwood Pottery and in 1893 the company sent him to Paris for further training. There he became deeply influenced by the Art Nouveau style, by French potters' experiments with high-fired Chinese matte glazes and by their belief that vases were sculpture rather than vessels to be decorated. After his return in 1896 he worked for Rookwood for three more years until tuberculosis forced him to move to the healthier climate of Colorado. At the pottery he established in Colorado Springs the lessons of Paris were put into practice. He also believed his work was best realized by creating a master mould of the original work from which slip-cast pottery was produced in plaster moulds. As *House Beautiful* observed in 1903: 'Mr. Van Briggle's idea in this matter is that it is far more satisfactory to spend unlimited time and thought in carrying out an idea which may be worthy of repetition, each reproduction being different in color and glaze effect, than to attempt for every vase a new design which must of necessity often be careless and hasty in thought and execution.' The pottery was acclaimed immediately for its matte

132

glazes, subtle Art Nouveau forms and design motifs based on native flowers. His wife Anne continued to operate the pottery after Van Briggle's early death in 1904.

Art pottery production on the largest scale was realized at companies that added it as a line to their routine output. Made in towns such as Zanesville, Ohio (known as 'Clay City'), this pottery was often a cheap, uninspired imitation of Rookwood and other

130

firms. Teco ware, produced at the Gates Pottery of Terra Cotta, Illinois, was an exception. The company's first catalogue of the line (1904) stated: 'In the Teco Art Pottery the constant aim has been to produce an art pottery having originality and true artistic merit, at a comparatively slight cost. . . .' By commissioning designs from Prairie School architects such as Wright and sculptors such as Fritz Wilhelm Albert, and by developing outstanding silvery-green matte glazes, William Day Gates (1852–1935) was able to achieve his artistic goals. With a pottery already equipped for the production of architectural terracotta at his disposal and the use of moulds instead of hand

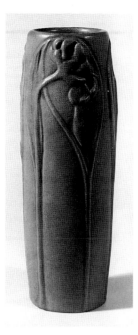

132 LEFT Vase, 1903,
Van Briggle Pottery

133 RIGHT Cover for
Alice Brown's *Meadow
Grass* (1895), designed
by Louis Rhead for
Copeland and Day

throwing, Gates was able to offer his pottery at a price the average consumer could afford.

Thus Arts and Crafts pottery production ranged from unique virtuoso pieces to factory-produced objects that embodied the movement's aesthetics and sometimes its principles of construction as well. This diversity of production also applied to furniture, metal-work and books. Private presses were the most individualistic expressions of the book as a work of art with their hand-made papers, proprietary typefaces, specially designed decorations and often their use of calligraphy and hand-illumination. Literary houses and other small presses produced high-quality work in limited editions of a few hundred. Presses such as Copeland and Day advocated the integration 133 of typography, printing, illustration and binding. Furthermore, they encouraged graphic artists to relate the design of the book to its literary content. Larger commercial houses like Houghton Mifflin in Boston were instrumental in disseminating the new emphasis on unity in graphic design through the sale of inexpensive, decorated books with cloth bindings.

Morris had asked, 'What business have we with art at all, unless all can share it?', but objects made by hand were more expensive and thus precluded the majority. In order to realize the Arts and Crafts goal of

167

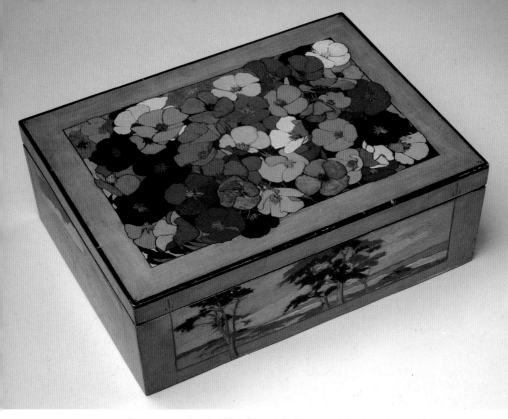

134 Box, 1929, Lucia Kleinhans Mathews at The Furniture Shop

art made available to all, compromises had to be made. Either art had to be redefined to include machine production or the craftsman ideal had to be restricted to handwork for an elite.

One solution to the paradox was to achieve democracy in art by creating it yourself. An important component of the Arts and Crafts message was that everyone should experience the joy of craftsmanship; the result was an avalanche of home-made furniture, wall hangings, curtains, pillows and picture frames. Morris and Co. marketed embroidery patterns, department stores sold metalworking kits and Stickley's *The Craftsman* published designs and models for furniture. A variety of other publications (for example, *Mission Furniture: How to Make It*, *Making Built-In Furniture* and *Arts-Crafts Lamps*) spread the 'do-it-yourself' ethos of the Arts and Crafts movement.

168

135 Portière, *c.* 1884, designed by Candace Wheeler,
fabric made by Cheney Brothers >

Professional craftsmen, however, were often wary of amateur work, fearing that standards would be lowered if good intentions were the criteria for judging the quality of an object. This was particularly true in the textile arts, where the line between the professional and the hobbyist was thin.

Countless women beautified their homes with cushion covers, embroidered mats, and table scarves purchased in a kit where the design was marked on the cloth and the embroidery silks included in the package. Professionals such as the Boston designer George W. Fenety (1854–1933) sold these kits, which women usually executed with a 'running' or 'darning' stitch. As discussed earlier, textiles were also the greatest medium for art as philanthropy. The Scuola d'Industrie Italiane in New York sold immigrant embroidery; missionaries taught Native American women lace-making on the White Earth Reservation in Minnesota and then marketed their work. The establishment of schools and societies helped profession-alize the textile arts – Candace Wheeler (1827–1923) envisioned her New York Society of Decorative Arts as an 'American Kensington School' and succeeded in developing art needlework as a profit-making activity for women craftworkers.

The Arts and Crafts story is replete with accounts of amateurs turning professional for the 'joy in labor'. Jarvie had been a clerk in the Chicago city government; Charles Rohlfs rejected a successful acting career for furniture making; Karl Kipp, head of the metalworking department at the Roycroft community, had been a banker. Unless work remained on an amateur level, however, the dichotomy of combining hand-crafted and democratic art was usually not resolved, but resulted in a choice: either the work was fulfilling for the maker or it was available to the middle-class user. For the maker, the craftsman ideal was achieved in studios, guild-like associations, and utopian communities.

Arthur Stone (1847–1938) established his metalwork shop in Gardner, Massachusetts, along the lines of a guild. He initiated an apprenticeship system and recognized the individual contributions of his craftsmen by having them mark their own initials next to the shop mark. As the *Bulletin* of the SACB noted in 1926: 'Mr Stone believes that each assistant is entitled to a part of the profits, which are divided every six months.' Unrivalled in the techniques of chasing, piercing, fluting and repoussé, Stone also excelled as a designer. His work contains references to many different styles of ornament – Celtic, Gothic, Moorish, Renaissance – but he preferred to draw his motifs

135

131

136

170

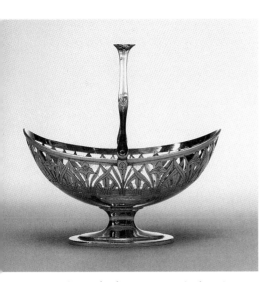

136 Sugar basket, *c.* 1915, Arthur Stone

137 Music stand, *c.* 1901–06, designed by
Will Price at the Rose Valley Shops

from New England gardens and wild flowers. In the 1920s and 30s his
work reflected the growing popularity of the Colonial Revival, with
such eighteenth-century forms as beakers, tankards, flagons, punch-
bowls and porringers dominating shop production. His silver was
characterized by high surface finish for, unlike metalsmiths in
Chicago, Stone did not feel the need to prove that his work had been
hammered by hand.

The Furniture Shop of San Francisco was founded in 1906 by
Arthur (1860–1945) and Lucia Kleinhans (1870–1955) Matthews. 134
Work was plentiful, since the city was engaged in rapid rebuilding
after the great earthquake. Maintaining a work-force of between
twenty and fifty craftsmen, The Furniture Shop provided total
interior design from furniture and wood panelling to murals and
accessories. Although much of their production was commercial, the
Mathews are best known for the collaborative work they executed for
special commissions. With Arthur providing the design and Lucia the
colour scheme and the carving, they created elaborate decorated
furniture painted with idyllic scenes of the California landscape.

171

Leaders of the Arts and Crafts movement in San Francisco, the Mathews were principal founders and contributors to *Philopolis*, a journal devoted to civic reform.

As models of the simple life in which art, labour and leisure were completely integrated, communities such as Ralph Radcliffe White-head's Byrdcliffe Colony in rural Woodstock, New York, were the ultimate expression of Arts and Crafts principles. At Oxford, Whitehead (1854–1929) had been converted to the ideals of Ruskin; the two later travelled together to Italy. After inheriting a fortune from his father, he came to America with the goal of establishing a craft community. In 1902 he founded Byrdcliffe, which he described as a place where craftsmen could escape 'the slavery of our too artificial and too complex life, to return to some way of living, which requires less of material apparatus'. Whitehead built a complex of thirty buildings, all constructed of local materials, and invited craftsmen to this bucolic setting where they might combine furniture, textile, pottery and metalwork production with callisthenics, drama and music. The enterprise, however, was short-lived. The furniture was too labour-intensive to sell profitably, most of the craftsmen only wanted to stay for the summer months and Whitehead, on whose financial support the community depended, was a difficult and dictatorial man. By 1915, most craftsmen had deserted and Byrdcliffe became a private family estate.

To be short-lived seemed the fate of Arts and Crafts communities. Although Rose Valley was no exception (1901–09), it came closest to fulfilling the quest for organic wholeness that led city dwellers to live communally in the country. The community's leader, the architect William L. Price (1861–1916), renovated old textile mills outside Philadelphia to serve as craft shops. At its height Rose Valley had over one hundred settlers and produced furniture, pottery, bookbinding and the journal *The Artsman*, whose subtitle 'The Art that is Life', summarized the ideals of the Arts and Crafts movement. As at Ash-bee's Guild of Handicraft in Chipping Campden, labour and leisure were integrated: concerts, lectures and plays were part of daily life there. The community was also more democratic than most. Local government consisted of the Rose Valley Folk, who modelled their town meeting on the 'motes' held in Morris's *News from Nowhere*.

The Roycroft community (1895–1938) in East Aurora, New York, was more commercial than Byrdcliffe or Rose Valley. Its founder, Elbert Hubbard (1856–1915), had been a partner at the Larkin soap company, where he pioneered the mass-marketing

137

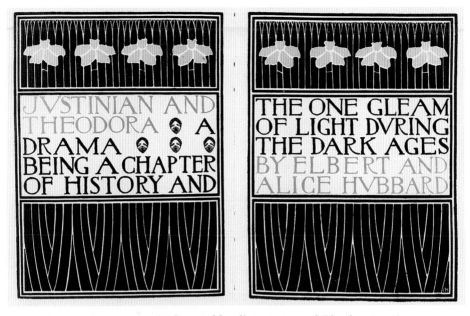

138 Title-page for Elbert and Alice Hubbard's *Justinian and Theodora* (1906), designed by Dard Hunter for the Roycroft Press

techniques he later applied at Roycroft. Visiting Merton Abbey in 1893, he returned to America determined to establish hand-printing along the lines of Morris's Kelmscott Press. Despite the initially rather clumsy work, the press was immediately successful and led to the establishment of a bindery and a leather shop, and within a few years furniture, metalwork and a stained-glass studio were added.

While most of the community's over four hundred workers were local citizens trained at Roycroft, Hubbard did attract some exceptional craftsmen from outside New York state. Dard Hunter (1883–1966), for example, designed furniture, metalwork, stained glass and books before leaving to study in Vienna. Eventually Hunter established the Mountain House Press, where he wrote the text for his books, designed and cast the type and composed and printed the copy on paper he had made himself. Louis Kinder, a German book binder, and Samuel Warner, an English illustrator, also elevated the quality of book production at Roycroft. 138

Hubbard's system was one of benevolent capitalism rather than the socialist democracy he claimed. Working conditions were excellent by early twentieth-century standards: an eight-hour day was the

norm; workers enjoyed playgrounds, libraries, classes and lecture series; and crafts rotation was encouraged. (Ashbee's wife Janet noted that craftsmen 'in the intervals of book making lend a hand to spread mortar or adjust a cornerstone.') Hubbard, however, paid minimum wages (albeit supplemented with gifts of food and coal) and exercised autocratic control over the community. Although Janet Ashbee described Hubbard as 'mostly Ruskin and Morris with a good strong American flavour', British Arts and Crafts beliefs were considerably watered down in the version Hubbard embraced. He had a genius for promotion, seen in his self-aggrandizing journals *The Philistine* and *The Fra* and in his innovative marketing techniques. Considered to be the inventor of the premium concept, Hubbard also used direct mail and adroit packaging to boost the sales of Roycroft products. Unlike Byrdcliffe or Rose Valley, Roycroft was financially successful, perhaps because Hubbard believed that 'The World of Commerce is just as honorable as the World of Art and a trifle more necessary.'

'The World of Commerce' also ensured greater availability, though at the expense of the craftsman's joy in labour to produce a unique object. Grand Rapids, Michigan, was the centre of the furniture industry at the turn of the century. Manufacturers there responded to the popularity of the Arts and Crafts movement as a style, if not as a philosophy, by producing lines with names such as 'Quaint', 'Handicraft' and 'Lifetime'. Many of the companies produced cheap imitations of Stickley's Craftsman furniture and other mission designs. For these manufacturers, Arts and Crafts was just one more style, to be added to their existing Renaissance, Tudor and Colonial lines. They would use veneers to imitate quarter-sawn oak, tenons would be applied to appear structural and cast brass and copper hardware would be used instead of hammered materials.

Several Grand Rapids companies, however, executed mass-produced goods of high quality and innovative design. David Kendall (1851–1910) of the Phoenix Furniture Company worked in many styles; his Arts and Crafts designs were perhaps the most influential. In 139 1894 Kendall designed what became known as the 'McKinley chair' after President William McKinley purchased one. A simple, comfortable form with Chinese details and caning, Gothic arches and oak slightly stained green, the chair stayed in production for thirty years and was imitated by other companies. Its popularity was noted by the *Michigan Tradesman* in 1910: 'The McKinley Chair . . . had a great sale and is said to be the basis of arts and crafts furniture.'

The Charles P. Limbert Company of Grand Rapids and Holland,

174

139 'McKinley chair', c. 1894–1920s, designed by David Wolcott Kendall for the Phoenix Furniture Company >

Michigan (1902–44), popularized the severe geometry characteristic of the most progressive design. Limbert's tables, plant stands and benches often incorporate the groupings of square cut-outs on Mackintosh's and the Wiener Werkstätte's furniture. A Limbert table is very similar to the one in the entrance hall of Mackintosh's 1903 Hill House; a Limbert chair was directly inspired by one the architect designed for the Willow Tea Rooms in Glasgow.

140

Limbert's use of diagonal crosses, canted sides and square cut-outs reflect the belief of some Arts and Crafts proponents that simplicity required an aesthetic based on pure geometry and the rejection of all historical references. Economic factors played a role in the development of this aesthetic, since straight lines and unornamented forms were far better suited to machine production than curvilinear and carved ones. The almost universal preference for oak is another example of how virtue was made of economic necessity. Championed as an indigenous material, oak was also vastly abundant. It is no coincidence that just as walnut became increasingly scarce in the 1890s, advocating the use of oak became part of Arts and Crafts rhetoric.

Stickley's brothers had their own companies that produced Arts and Crafts furniture: Stickley Brothers (1891–c. 1932) in Grand Rapids and L. and J. G. Stickley (1902–present), located in Fayetteville, New York, near Gustav's own factory. In both design

140 Plant stand, c. 1910, Charles P. Limbert Company

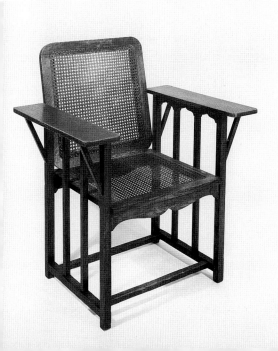

and the marketing technique of selling an Arts and Crafts lifestyle, the L. and J. G. Stickley company was especially derivative of Gustav. Stickley Brothers' line of 'Quaint' furniture was more directly influenced by British designers such as Baillie Scott and Voysey and by Liberty and Co. The furniture was often decorated with the kind of stylized floral inlay produced by designers like E. A. Taylor at Wylie and Lochhead in Glasgow. British connections were strong: Albert Stickley, the company president, had a factory and showrooms marketing Stickley Brothers' work in London from 1897 to 1902 and hired several British designers to work in Grand Rapids. 141 Although Stickley Brothers' designs could be progressive, the quality of construction was inconsistent. Some lines were well made, but oak veneer was often used on the back of furniture and plywood on drawer bottoms, and dowels might hold the piece together instead of through tenons.

Such practices enraged Gustav Stickley, who believed them to be dishonest and in violation of Arts and Crafts construction principles. His company logo was, together with a joiner's compass and Stickley's signature, 'Als ik Kan', which means in Flemish 'as well as I can'. Like most American Arts and Crafts adherents, Stickley had no quarrel with mass production or machinery. His Craftsman Work-

141 Desk, c. 1894–1901, Stickley Brothers Company

142 'In one sense a workroom is always a library', published in *The Craftsman* December 1905

143 'Chimneypiece and fireside seats in a typical Craftsman living room', published in *The Craftsman* April 1907

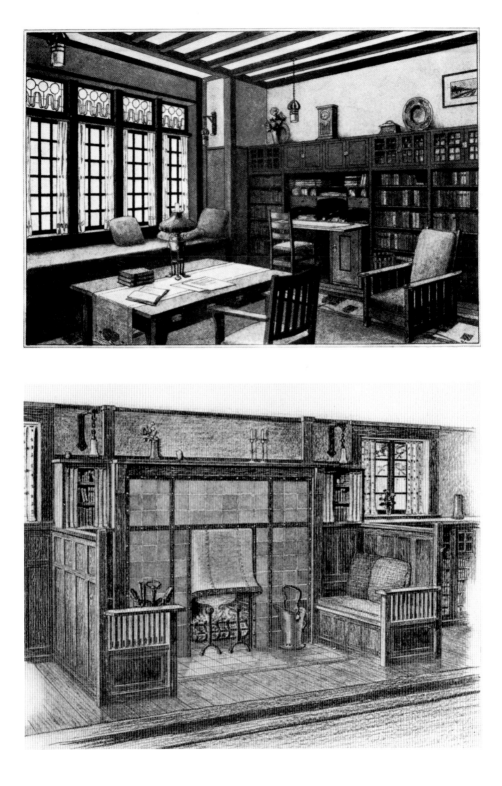

shops employed several hundred workers who used the latest technology. He believed, however, that a quality product and enlightened working conditions could take place within a factory context. In 1900 he introduced his 'New Furniture' and until 1915, when the over-extension of the company and cheaper versions of his furniture offered by other companies forced him to declare bankruptcy, he remained a leading figure in the Arts and Crafts movement. As discussed earlier, Stickley's journal *The Craftsman* provided the forum to promote, as he stated, 'a simple, democratic art' that would provide Americans with 'material surroundings conducive to plain living and high thinking'. He advocated the goal of the simple life not only by his company's production of furnishings to accompany it but also by publishing working plans for his furniture, metalwork and needlework so that people could execute his designs themselves. Given that his business was selling the finished products, his willingness to provide free plans for furnishings and houses attests to the sincerity of his beliefs.

Arts and Crafts objects were available on many different economic levels in America and were produced in a wide variety of settings. What they shared was the context in which they were to be used – an interior where all elements were harmoniously integrated. The concept of total design from landscape to hardware encompassed Arts and Crafts ideals regarding aesthetics, home life and work. The vision was not limited to the designs of individual architects such as Wright or Greene and Greene, nor to wealthy individuals who could afford the treasures of Robineau or Stone. Ordering from catalogues, shopping at department stores and Arts and Crafts society showrooms and making objects with their own hands, middle-class people could furnish their homes in an Arts and Crafts style. Stickley's *The* *Craftsman* showed them how, with illustrations of interiors in every issue. A complete Arts and Crafts vocabulary can be learned from examining its pages: the interiors all had open plans, in which livingrooms were oriented around an inglenook with built-in settles and a fireplace. Windows were leaded, ceilings low-beamed and walls wood-panelled with perhaps a stencilled frieze. Design unity was attained by the choice of oak furniture, ceramics and metalwork with stylized, geometric ornament and textiles of natural linens and cottons in earth-tone colours. Such interiors demonstrate the ultimate aim of the Arts and Crafts movement: that life within the rooms would be transformed by design and thus provide relief from alienation in an industrial society.

142–43

The Arts and Crafts Movement on the Continent

Arts and Crafts assumed many different forms throughout Europe. While the British movement's repugnance towards industrialization was not shared by many Continental countries (those that had never been industrialized had no motivation to reject it), two fundamental aspects of Arts and Crafts philosophy were embraced. The first was the use of design to express a country's identity, which is now known as romantic nationalism or the National Romantic movement. The second was the attempt to reform industrial design by applying certain Arts and Crafts values to machine production.

The two areas of Europe most influenced by the ideals of Ruskin, Morris and other British leaders of the Arts and Crafts movement were Scandinavia and the middle European countries of Germany, Austria and Hungary. All these countries shared a profound awareness of the British Arts and Crafts movement. Their leaders in design reform read Ruskin and Morris and subscribed to *The Studio*. Most of them came to Britain to see first-hand the buildings of Webb, Shaw, Baillie Scott and Voysey and visited international exhibitions where British crafts were prominently displayed. They all revered the crafts ethic – integrity in the use of materials, art applied to everyday objects and the ideal of design unity. Often, however, this ethic did not extend to the hand-made and was as stylistically eclectic as the British movement itself. Scandinavian and middle European countries did not reject Art Nouveau with the firmness of Britain nor did they embrace it with the fervour of France, Belgium and Italy. In northern and eastern Europe Art Nouveau or Jugendstil (Youth style, after Munich's avant-garde journal *Jugend*) was one stylistic option of many to express reform principles. It tended to be more disciplined and restrained there (and thus less alien to a British aesthetic) than in France, Belgium or Italy.

SCANDINAVIA

A search for national self-expression took place throughout Scandinavia in the late nineteenth century. Norway was striving for

independence from Sweden, which was finally achieved in 1905. Finland had also been part of Sweden, but had been ceded to Russia in 1809. Its relative autonomy under the Czar was curtailed at the end of the century, adding another spur to an already burgeoning nationalism.

The loss of these territories had also triggered a period of self-examination in Sweden. As in Great Britain and America, the new nationalism was manifested in a growing interest in each country's own past, first seen in literature through the rediscovery of ancient legends and the study of native languages, and then in the arts through the revival of folk crafts and medieval vernacular architecture. The two merged in the Viking Revival (also called the 'dragon style') in the late nineteenth century. The Revival was particularly strong in Norway, where Norse mythology stirred poets to create new epic tales and where the excavations of ancient Viking ships in the 1860s inspired dragon decoration. Well into the twentieth century, wooden dragon heads peered from the roofs of summer cottages, dragon tails formed the handles of ceramic bowls and dragon feet supported silver jardinières.

As early as 1874, the Handarbetets Vänner (Friends of Textile Art Association) was established in Sweden with the goal of reviving indigenous techniques and styles. The Suomen Käsityön Ystävät (Friends of Finnish Handicrafts) was founded in 1879 to collect and exhibit folk textile designs and to improve modern standards; similar organizations were launched in Denmark and Norway. While the focus was often on textiles (considered a pure peasant art), many organizations, such as the Föreningen Svensk Hemslöjd (Swedish Handicraft Society), founded in 1899, studied and collected all country crafts. Like their British counterparts, the mission of all these organizations was not merely to preserve and copy old work but to have it serve as a basis for the new. Rejecting the separation of fine and decorative art (also as in Britain), training centres such as the School of Arts and Crafts in Helsinki were opened (1871) that would encourage not only craft but also its application to industry. At the turn of the century, the Svenska Slöjdföreningen (Swedish Society for Industrial Design, founded in 1845) became a leader in promoting the alliance between art and industry. Skansen, the world's first open-air museum, was established in 1899 in Stockholm. With its attempt to recapture peasant life by housing ethnographic collections in vernacular buildings, it created a precedent that was imitated throughout Europe and America.

144 Jardinière,
1900, Torolf Prytz
for J. Tostrup, Oslo

Finland provides a model for the romantic nationalism that was repeated, to a somewhat lesser extent, in the other Scandinavian countries. The great Finnish saga *The Kalevala* or *The Land of Heroes* was published for the first time in 1835. These epic poems originated in an ancient oral tradition of story-telling in the eastern province of Karelia, a remote, unspoilt wilderness that nationalists regarded as a repository of all that was essentially Finnish. The poet Eino Leino, the composer Jean Sibelius and the artist Akseli Gallen-Kallela all immortalized both *The Kalevala* and Karelia in their work.

Gallen-Kallela (1865–1931) epitomized romantic nationalism in Finland. Born Axel Gallén, he later changed his Swedish-sounding name for one more authentically Finnish. Although trained in Paris, Gallen-Kallela fervently believed in looking to the peasant traditions of his own culture for inspiration and made many pilgrimages to Karelia. In 1889 he began designs for his home and studio, Kalela, which are considered to be the first architectural drawings relying primarily on motifs from Finnish vernacular architecture. When his house was built in 1894–95, its gable roof, log walls, balconies and high ceilings became the model for the revival of Finnish wooden architecture. His paintings and etchings re-created the poetic world of *The Kalevala*, depicting monumental figures engaged in battle wearing authentic Karelian costume.

An avid reader of Morris, Gallen-Kallela embraced the ideal of the artist–craftsman who designed in all media. For Kalela, he designed and sometimes made furniture, stained glass, textiles, frescoes and

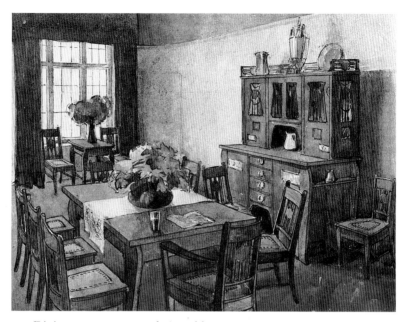

145 Dining-room, *c.* 1903, designed by Louis Sparre at the Iris factory

even door-hinges (he also designed posters, bookbindings and jewelry). In the best Arts and Crafts tradition, he believed in the equality of the fine and decorative arts, and that a national art must be concerned with raising standards in industrial design as well. He 145 worked closely with his friend Louis Sparre (1863–1964), a Swedish artist who established the Iris factory in Porvoo (near Helsinki) in 1897. The factory concentrated on furniture production (Gallen-Kallela contributed some of the designs) but also produced a line of ceramics, designed by the Anglo-Belgian painter and ceramist Alfred William Finch. The furniture's bold, geometric designs were less informed by the vernacular than pure romantic nationalism would dictate, but even Gallen-Kallela was committed to making a modern statement as well.

This interest is reflected in his textile designs for the Friends of Finnish Handicrafts. Gallen-Kallela took a traditional Finnish knotting technique, the *ryijy*, and modernized it by applying strong, 146 geometric patterns. His first *ryijy* was designed for the Paris Exposition Universelle in 1900 where (a more significant first), Finnish art was displayed in its own pavilion.

The Swedish historian Ulf Hård af Segerstad, describing the intense response to Ruskin and Morris in Scandinavia, points out how design was an essential tool in establishing national identity, especially in Finland. He notes, 'the brilliant symbol of this fight for cultural freedom was the country's pavilion at the Paris Exposition . . . [it] was 147 visited by far more people and written about more widely than any other.' If Gallen-Kallela was, as he has often been called, Finland's 'national artist', then Eliel Saarinen (1873–1950) was the country's 'national architect'. With his partners, Herman Gesellius (1874–1916) and Armas Lindgren (1874–1929), Saarinen built the Finnish pavilion. Although many of the design sources were drawn from far afield (Otto Wagner in Vienna for the overall plan, Richardson in Boston for the porches and windows), the form was thought to be national and the ornamentation was based on indigenous animals and plants – bears, squirrels and pine cones. The facade was painted to resemble granite and the portals were made of this stone, a notoriously hard material which had symbolic significance in Finland not only because it was native but also because it was associated with the strength and durability of the Finnish character. The nationalist theme continued inside: the central hall was decorated with Gallen-Kallela's frescoes of stories from *The Kalevala*, the Iris factory contributed a room that

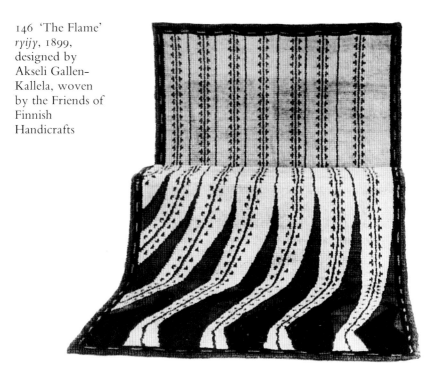

146 'The Flame' *ryijy*, 1899, designed by Akseli Gallen-Kallela, woven by the Friends of Finnish Handicrafts

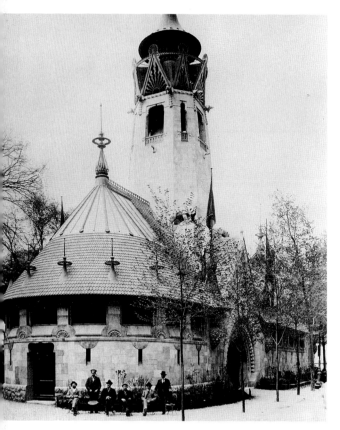

147 Herman Gesellius, Armas Lindgren and Eliel Saarinen, Finnish Pavilion, 1900 Paris Exposition Universelle

148, 149 OPPOSITE Gesellius, Lindgren and Saarinen, Hvitträsk, Lake Vittträsk, 1901–03. Exterior; dining-room. Around 1900 *ryijys*, originally made as floor rugs, came to be used as combination sofa, floor and (sometimes) wall coverings.

contained his furnishing designs and the Friends of Finnish Handi-crafts provided *ryijys*, draperies and upholstery fabrics.

148–49 Hvitträsk, the home and studio that Saarinen, Gesellius and Lindgren built for themselves (1901–03), has become another national symbol. It embodies the Arts and Crafts ideal of design unity, called on the Continent *Gesamtkunstwerk* – a total work of art where the building, its furnishings and its setting form an environmental whole. Dramatically sited on a ridge above Lake Vittträsk, west of Helsinki, the building seems to grow out of its granite foundation. Hvitträsk is actually a series of structures – one free-standing, the others connected with skylighted studios. The house is tied to its site with stone walls, a series of outdoor terraces, pavilions and porches, and the local materials of which it is made – granite, plaster and logs, with pantiles and shingle for the roofs. Saarinen's was the dominant hand on the

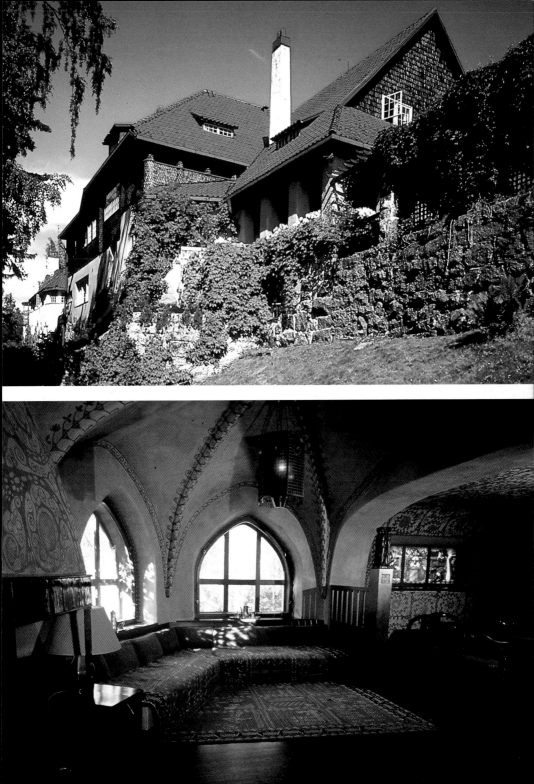

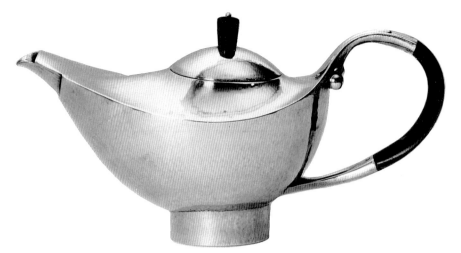

150 Coffee-pot, 1906, designed by Johan Rohde for Georg Jensen
Sølvsmedie, Copenhagen

interior, especially after Lindgren left the partnership in 1905 and Gesellius in 1907. Saarinen designed much of the furnishings for the house – for example, the dining-room table, chairs and *ryijy*, which was woven by his wife Loja.

The Swedish artist Carl Larsson's house, Little Hyttnäs, also fulfils the Arts and Crafts ideal of the home as both a total work of art and a rural retreat embodying the best native traditions. Having inherited a cottage in Sundborn, part of the province of Dalarna, Larsson and his wife Karin transformed it first into a summer home and after 1901, a permanent residence. In 1889 Larsson had instructed young artists to 'go out and preach to all people the fair and joyful message of art . . . carve stoops and staves, make doors and cupboards, storm the china factories . . . Yes, painter, build the houses yourself.' He and his wife were able to achieve this goal. Carl covered the walls with ornamental detail, designed furniture and with Karin planned the many additions to the house. Karin, herself a trained artist, also designed some of the furniture as well as designed, wove and embroidered textiles for the house.

Little Hyttnäs was immortalized in the five books of watercolours Larsson produced between 1899 and 1913. For *Ett hem* (A Home), the first and best-known, he painted scene after scene of domestic felicity with Karin and their eight children. He became the best-loved painter

151 OPPOSITE Portières, 1900, designed by Frida Hansen, woven by Det Norske Billedvæveri, Oslo

152 RIGHT Plate, 1901, designed by Thorvald Bindesbøll for Københavns Lervarefabrik, Copenhagen

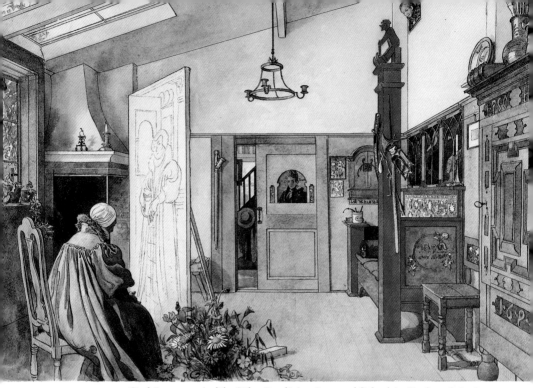

153 Carl Larsson *Ateljén* (The Studio), 1895, published in *Ett hem* (1899)

in Sweden: his work and life were inseparable in the eyes of his
compatriots, who saw his watercolours as proof positive that he had
attained the simple life by perfectly harmonizing work, recreation,
nature and family.

 Deeply influenced by the Arts and Crafts movement, Larsson
modified the British ideal to a Scandinavian environment. The house
itself has chimneys, inglenooks and wide bay windows in the English
style, combined with Swedish log construction, figured walls and
153 tiled stoves. Larsson's studio, depicted in *Ett hem*, contains an English-
style lancet window (painted with medieval motifs) behind a settee he
designed and topped with a caricature of himself. The other furnish-
ings are in seventeenth- and eighteenth-century vernacular styles.

 Popular throughout Scandinavia and translated into German as
well, Larsson's books were enormously influential. His home, now a
museum, is as well-loved today as it was in the early part of the
century. He was part of a circle of reformers in Sweden that included
the writer Ellen Key, who wrote in 1899 a widely distributed booklet

entitled *Skönhet för alla* (Beauty for All), in which she emphasized the importance of an aesthetically pleasing environment and insisted that it be made accessible to all. She called for 'domestic equipment that fulfils the most vital requirements – namely, that everything should answer the purpose it was intended for. A chair should be comfortable to sit on, a table comfortable to work or eat at, a bed good to sleep in.'

This functionalism and the vernacular in design were also the major Arts and Crafts influences in Denmark and Norway, where, as in all the Scandinavian countries, they were matched by successful efforts to improve industrial production. Norway was a leader in textile design, where Gerhard Munthe (1849–1929) pioneered a revival of tapestry weaving. He used traditional techniques with subjects from Norwegian folk tales but rendered them in a modern linear style. Frida Hansen (1855–1931) also combined the ageless with the innovative. She often depicted tales from Norwegian sagas, but invented a method of 'transparent' weaving in which parts of the warp were left exposed, creating a three-dimensional effect in other areas that were filled with conventionalized flowers.

151

154 Writing desk, 1903, designed by Koloman Moser for the Charlottenlund Palace, Stockholm

Denmark was acclaimed for its ceramics and unrivalled in metalwork. To cite only a few examples, the Royal Copenhagen Porcelain Manufactory was an innovator in ceramics painted under the glaze and the use of slip decoration. The multi-disciplinary Danish artist Thorvald Bindesbøll (1846–1908) was renowned for the bold, abstract patterns he created for many ceramic companies. Georg Jensen (1866–1935) is still the best-known Danish craftsman. His silver designs, ranging from simple, geometric hollow-ware to sculptural, highly textured jewelry, have become such classics that many are still in production. Jensen employed equally talented craftsmen such as Johan Rohde (1856–1935). Trained as a painter, Rohde followed an Arts and Crafts path when he became involved with decorative arts by designing objects for his own use at home.

152

150

HUNGARY, AUSTRIA AND GERMANY

Romantic nationalism was a phenomenon throughout Europe at the turn of the century, but the shifting geography of European borders had much to do with the way it was manifested. Although the 1848–49 War of Independence in Hungary had been suppressed by Emperor Franz Josef, the Austro-Hungarian Compromise of 1867 gave the country relative autonomy and divided power between the two capitals of Budapest and Vienna. The desire for even more political independence from Habsburg domination was rife at the turn of the century and was realized in the arts by a revival of indigenous architecture and crafts. Until 1870 Germany had been a loose coalition of states but under the leadership of the Prussian Chancellor Otto von Bismarck it had been forged into an empire. Newly established as a country, Germany was in search of a national identity, which in the arts became a search for a national style. Austria's humiliating loss of Schleswig-Holstein to Prussia in the 'Seven Weeks War' of 1866 and the lessening of the state's power in the Austro-Hungarian Compromise contributed to a need for a unifying force that would hold the splintering empire together. The need was met in part by a Pan-Germanism manifested, for example, in Franz Josef's attempt to establish German as the language of the empire and by a burgeoning interest in *volkisch* culture.

In each country romantic nationalism could either be a conservative or a progressive force, depending on what cause it was called to serve. In Germany and Austria adherents were more likely to be deeply conservative, rejecting Socialism, modernism and urbanism as

decadent and deracinating. Instead, they yearned for a past where people lived on the land and in harmony with nature. This idealization of the folk, known in Germany as *Heimatkunst* (homeland art) and in Austria as *Provinzkunst* (art of the provinces), could have ominous consequences. In its extreme form, advocation of earthy, peasant culture as a true reflection of the national soul could escalate to an intolerance for anyone not considered part of the native culture and thus contribute to the anti-intellectualism and virulent anti-Semitism that reached such nightmarish proportions in the 1930s.

The avant-garde, however, also took up the cult of the primitive. The German Expressionists and members of the Austrian Sezession such as Gustav Klimt and Joseph Maria Olbrich found in folk art an ideal simplicity and saw these images as universal symbols of human creativity.

In Hungary, romantic nationalism was mostly allied to progressive forces calling for an improvement in the lives of the rural poor, social reform and a new modernism forged from a greater understanding of the past. Folk art had special meaning in the Hungarian quest for cultural and political independence. It represented a rejection of Vienna, the centre of the Habsburg empire, and highlighted the country's own unique development. This search for a national identity was crystallized in the Millennium Celebrations of 1896, which marked one thousand years since the Magyars arrived in Hungary. Along with the idealization of a glorious Magyar past came the cult of Attila the Hun, who, according to popular belief, was an ancestor of the Magyars. It was believed that some of the original Huns did not return to Asia after the death of Attila but remained in Transylvania. Thus, just as romantic nationalists in Finland looked to Karelia for inspiration, so too did Hungarians look to Transylvania (now part of Romania). Its crafts and buildings were considered to be Hungary's oldest heritage and cherished accordingly. Home industry associations were formed there and the region became the centre for the study of vernacular traditions.

Transylvania was the major design source for the Gödöllő Artists' Colony, the Arts and Crafts community (founded in 1903) that came closest to fulfilling the ideals generated by Ruskin and Morris. Aladár Körösfői-Kriesch (1863–1920), the leading figure of the Gödöllő group, wrote a book entitled *Ruskinról s az angol prerafaelitákról* (On Ruskin and the English Preraphaelites, 1905) in which he outlined the role the artist should play in reforming society. Körösfői and the other founders of Gödöllő believed strongly that making and using

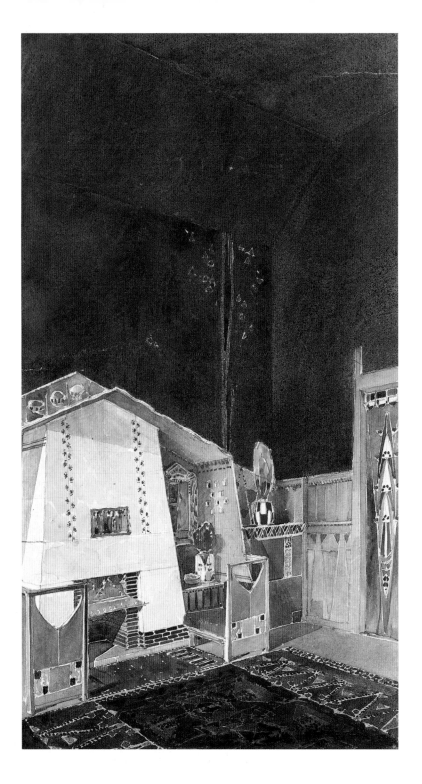

handcrafted folk objects would have a transforming power in people's lives.

Unlike communities and workshops in Austria and Germany, Gödöllő's goals were social as well as artistic. Through the revival of crafts, the artists wanted to help the rural poor and give them a means for staying on the land rather than emigrating to the cities or to America. Their pottery, woodwork and leatherwork and, above all, their weaving studios trained local young people in crafts production.

Körösfői provided some of the designs for tapestry which were executed using only pure vegetable dyes with traditional techniques, most typically the Kalim or Torontál characteristic of southern and eastern Hungary. His *Women of Kalotaszeg* (1908) is not only a revival 156 in terms of its technique but also depicts women wearing traditional embroidered dresses. The peasants of Kalotaszeg were encouraged to promote their local crafts; the stylized floral embroidery that decorated their clothes was displayed at exhibitions and won international acclaim. Körösfői's tapestry depicts peasant women from the very heart of Transylvania in their Sunday dresses: the figures themselves and the background echo the linear, almost abstract, patterns of the embroideries they wear. *Women of Kalotaszeg* was executed with the Scherebeck technique, a Swedish weave taught

155 OPPOSITE Joseph Maria Olbrich, Olbrich house, Darmstadt, 1900–01. Watercolour of living-room

156 *Women of Kalotaszeg* 1908, Aladár Körösfői-Kriesch, Gödöllő

157 Sándor Nagy *Julia, Lovely Girl* 1913, Gödöllő, cartoon for stained glass for the Palace of Culture, Marosvásárhely

at Gödöllő – demonstrating that the community was also part of a larger international revival of all handcraft techniques.

While successfully creating a Hungarian version of the simple life, the Gödöllő Colony was not an isolated community. In the first decade of the twentieth century, Gödöllő's artists, designers and craftsmen were responsible for much of the decoration of Hungarian pavilions at international exhibitions. They collected most of the material and illustrated the influential five-volume study *A magyar nép müvészete* (The Art of the Hungarian People, 1907–22), which recorded vernacular furnishings and architecture throughout the country. With these commissions they played a key role in the development of indigenous Hungarian design and fostered the myths and legends that would help forge a national identity. For the Palace of Culture in Marosvásárhely (now part of Romania) two Gödöllő artists designed the stained glass. Ede Toroczkai–Wigand (1870–1945) created a series of windows based on the legends of Attila the Hun and Sándor Nagy (1868–1950) completed another inspired by Transylva-

157

nian folk ballads. Many of the images were not historically accurate –
Toroczkai-Wigand's depictions of Attila's house were taken from
contemporary Transylvanian peasant furniture and buildings – but
had such emotional resonance that they were accepted as true
representations.

The architect Ödön Lechner (1845–1914), not himself part of the
Arts and Crafts movement, exerted a profound effect on those who
were and epitomizes the way that romantic nationalism could be
firmly linked to modernism. Pioneer of the 'Hungarian' style,
Lechner in 1906 discussed his indebtedness to English precedent,
witnessed on several trips to Britain: 'My attention now turned to
English architecture where the atmosphere of the real countryside still
lingers in country houses and cottages and its simplicity is carefully
preserved.' He then applied this model of the vernacular to his own
country: 'Hungary most certainly has its own national, clearly
distinguishable style . . . It had its origin with the common people . . .
We have to study this Hungarian folk style as if it were a language.'

158

158 Ödön
Lechner, Postal
Savings Bank,
Budapest, 1899–
1901. Front and
side facades

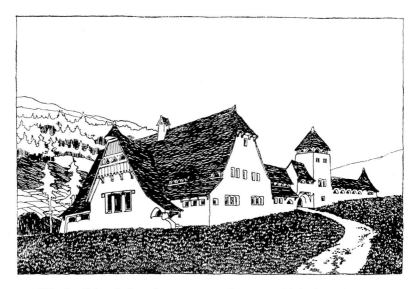

159 Károly Kós, design for a manor house, published in his *Magyar Iparművészet* (1908)

He searched for the original architecture of Hungary and found it in a mixture of oriental, Indian and indigenous folk sources (Asia, home of Attila, and India were considered at the time to be cultural ancestors of
158 Hungary). Buildings such as his Postal Savings Bank in Budapest (1899–1901) demonstrate his devotion to folk motifs but also to making a modern statement: he used the latest building technology and the concrete and steel structure is proudly revealed.

Lechner became the mentor of a group of architects who adopted his Hungarian style. The leader of these *Fiatalok* (Young Architects) was Károly Kós (1883–1977), who took Lechner's nationalism still further. Kós advocated creating a modern style of architecture not only by adopting vernacular ornament but also the structure of medieval Transylvanian buildings. He wrote several books on the architecture of the region and profusely illustrated them with his own
159 designs for modern adaptations of the medieval wooden structures. Following the British model, he designed a garden city within Budapest complete with the Transylvanian spires, wood balconies and turrets he admired so much.

The improvement of industrial production was an aspiration that Hungarian design reformers shared with those in other

Continental countries. The best-known workshop was the Zsolnay Porcelain Works in Pécs, where Vilmos Zsolnay (1828–1900) experimented with the metallic crystal glazes that were praised 160 throughout Europe. Furthermore, he invented a type of pyrogranite roof tile which, being frost-proof, was immediately used by architects such as Lechner for their buildings. As in Britain and Scandinavia, he hired some of the country's leading artists to produce designs for the company. Although at first the Zsolnay factory combined technical innovation with the use of traditional folk motifs such as tulips and deer, Art Nouveau decoration became dominant after the turn of the century.

Design reform movements in many Continental countries follow a course remarkably parallel to Great Britain's or were inspired by it. Modelled on London's South Kensington Museum, the Österreichisches Museum für Kunst und Industrie (Austrian Museum for Art and Industry) was founded in 1864 with the same goal – to link art and industry by having its collections provide companies with design inspiration. Established four years later, the Museum's Kunstgewerbeschule (School of Applied Arts) was also based on South Kensington precedent; at the turn of the century it trained most of the

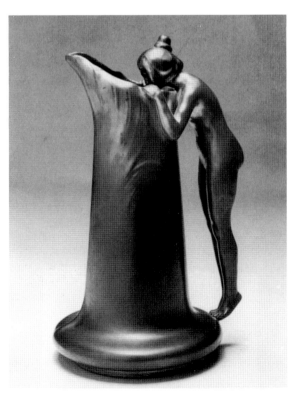

160 Vase, c. 1900,
Zsolnay Porcelain Works

progressive designers who worked at the Wiener Werkstätte (Vienna Workshop). Just as the Arts and Crafts Exhibition Society was founded in London to reject the Royal Academy's narrow definition of what constituted art, the Sezession was organized in Vienna in rebellion against the constraints of the Künstlerhaus (Society of Artists). With its first exhibition in the spring of 1898, the artists and designers of the Sezession displayed the works of their colleagues abroad as well as their own. Their primary motive was to bring Austria to the forefront of modern art; their anti-historicist motto was: 'To the age its art, to art its freedom'. Since their definition of modern art gave the applied arts a status equal to fine arts, furnishings were prominently displayed at the first and at subsequent exhibitions. The eighth exhibition (1900) featured Ashbee and the Guild of Handicraft, Mackintosh and Margaret Macdonald among the leading British designers represented.

The architect Josef Hoffmann (1870–1956), a founding member of the Sezession, wanted to take the goal of unifying all art forms still further. He had been deeply influenced by reading Ruskin and Morris and after visiting Ashbee's Guild of Handicraft in 1902, he returned to Austria determined to establish a similar craft organization. In the work programme of the Wiener Werkstätte, which he founded with his fellow Sezessionist and architect Koloman Moser (1868–1918) in 1903, Hoffmann declared: 'Our aim is to create an island of tranquillity in our own country, which, amid the joyful hum of arts and crafts, would be welcome to anyone who professes faith in Ruskin and Morris.'

Hoffmann, however, was selective in his choice of British Arts and Crafts principles. Ignoring the social reform aspects, he adhered only to those concerning reform of design – functionalism and craftsmanship. These he combined with an even more rigorous (some thought fanatical) application of *Gesamtkunstwerk* than had ever before been attempted. For the Purkersdorf Sanatorium (1904–05), the Werkstätte's first important commission, the firm designed everything save the kitchen utensils. Hoffmann and Moser applied to the building a severe geometry that became a hallmark of Werkstätte design. The exterior is characterized by a flat roof and bare surface planes. The interior was equally austere: the walls were white and almost the only ornament was the constant repetition of circles and squares. The concrete interior supports were left exposed, a startling assertion of functionalism previously confined to buildings such as railway stations. Their rhythm becomes an integral part of the incessant

161

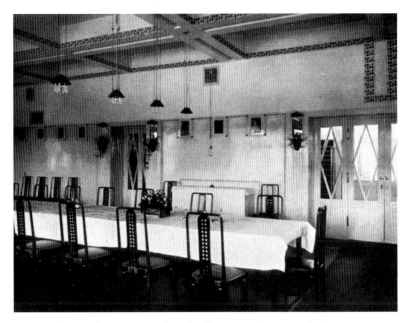

161 Josef Hoffmann, Purkersdorf Sanatorium, Vienna, 1904–05. Dining-room

geometry which extended to every detail, including plant holders, light fixtures and upholstery.

Many historians have given the credit for this reductive geometry to Mackintosh, whose designs were greeted with wild acclaim in Vienna and who was a close friend of Hoffmann. Others deny Mackintosh's influence and insist that his style and the Werkstätte's evolved simultaneously. Regardless of the source of inspiration, the square as *leitmotif* would be repeated in all the company's media. 162

Hoffmann and Moser championed the use of more modest materials such as plate and sheet metal for tableware and semi-precious stones for jewelry in the belief that exceptional design and production were most important. Both, however, were passionate not only about the highest standards of craftsmanship but also, when special commissions permitted, about the finest materials. Their simple, symmetrical motifs were often applied to the most exquisite coloured marble and exotic woods. Their advocacy of luxurious 154
simplicity was not incongruous, as the Werkstätte did not burden itself with the English Arts and Crafts movement's mournful paradox between the fundamental elitism engendered by labour-intensive

199

handwork and a more democratic art. Declaring that since 'it is absolutely no longer possible to convert the masses', Hoffmann believed 'then it is all the more our duty to make happy those few who turn to us.'

Prestigious private commissions, coupled with the sponsorship of Fritz Wärndorfer (heir to an enormous textile company), enabled production to be extensive; in 1914 the Werkstätte changed its trade classification from handcrafts to factory. The firm's own highly skilled craftsmen executed designs in many media such as metalwork and leather; others such as ceramics, glass and textiles were licensed out and produced according to Werkstätte designs. As the firm expanded its activities and more designers and craftsmen were taken on, the architectonic geometry favoured by Hoffmann and Moser was gradually replaced by more complicated pictorial and eclectic styles. (Moser's departure in 1907 had accelerated this shift.) The Neo-classical Biedermeier style that Austrians revived at the turn of the century as representing the last period before industrialization also became an important influence.

Whether unornamented or patterned, privately commissioned or made in multiples, the products of the Werkstätte were expensive. Although never shunning the use of machinery, the Werkstätte would not compromise its high ideals about craftsmanship in order to make good design available to the majority.

This attitude was not shared by most of the workshops established in Germany. The first (1897) and most influential was the Vereinigte Werkstätten für Kunst im Handwerk (United Workshops for Art in Craftswork) in Munich. Although its founders looked to British precedent in raising design standards by applying simplicity, integrity and fitness for purpose to making everyday objects, they rejected Ruskin and Morris's belief in the sanctity of the hand-made. Like the Wiener Werkstätte, the Vereinigte Werkstätten were not interested in social reform. But unlike their Viennese counterpart, the Vereinigte Werkstätten were equally indifferent to individualism in the work process. Since their aim was quality production at an affordable price, they advocated any method that would improve German standards of production and make the country more competitive with foreign goods. The Werkstätten employed the latest technology and, while emphasizing the central role of the designer and promoting close co-operation with those who executed the work, rejected the notion that the designer should also be the maker.

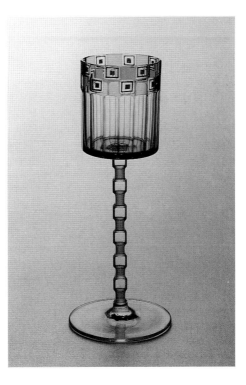

162 Wine goblet, *c.* 1905, designed by Otto Prutscher for the Wiener Werkstätte

Richard Riemerschmid (1868–1957), one of the founders and principal designers of the Werkstätten, exemplifies its approach to production. He was happy to create furnishings for special commissions that would be executed largely by hand, yet his simple, rational designs were well suited to machine production and interchangeable parts, their veneers and lamination replacing solid timber. He also designed for the Werkstätten's main competitor, the Dresdener Werkstätten für Handwerkskunst (Dresden Workshops for Arts and Crafts), which were established a year later in 1898. Its founder, Karl Schmidt, spent a year in England after completing his training as a carpenter but believed that handcraftsmanship was no longer an option in contemporary life if good design was to become more democratic. He strongly supported Riemerschmid's development of a line called Maschinenmöbel (machine-made furniture), first exhibited in 1906. The historian John Heskett attests to the German workshops' commercial success: 'In just over a decade after their foundation, the major workshops had become transformed from small associations of artists intent on asserting their role and their

163

standards in production, to large, highly capitalized businesses with a chain of their own outlets.'

Not all efforts in Germany were directed towards design reform through mass production. Many still believed, as did the Darmstadt publisher Alexander Koch, that standards could only be raised by more individualistic creations 'in which intelligence, taste, unique ideas and the highest possible indigenous spirit are given expression. The machine cannot do that.' His ruler, the Grand Duke Ernst Ludwig of Hesse, shared this view of design reform whereby the 'trickle down' effect of artists providing the superlative examples would raise the general level of taste. An anglophile who had commissioned Baillie Scott and Ashbee to design interiors for his palace in 1897–98, Ernst Ludwig followed British craft ideals by establishing an artists' colony in Darmstadt in 1899. He invited Joseph Maria Olbrich (1867–1908), the architect of the Sezession building in Vienna, to design houses and studios for six of the original seven artists (Peter Behrens designed his own house), which opened to public view in 1901 as an exhibition entitled 'Ein Dokument Deutscher Kunst' (A Document of German Art). The Darmstadt community realized the ideal of *Gesamtkunstwerk* but output of their exquisite products was limited and the community was always dependent on the Duke's patronage and subsidies from the city government.

The German Werkstätten and the Darmstadt colony represent conflicting beliefs about the function of design – the opposition between what has been called 'the utopia of the pulse and that of the piston'. The German workshops promoted 'the utopia of the piston': the belief that design should be objective and rational and that criteria for judgment should be based on efficiency and functionalism. The Darmstadt community exemplifies 'the utopia of the pulse': the belief in individuality as an extension of a unique sensibility. Both views were represented in the Deutsche Werkbund, founded in 1907 to bring together the diverse interests of art, craft, industry and commerce. Riemerschmid and Bruno Paul of the Vereinigte Werkstätten were founding members, as were Hoffmann and Olbrich. The Werkbund included architects, printers, manufacturers, artists and potters; all were united in the pursuit of *Qualität* but differed in determining how quality should be defined.

Hermann Muthesius (1861–1927) became the spokesman for the aesthetics of functionalism. In 1896 he had been posted to the German Embassy in London with the brief of studying the relevance of British architecture and design to the German condition. He stayed seven

years and on his return published the monumental three-volume study *Das englische Haus* and joined the Prussian Board of Trade in charge of design education. Although he had the greatest admiration for the revival of crafts and vernacular architecture in Britain, he declared 'the curse which lies upon their products is one of economic impossibility' and that Germany must turn to forms created by 'the children of the new age', the engineer and the industrialist.

While Muthesius became the Werkbund's most vocal advocate of *Typisierung* or standardization, Henry van de Velde (1863–1957) led the opposition against it. A Belgian architect and designer, van de Velde had come to Germany in 1899 to run one of the more crafts-oriented workshops in Berlin. In 1902 he was invited to Saxony by the Grand Duke of Saxe-Weimar to help improve craft conditions there and to found a school for the applied arts (this later became the basis for the Bauhaus). Van de Velde abhorred Muthesius's attack on individuality and considered it both a threat to creativity and a denial

164

163 Chair, 1904–06, designed by Richard Riemerschmid for the Dresdener Werkstätten für Handwerkskunst. In the *Maschinenmöbel* line, assembly remained by hand but all the components were machine-made.

164 Side chair, *c.* 1895–98, designed by Henry van de Velde for Bloemenwerf, Uccle, Belgium. Made for the dining-room of his own house

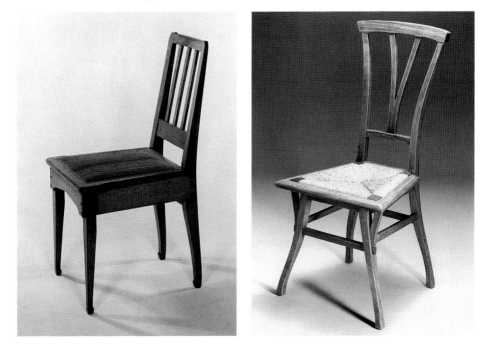

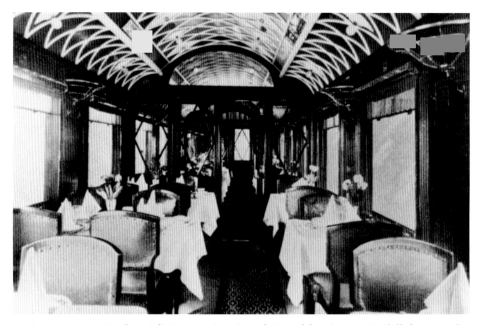

165 Railway dining-car interior, designed by August Endell for Van der Zypen & Charlier, exhibited at the 1914 Cologne Werkbund Exhibition

of the artist's autonomy. He did not believe that art and industry could ever be united, since their goals were mutually exclusive.

Most members of the Werkbund were not as radical in either direction and despite the continuing controversy within opposing factions, the Werkbund succeeded in fostering co-operation between art and industry. Its exhibitions and publications did much to promote German design, culminating in the 1914 Werkbund exhibition in Cologne, where its members' success in gaining commissions for designing everything from coffee services to railway cars was evident.

165 Peter Behrens's career represents one resolution of the dilemma. First trained as a painter, Behrens (1868–1940) had been a member of the Vereinigte Werkstätten as well as the Darmstadt community. After spending several years designing for crafts production, in 1907 he was appointed artistic adviser to the giant electronics firm Allgemeine Elektricitäts-Gesellschaft (AEG) in Berlin. Behrens combined his background in both Arts and Crafts and industrial design to produce an innovation for the twentieth century – a

company image as *Gesamtkunstwerk*. For AEG he designed electrical appliances from kettles to dentist drills; factories, workers' houses and furnishings for them; posters and new typefaces. He succeeded in bringing individuality to mass-produced goods but at the cost of workers' creative fulfilment.

166

These opposing convictions concerning the role of the designer and how objects should be made were played out in workshops and design schools throughout Europe but most notably at the Bauhaus (founded in 1919). Although the Bauhaus has come to embody the modern movement and the functionalist design ethic, its leader, Walter Gropius, was at least initially opposed to Muthesius. Gropius emphasized the importance of teaching the crafts and believed they should be the conscience of industry. The conflict between standardization and individuality, the question of whether or not a unique, hand-crafted object is morally superior to a mass-produced one and the problem of defining what kind of design most benefits society are issues that are still with us today, yet to be resolved.

166 Poster, 1907,
designed by
Peter Behrens for AEG

Postscript

The First World War is considered to mark the demise of the Arts and Crafts. As early as 1907 the British Socialist A. R. Orage declared that 'virtue had gone out of the movement. The disappearance of sociological ideas has in fact left the craft ideas of the movement pale and anaemic.' At their most idealistic, Arts and Crafts advocates vowed to change society through the transformation of the work process. Even their most radical leaders, however, were unwilling to divorce themselves completely from the prevailing culture in order to create a truly oppositional one. Although Orage sounded the death-knell prematurely, the initial crusading spirit had certainly lost its momentum by 1910.

Arts and Crafts proponents were never able to resolve the dichotomy between the quest for a democratic art and one which upheld the highest standards of craftsmanship. Attempts to find solutions differed in Britain and America. In Britain, the Arts and Crafts movement was a phenomenon within high culture; in the nineteenth century, high thought and class restrictions went together. When Ambrose Heal proposed in 1913 that the Arts and Crafts Exhibition Society establish a permanent shop, he was rebuffed on the grounds that such commercialism was unacceptable. The British upper-class aversion to trade coupled with the inherent expense of hand labour using the finest materials meant that Arts and Crafts products were restricted to an elite. Gentlemen like William Morris had to fight to make crafts respectable. Because of British reluctance to combine art and commerce, the movement was only directed at the broad masses of people through philanthropy or through amateur handicrafts.

Americans, with fewer class restrictions, did not have this battle. They were less ambivalent than the British about marketing the Arts and Crafts movement and anti-industrialism was far less rooted in the country's culture. Consequently, the Arts and Crafts reached a broad section of the populace in America but, with no real class issues, had little of Britain's ideological component. It is no coincidence that the

best-known leaders of the American movement were businessmen. As the American historian Eileen Boris observed, Stickley and Hubbard 'democratized even as they diminished the legacy of Ruskin and Morris'. Although Arts and Crafts ideals may have been diluted, the products could reach a greater audience.

The Arts and Crafts movement was always both conservative and progressive but by the second decade of the twentieth century this uneasy balance shifted, with forces becoming polarized in different directions. The Georgian and Colonial Revivals gained ascendancy among conservatives, while more progressive adherents pressed for a styleless functionalism that later became associated with international modernism.

In terms of production, many studios and workshops survived by rejecting the notion of industrial art and accepting that the price for 'pure' craftsmanship would be restricted output and a limited clientele. Others embraced the Swedish motto 'more beautiful things for everyday use', and accepted the sacrifice of handwork in order that more people could enjoy good design. Like the German Werkstätten, their products celebrated the simplicity and rationality that could be obtained by the machine. Other companies jettisoned any philosophical approach and simply catered to the taste for a hand-made vernacular look. (The endless production of housing stock with applied half-timbering is a good example.)

An acknowledgment that the Arts and Crafts movement failed to attain its ambitious but contradictory goals should not preclude appreciation of its many real achievements. The movement left important legacies in design education, city planning, the development of industrial art and the continuation of craft studios. Although it did not succeed in its aim of cultural regeneration, it provided a framework for recognizing the contribution of the individual in an increasingly mass society.

The movement is no longer valued only in the context of a continuum which reached its zenith in modernism but can be evaluated on its own merits. While crediting its progressive aspects, the conservative nature of much Arts and Crafts production can also be recognized as an integral part of it – which has significantly affected how we judge good design today.

Select Bibliography

GENERAL

Anderson, Timothy J., Eudorah M. Moore and Robert W. Winter. *California Design 1910*. Pasadena: California Design Publications, 1974.

Anscombe, Isabelle, and Charlotte Gere. *Arts and Crafts in Britain and America*. London: Academy Editions, 1978.

Arts and Crafts Quarterly. Trenton, NJ, 1986.

Attfield, Judy, and Pat Kirkham. *A View from the Interior. Feminism, Women and Design*. London: Women's Press, 1989.

Benton, Tim and Charlotte, with Dennis Sharp. *Architecture and Design 1880–1939: An International Anthology*. New York: Whitney Library of Design, 1975.

Boris, Eileen. *Art and Labor: Ruskin, Morris and the Craftsman Ideal in America*. Philadelphia: Temple University Press, 1986.

Bowman, Leslie. *American Arts and Crafts: Virtue in Design* (exh. cat.). Los Angeles County Museum, 1990.

Brandt, Beverly. 'Mutually Helpful Relations: Architects, Craftsmen and the Society of Arts and Crafts, Boston'. Ph. D. Dissertation, Boston University, 1985.

Brandt, Frederick R. *Late 19th and Early 20th Century Decorative Arts: The Sydney and Frances Lewis Collection in the Virginia Museum of Fine Arts*. Richmond: Virginia Museum of Fine Arts, 1985.

Burke, Doreen Bolger, et al. *In Pursuit of Beauty: Americans and the Aesthetic Movement*. New York: Metropolitan Museum of Art, 1986.

Callen, Anthea. *Angel in the Studio: Women in the Arts and Crafts Movement, 1870–1914*. London: Astragal, 1979.

Calloway, Stephen. *Twentieth-Century Decoration: The Domestic Interior from 1900 to the Present Day*. London: Weidenfeld and Nicolson, 1988.

Clark, Robert Judson, ed. *The Arts and Crafts Movement in America, 1876–1916*. Princeton University Press, 1972.

Cooper, Jeremy. *Victorian and Edwardian Furniture and Interiors*. London: Thames and Hudson, 1987.

Coulson, Anthony J. *A Bibliography of Design in Britain 1851–1970*. London: Design Council, 1979.

Craft History. Bath: Combined Arts, 1988– .

Crawford, Alan, ed. *By Hammer and By Hand: The Arts and Crafts Movement in Birmingham*. Birmingham Museum and Art Gallery, 1984.

Davey, Peter. *Arts and Crafts Architecture; The Search for Earthly Paradise*. London: Architectural Press, 1980.

Denker, Bert, and Cheryl Robertson, eds. *The Substance of Style: New Perspectives on the American Arts and Crafts Movement*. Winterthur Museum with University of Chicago Press, 1991.

Encyclopaedia of Arts and Crafts. The International Arts Movement 1850–1920. Consultant Wendy Kaplan. London: Headline, 1989.

Floud, Peter, et al. *Catalogue of an Exhibition of Victorian and Edwardian Decorative Art*. London: Victoria and Albert Museum, 1952.

Gere, Charlotte. *Nineteenth-Century Decoration. The Art of the Interior*. London: Weidenfeld and Nicolson, 1989.

Gilbert, James B. *Work Without Salvation: America's Intellectuals and Industrial Alienation, 1880–1910*. Baltimore: Johns Hopkins University Press, 1977.

Journal of Design History. Oxford University Press, 1988– .

The Journal of the Decorative Arts Society. Brighton: The Decorative Arts Society, 1977– .

Kahler, Bruce Robert. 'Art and Life: The Arts and Crafts Movement in Chicago, 1897–1910.' Ph. D. Dissertation, Purdue University, IN, 1986.

Kaplan, Wendy. '*The Art that is Life.' The Arts and Crafts Movement in America, 1875–1920* (exh. cat.). Boston: Museum of Fine Arts and Little, Brown, 1987.

Lambourne, Lionel, intro. *The Arts and Crafts Movement: Artists, Craftsmen & Designers 1890–1930* (exh. cat.). London: Fine Art Society, 1973.

——. *Utopian Craftsmen: The Arts and Crafts Movement from the Cotswolds to Chicago*. London: Astragal, 1980.

Lancaster, Clay. *The Japanese Influence in America*. New York: Walton H. Rawls, 1963.

Lears, Jackson. *No Place of Grace: Antimodernism and the Transformation of American Culture, 1880–1920*. New York: Panthcon, 1981.

Ludwig, Coy L. *The Arts and Crafts Movement in New York State, 1890s–1920s*. Gallery Association of New York State, 1983.

Naylor, Gillian. *The Arts and Crafts Movement. A study of its sources, ideals and influence on design theory*. London: Trefoil, 1990.

Nuttgens, Patrick, ed. *Mackintosh and his Contemporaries in Europe and America*. London: John Murray, 1987.

Prairie School Review. Park Forest, IL, 1964–77.

Rodgers, Daniel. *The Work Ethic in Industrial America, 1850–1920*. University of Chicago Press, 1978.

Smith, Mary Ann. *Gustav Stickley: The Craftsman*. Syracuse University Press, 1983.

Stein, Roger B. *John Ruskin and Aesthetic Thought in America, 1840–1900*. Cambridge, MA: Harvard University Press, 1967.

Tiller: a bimonthly devoted to the Arts and Crafts Movement. Bryn Mawr, PA: The Artsman, 1982–86, 1990.

Triggs, Oscar Lovell. *Chapters in the History of the Arts and Crafts Movement*. Chicago: Bohemia Guild of the Industrial Arts League, 1902.

SELECTED PERIOD JOURNALS

Aglaia: Journal of the Healthy and Artistic Dress Union. London, 1890–96. *The Art Craftsman*. London, 1908–c. 1911. *The Art Decorator*. London, 1890–1914; continued as *The Artworkers' Studio*, 1914–29. *The Art Workers' Quarterly*. London, 1902–06. *The Artsman*. Philadelphia, 1903–07. *Brush and Pencil*. Chicago, 1897–1907. *Bungalow Magazine*. Los Angeles, 1909–10. *The City*. Letchworth, 1908–11. *Cottage Gardening*. London, 1892–99; incorporated with *The Gardener*. The

Country House. London, 1896. *Country Life Illustrated (Country Life)*. London, 1897– . *The Chautauquan*. Chautauqua, NY, 1880–1914. *The Craftsman*. Eastwood, NY, 1901–16. *The Craftsman*. London, 1903. *Dekorative Kunst*. Munich, 1897–1929. *Design and Industries Association Journal*. London, 1927–32; continued as *Design for Today*, 1927–33, and *Design in Industry* 1933–36. *Deutsche Kunst und Dekoration*. Darmstadt, 1897/98–1934. *Dryad Quarterly*. Leicester, 1931–45. *The Evergreen: A Northern Seasonal*. Edinburgh, 1895–97. *The Furnisher and Decorator*. London, 1889–92. *Handicraft*. Society of Arts and Crafts, Boston, 1902–05; National League of Handicraft Societies, 1911–12. *The Hobby Horse*. London, 1884, 1886–92. *House Beautiful*. Chicago; Boston; New York, 1896– . *Igdrasil: Journal of the Ruskin Reading Guild*. London, 1890–92. *Inland Architect and News Record*. Chicago, 1883–1908. *International Studio*. New York, 1897–1931. *Keramic Studio*. Syracuse, NY, 1899–1930. *Knight Errant*. Boston, 1892–93. *Die Kunst*. Berlin, 1902–07. *Kunst und Kunsthandwerk*. Vienna, 1898–1921. *The Ladies' Home Journal*. Philadelphia, 1883– . *Land of Sunshine*. Los Angeles, 1894–1901; continued as *Out West*, 1901–23. *Moderne Bauformen*. Stuttgart, 1902–44. *The Philistine*. East Aurora, NY, 1895–1915. *Rural Industries*. London, 1925–37. *The Studio*. London, 1893– . *Western Architect*. Minneapolis and Chicago, 1901–31. *The Woman Worker*. London, 1907–10.

Chapter One

Beauty's Awakening. The Centenary Exhibition of the Art Workers' Guild (exh. cat.). Brighton: Royal Pavilion, Art Gallery and Museum, 1984.

Benjamin, Frederick A. *The Ruskin Linen Industry of Keswick*. Beckermet, Cumbria: Michael Moon, 1974.

Carruthers, Annette, and Frank Johnston. *The Guild of Handicraft 1888–1988* (exh. cat.). Cheltenham Art Gallery and Museum, 1988.

Crawford, Alan. *C. R. Ashbee: Architect, Designer and Romantic Socialist*. New Haven and London: Yale University Press, 1985.

——, Mary Greensted and Fiona MacCarthy. *C. R. Ashbee & the Guild of Handicraft* (exh. cat.). Cheltenham Art Gallery and Museum, 1981.

Darby, Michael. 'Owen Jones and the Eastern Ideal'. Ph. D. Dissertation, University of Reading, 1974.

Durant, Stuart, intro. *Christopher Dresser 1834–1904*. London: Fine Art Society, Richard Dennis and John Jesse, 1973.

Christopher Dresser 1834–1904 (exh. cat.). London: Camden Arts Centre, 1979.

Fairclough, Oliver, and Emmeline Leary. *Textiles by William Morris and Morris & Co. 1861–1940*. London: Thames and Hudson, 1981.

Faulkner, Peter. *Against the Age. An Introduction to William Morris*. London: Allen and Unwin, 1980.

Halén, Widar. *Christopher Dresser*. London: Phaidon Christie's, 1990.

Henderson, Philip. *William Morris: His Life, Work and Friends*. London: Thames and Hudson, 1967.

MacCarthy, Fiona. *British Design since 1880. A Visual History*. London: Lund Humphries, 1982.

—. *The Simple Life: C. R. Ashbee in the Cotswolds*. London: Lund Humphries, 1981.

Massé, H. J. L. J. *The Art-Workers' Guild 1884-1934*. London: Art-Workers' Guild, 1935.

Naylor, Gillian, ed. *William Morris by Himself. Designs and Writings*. London: Macdonald Orbis, 1988.

Needham, Paul, Joseph Dunlap and John Dreyfus. *William Morris and the Art of the Book*. London and New York: Oxford University Press with Pierpont Morgan Library, 1976.

Parry, Linda. *William Morris Textiles*. London: Weidenfeld and Nicolson, 1983.

Robson, Susanna. *An Introduction to the Essex House Press*. London: Victoria and Albert Museum, 1986.

Stansky, Peter. *William Morris*. Oxford University Press, 1983.

—. *Redesigning the World. William Morris, the 1880s and the Arts and Crafts*. Princeton University Press, 1985.

Stoppani, Leonard, et al. *William Morris and Kelmscott*. London: Design Council, 1981.

Thompson, Paul. *The Work of William Morris*. London: Heinemann, 1967.

Watkinson, Raymond. *William Morris as Designer*. London: Studio Vista, 1967.

Chapter Two

Aitken, Peter, Cameron Cunningham and Bob McCutcheon. *The Homesteads. Stirling's Garden Suburb*. Stirling: the authors, 1984.

Amery, Colin, et al. *Lutyens: The Work of the English Architect Sir Edwin Lutyens (1869-1944)* (exh. cat.). London: Arts Council of Great Britain, 1981.

Aslet, Clive. *The Last Country Houses*. New Haven and London: Yale University Press, 1982.

Backemeyer, Sylvia, and Theresa Gronberg, eds. *W. R. Lethaby 1857-1931. Architecture, Design and Education* (exh. cat.). London: Lund Humphries, 1984.

Beevers, Robert. *The Garden City Utopia. A Critical Biography of Ebenezer Howard*. London: Macmillan, 1988.

Brandon-Jones, John, et al. *C. F. A. Voysey: architect and designer 1857-1941* (exh. cat.). London: Lund Humphries, 1978.

Brown, Jane. *Gardens of a Golden Afternoon. The Story of a Partnership: Edwin Lutyens and Gertrude Jekyll*. London: Allen Lane, 1982.

Brown, Roderick, ed. *The Architectural Outsiders*. London: Waterstone, 1985.

Coatts, Margot, and Elizabeth Lewis, eds. *Heywood Sumner Artist and Archaeologist 1853-1940* (exh. cat.). Winchester City Museum, 1986.

Fawcett, Jane, ed. *Seven Victorian Architects*. London: Thames and Hudson, 1976.

Fellow, Richard A. *Sir Reginald Blomfield: An Edwardian Architect*. London: Zwemmer, 1985.

Gradidge, Roderick. *Dream Houses: The Edwardian Ideal*. London: Constable, 1980.

—. *Edwin Lutyens. Architect Laureate*. London: Allen and Unwin, 1981.

Hawkes, Dean, ed. *Modern Country Homes in England. The Arts and Crafts Architecture of Barry Parker 1867-1944*. Cambridge University Press, 1986.

Howarth, Thomas. *Charles Rennie Mackintosh and the Modern Movement*. London: Routledge and Kegan Paul, 1977.

Hubbard, Edward, and Michael Shippobottom. *A guide to Port Sunlight Village including two tours of the village*. Liverpool University Press, 1988.

Jackson, Frank. *Sir Raymond Unwin: Architect, Planner and Visionary*. London: Zwemmer, 1985.

Kornwolf, James D. *M. H. Baillie Scott and the Arts and Crafts Movement*. Baltimore and London: Johns Hopkins University Press, 1972.

Lethaby, William Richard. *Philip Webb and his Works*. London: Oxford University Press, 1935, reprinted with intro. by Godfrey Rubens, Raven Oak Press, 1979.

Macleod, Robert. *Charles Rennie Mackintosh*. Feltham: Country Life, 1968.

—. *Style and Society: architectural ideology in Britain 1835-1914*. London: RIBA, 1971.

Muthesius, Hermann. *Das Englische Haus* (The English House). Berlin, 1904-05.

Richardson, Margaret. *Architects of the Arts and Crafts Movement*. London: Trefoil, 1983.

Rubens, Godfrey. *William Richard Lethaby: His Life and Work 1857-1931*. London: Architectural Press, 1986.

Saint, Andrew. *Richard Norman Shaw*. New Haven and London: Yale University Press, 1976.

Savage, Peter. *Lorimer and the Edinburgh Craft Designers*. Edinburgh: Paul Harris, 1980.

Service, Alastair. *Edwardian Architecture: A Handbook of Building Design in Britain 1890-1914*. London: Thames and Hudson, 1977.

—, ed. *Edwardian Architecture and its Origins*. London: Architectural Press, 1975.

Simpson, Duncan. *C. F. A. Voysey. An architect of individuality*. London: Lund Humphries, 1979.

Walker, Lynne B. 'E. S. Prior 1852-1932'. Ph. D. Dissertation, University of London, 1978.

Chapter Three

Anscombe, Isabelle. *A Woman's Touch. Women in Design from 1860 to the Present Day*. London: Virago, 1984.

Baynes, Ken and Kate. *Gordon Russell*. London: Design Council, 1981.

Bennett, Mary, intro. *The Art Sheds 1894-1905. An Exhibition to celebrate the Centenary of the University of Liverpool 1981* (exh. cat.). Liverpool: Mersey County Council, 1981.

Billcliffe, Roger. *Charles Rennie Mackintosh. The Complete Furniture, Furniture Drawings and Interiors*. Guildford: Lutterworth Press, 1979.

—. *Mackintosh Furniture*. Cambridge: Lutterworth Press, 1984.

—. *Mackintosh Textile Designs*. London: John Murray, 1982.

Blench, Brian, et al. *The Glasgow Style 1890-1920* (exh. cat.). Glasgow Museums and Art Galleries, 1984.

Bowe, Nicola Gordon. *The Dublin Arts and Crafts Movement 1885-1930* (exh. cat.). Edinburgh College of Art, 1985.

—. *The Life and Work of Harry Clarke*. Dublin: Irish Academic Press, 1990.

Breeze, George. *Edith Payne 1875-1959* (exh. cat.). Birmingham Museums and Art Gallery, 1979.

—. *Joseph Southall 1861-1944 – Artist-Craftsman* (exh. cat.). Birmingham Museums and Art Gallery, 1980.

—. intro. *Arthur and Georgie Gaskin* (exh. cat.). Birmingham Museums and Art Gallery, 1982.

Buckley, Cheryl. *Potters and Paintresses. Women Designers in the Pottery Industry 1870-1955*. London: Women's Press, 1990.

Burkhauser, Jude, ed. '*Glasgow Girls': Women in Art and Design in Glasgow 1890-1920*. Edinburgh: Canongate, 1990.

Carruthers, Annette. *Ernest Gimson and the Cotswold Group of Craftsmen* (exh. cat.). Leicester Museum and Art Gallery, 1978.

Catleugh, Jon, et al. *William De Morgan Tiles*. London: Trefoil, 1983.

Coatts, Margot. *A Weaver's Life: Ethel Mairet 1872-1952*. London: Crafts Council, 1983.

—. *A Weaver's Life: Ethel Mairet 1872-1952. A Selection of Source Material*. London: Crafts Council, 1984.

Comino, Mary. *Gimson and the Barnsleys: 'Wonderful furniture of a commonplace kind'*. London: Evans, 1980.

Cormack, Peter. *Christopher Whall 1849-1924: Arts and Crafts Stained Glass Worker* (exh. cat.). London: Borough of Waltham Forest, 1979.

—. *Women Stained Glass Artists of the Arts and Crafts Movement* (exh. cat.). London: Borough of Waltham Forest, 1985.

Cumming, Elizabeth S. *Arts and Crafts in Edinburgh 1880-1930* (exh. cat.). Edinburgh College of Art, 1985.

—. 'Phoebe Anna Traquair and her contribution to Arts and Crafts in Edinburgh'. Ph. D. Dissertation, University of Edinburgh, 1987.

Franklin, Colin. *The Private Presses*. London: Studio Vista, 1969.

Gaunt, William, and M. D. E. Clayton-Stamm. *William De Morgan*. London: Studio Vista, 1971.

Gere, Charlotte, intro. *The Earthly Paradise: F. Cayley Robinson, F. L. Griggs and the painter craftsmen of the Birmingham Group* (exh. cat.). London: Fine Art Society, 1969.

—, intro. *Jewellery and Jewellery Design 1850-1930 & John Paul Cooper 1869-1933* (exh. cat.). London: Fine Art Society, 1975.

—, and Geoffrey Munn. *Artists' Jewellery of the Pre-Raphaelite and Arts and Crafts Movements*. Woodbridge, Suffolk: Antique Collectors Club, 1989.

Gilmour, Pat. *Artists at Curwen*. London: Tate Gallery, 1977.

Good Citizens' Furniture: The Works of Ernest and Sidney Barnsley (exh. cat.). Cheltenham Art Gallery and Museum, 1976.

Goodden, Susanna. *At the Sign of the Fourposter: A History of Heal's*. London: Heal & Son, 1984.

Greenwood, Martin. *The Designs of William De Morgan*. London: Richard Dennis, 1989.

Haslam, Malcolm. *English Art Pottery 1865-1915*. London: Antique Collectors' Club, 1975.

Hinks, Peter. *Twentieth Century British Jewellery 1900-1980*. London: Faber and Faber, 1983.

Hogben, Carol. *The Art of Bernard Leach*. London: Faber and Faber, 1978.

Johnston, Priscilla. *Edward Johnston*. London: Faber and Faber, 1959.

Kirkham, Pat. *Harry Peach: Dryad and the DIA*. London: Design Council, 1986.

Levy, Mervyn. *Liberty Style. The Classic Years: 1898-1910*. London: Weidenfeld and Nicolson, 1986.

Liberty's 1875–1975. An exhibition to mark the firm's centenary (exh. cat.). London: Victoria and Albert Museum, 1975.

MacCarthy, Fiona. *Eric Gill*. London: Faber and Faber, 1989.

Macfarlane, Fiona C., and Elizabeth F. Arthur. *Glasgow School of Art Embroidery 1894–1920* (exh. cat.). Glasgow Museums and Art Galleries, 1980.

Morris, Barbara. *Liberty Design 1874–1914*. London: Pyramid, 1989.

Morton, Jocelyn. *Three Generations in a Family Textile Firm*. London: Routledge and Kegan Paul, 1971.

Parry, Linda. *Textiles of the Arts and Crafts Movement*. London: Thames and Hudson, 1988.

Katharine Pleydell-Bouverie: A Potter's Life 1895–1985. London: Crafts Council, 1986.

Plummer, Raymond. *Nothing need be ugly. The first 70 years of the Design & Industries Association*. London: Design & Industries Association, 1985.

Robertson, Pamela. *Margaret Macdonald Mackintosh* (exh. cat.). Glasgow: Hunterian Art Gallery, 1984.

Ruston, James H. *Ruskin Pottery* (exh. cat.). West Bromwich: Borough of Sandwell, 1975.

Tilbrook, Adrian. *The Designs of Archibald Knox for Liberty & Co*. London: Ornament Press, 1976.

Turner, Mark, intro. *A London Design Studio 1880–1963: The Silver Studio Collection*. London: Lund Humphries, 1980.

—, and Lesley Hoskins. *Silver Studio of Design. A Design and Source Book for Home Decoration*. Exeter: Webb and Bower, 1988.

Chapter Four

Brooks, H. Allen. *Frank Lloyd Wright and the Prairie School*. New York: Braziller, 1984.

—. *The Prairie School: Frank Lloyd Wright and his Midwest Contemporaries*. Toronto and Buffalo: University of Toronto Press, 1972.

—, ed. *Prairie School Architecture: Studies from 'The Western Architect'*. University of Toronto Press, 1975.

Cardwell, Kenneth H. *Bernard Maybeck: Artisan, Architect, Artist*. Santa Barbara: Peregrine Smith, 1977.

France, Jean R., et al. *A Rediscovery – Harvey Ellis: Artist, Architect*. Rochester, NY: Memorial Art Gallery, 1972.

Gebhard, David. 'William Gray Purcell and George Grant Elmslie and the Early Progressive Movement in American Architecture from 1900 to 1920'. Ph.D. Dissertation, University of Minnesota, 1957.

Gill, Irving J. 'The Home of the Future: The New Architecture of the West; Small Homes for a Great Country'. *The Craftsman* 30 (May 1916).

Hanks, David A. *The Decorative Designs of Frank Lloyd Wright*. New York: Dutton, 1979.

—. *Frank Lloyd Wright: Preserving an Architectural Heritage, Decorative Designs from The Domino's Pizza Collection*. New York: Dutton, 1989.

Hitchcock, Henry Russell. *In the Nature of Materials: 1887–1941, the Buildings of Frank Lloyd Wright*. New York: Duell, Sloan and Pearce, 1942.

Jordy, William H. *Progressive and Academic Ideals at the Turn of the Century*, vol. III,

American Buildings and their Architects (5 vols). Garden City, NY: Doubleday, 1972.

Kaiser, Harvey H. *Great Camps of the Adirondacks*. Boston: David R. Godine, 1982.

Kamerling, Bruce. 'Irving Gill: The Artist as Architect', *Journal of San Diego History* 25 (Spring 1979).

Keeler, Charles. *The Simple Home*. San Francisco: Paul Elder, 1904.

Lancaster, Clay. *The American Bungalow*. New York: Abbeville, 1965.

Makinson, Randell L. *Greene and Greene: Architecture as a Fine Art*. Layton, UT: Peregrine Smith, 1977.

—. *Greene and Greene: Furniture and Related Designs*. Santa Barbara and Salt Lake City: Peregrine Smith, 1979.

McCoy, Esther. *Five California Architects*. New York: Reinhold, 1960.

Moneta, Daniel P., ed. *Charles F. Lummis – The Centennial Exhibition*. Los Angeles: Southwest Museum, 1985.

Oliver, Richard. *Bertram Grosvenor Goodhue*. New York and Cambridge, MA: Architectural History Foundation and MIT Press, 1983.

Read, Cleota. *Henry Chapman Mercer and the Moravian Pottery and Tile Works*. Philadelphia: University of Pennsylvania Press, 1987.

Rhoads, Williams B. *The Colonial Revival*. New York: Garland, 1977.

Robertson, Cheryl. *The Domestic Scene (1897–1927): George M. Niedecken, Interior Architect* (exh. cat.). Milwaukee Art Museum, 1982.

Rosenthal, Bernard, and Paul E. Szarmach. *Medievalism in American Culture*. State University of New York at Binghamton, 1989.

Scully, Vincent, Jr. *Frank Lloyd Wright*. New York: Braziller, 1960.

—. *The Shingle Style*. New Haven: Yale University Press, 1971.

Sies, Mary Corbin. 'American Country House Architecture in Context: The Suburban Ideal of Living in the East and Midwest, 1877–1917'. Ph.D. Dissertation, University of Michigan, 1987.

Spencer, Brian, ed. *The Prairie School Tradition*. New York: Watson-Guptill, 1979.

Stevens, John Calvin, and Albert Winslow Cobb. *American Domestic Architecture*. Watkins Glen, NY: American Life Foundation and Study Institute, 1978; reprint of *Examples of American Domestic Architecture*, 1889, with intro. by Earle G. Shettlework, Jr. and William David Barry.

Stickley, Gustav, ed. *Craftsman Homes*. New York: The Craftsman Publishing Company, 1909, reprinted Dover, 1979.

—. *More Craftsman Homes*. New York: The Craftsman Publishing Company, 1912.

Sweeney, Robert. *Frank Lloyd Wright: An Annotated Bibliography*. Los Angeles: Hennessey and Ingalls, 1978.

Teitelman, Edward. 'Wilson Eyre and the Colonial Revival in Philadelphia', in Alan Axelrod, ed. *The Colonial Revival in America*. New York: W. W. Norton with Winterthur Museum, 1985.

Twombly, Robert. *Louis Sullivan: His Life and Work*. University of Chicago Press, 1986.

Weitze, Karen J. *California's Mission Revival*. Los Angeles: Hennessey and Ingalls, 1984.

Winter, Robert. *The California Bungalow*. Los Angeles: Hennessey and Ingalls, 1980.

Wit, William de, ed. *The Function of Ornament: The Architecture of Louis Sullivan*. New York: W. W. Norton with the Chicago Historical Society, 1986.

Wright, Frank Lloyd. *An Autobiography*. New York: Duell, Sloan and Pearce, 1943.

—. *Writings and Buildings*. New York: Meridan, 1960.

Wright, Gwendolyn. *Building the Dream: A Social History of Housing in America*. Cambridge, MA: MIT Press, 1983.

—. *Moralism and the Model Home: Domestic Architecture and Cultural Conflict in Chicago, 1873–1913*. Chicago and London: University of Chicago Press, 1980.

Chapter Five

Addams, Jane. *Twenty Years at Hull-House*. New York: MacMillan, 1910.

American Art Pottery: Cooper-Hewitt Museum. New York: Cooper-Hewitt Museum, 1987.

Arnest, Barbara, ed. *Van Briggle Pottery: The Early Years* (exh. cat.). Colorado Springs Fine Art Center, 1975.

The Arts and Crafts Furniture Work of L. & J. G. Stickley, c. 1914, reprinted, Watkins Glen, NY: American Life Foundation, 1978.

Arts and Crafts in Detroit 1906–1976 (exh. cat.). Detroit: The Detroit Institute of Arts, 1976.

Ayres, William, ed. *A Poor Sort of Heaven A Good Sort of Earth: The Rose Valley Arts and Crafts Experiment* (exh. cat.). Chadds Ford, PA: Brandywine River Museum, 1983.

Batchelder, Ernest. *Design in Theory and Practice*. New York: MacMillan, 1910.

Bavaro, Joseph J., and Thomas Mossman. *The Furniture of Gustav Stickley: History, Techniques, Projects*. New York: Van Nostrand Reinhold, 1982.

Blasberg, Robert W. *The Ceramics of William H. Grueby: Catalog of an Exhibition at the Everson Museum of Art*. Syracuse, NY: Everson Museum of Art, 1981.

—, with Carol L. Bohdan. *Fulper Art Pottery: An Aesthetic Appreciation, 1909–1929* (exh. cat.). New York: Jordon-Volpe Gallery, 1979.

The Book of the Roycrofters. Roycroft Shop catalogues, 1919, 1926, reprinted East Aurora, NY: House of Hubbard, 1977.

Bray, Hazel V. *The Potter's Art in California, 1885–1955* (exh. cat.). Oakland Museum, CA, 1980.

Brunk, Thomas W., et al. *The Arts and Crafts Movement in Michigan: 1886–1906*. Detroit: Pewabic Society, 1986.

Cathers, David M. *Furniture of the American Arts and Crafts Movement*. New York: New American Library, 1981.

Champney, Freeman. *Art and Glory: The Story of Elbert Hubbard*. New York: Crown, 1968.

Chickering, Elenita. *Arthur J. Stone: Handwrought Silver, 1901–1937* (exh. cat.). Boston Athenaeum, 1981.

Dale, Sharon. *Frederick Hurten Rhead: An English Potter in America* (exh. cat.). Erie Art Museum, PA, 1987.

Darling, Sharon. *Chicago Ceramics and Glass* (exh. cat.). Chicago Historical Society, 1979.

—. *Chicago Furniture: Art, Craft, and Industry 1833–1983*. Chicago Historical Society, 1984.

—. *Chicago Metalsmiths* (exh. cat.). Chicago Historical Society, 1977.

—. *Teco: Art Pottery of the Prairie School* (exh. cat.). Erie Art Museum, PA, 1989.

Dietz, Ulysses G. *The Newark Museum Collection of American Art Pottery*. Newark Museum, NJ, 1984.

Dow, Arthur Wesley. *Composition*. Garden City, NY: Doubleday, Page, 1920.

Duncan, Alastair, Martin Eidelberg and Neil Harris. *Masterworks of Louis Comfort Tiffany*. London and New York: Thames and Hudson and Abrams, 1989.

Eaton, Allen Hendershott. *Handicrafts of New England*. New York: Harper and Brothers, 1949.

Edwards, Robert. *The Byrdcliffe Arts and Crafts Colony: Life by Design*. Wilmington: Delaware Art Museum, 1985.

Eidelberg, Martin, ed. *From our Native Clay: Art Pottery from the Collections of the American Ceramic Arts Society*. New York: Turn of the Century, 1987.

Evans, Paul. *Art Pottery of the United States*. New York: Feingold & Lewis, 1987.

Finlay, Nancy. *Artists of the Book in Boston, 1800–1910*. Cambridge, MA: Houghton Library, 1985.

Freeman, John Crosby. *The Forgotten Rebel, Gustav Stickley and His Craftsman Mission Furniture*. Watkins Glen, NY: Century House, 1965.

Gray, Stephen, ed. *Arts and Crafts Furniture: Shop of the Crafters at Cincinnati*. Reprint, New York: Turn of the Century, 1983.

—. *A Catalog of the Roycrofters*. Reprint, New York: Turn of the Century, 1989.

—. *The Early Work of Gustav Stickley*. Reprint, New York: Turn of the Century, 1987.

—. *Lifetime Furniture*. Reprint, New York: Turn of the Century, 1981.

—. *Limbert's Holland Dutch Arts and Crafts Furniture*. Reprint, New York: Turn of the Century, 1981.

—. *The Mission Furniture of L. and J. G. Stickley*. Reprint, New York: Turn of the Century, 1983.

—. *Quaint Furniture: Arts and Crafts*. Reprint, New York: Turn of the Century, 1981.

—. *Roycroft Furniture*. Reprint, New York: Turn of the Century, 1981.

Gray, Stephen, and Robert Edwards, eds. *The Collection Works of Gustav Stickley*. Reprint, New York: Turn of the Century, 1981.

Hawes, Lloyd E. *Dedham Pottery and the Earlier Robertson's Chelsea Pottery*. Dedham Historical Society, MA, 1968.

Howe, Margery Burnham. *Deerfield Embroidery: Traditional Patterns from Colonial Massachusetts*. New York: Scribner's, 1976.

Hunter, Dard. *My Life with Paper*. New York: Knopf, 1958.

Johnson, Bruce. *The Official Identification and Price Guide to Arts and Crafts*. New York: House of Collectibles, 1988.

Jones, Harvey. *Mathews: Masterpieces of the California Decorative Style*. Santa Barbara and Salt Lake City: Peregrine Smith, 1980.

Keen, Kirsten Hoving. *American Art Pottery 1875–1930*. Philadelphia: Falcon Press, 1978.

Kiehl, David. *American Art Posters of the 1890's in the Metropolitan Museum of Art* (exh. cat.). New York: Metropolitan Museum of Art, 1987.

Koch, Robert. *Louis Tiffany: Rebel in Glass*. New York: Crown, 1964.

Lynn, Catherine. *Wallpaper in America, from the Seventeenth Century to World War I*.

New York: W. W. Norton, 1980.

Mahoney, Olivia. *Edward F. Worst, Craftsman and Educator*. Chicago Historical Society, 1985.

Marek, Don. *Arts and Crafts Furniture Design, The Grand Rapids Contribution 1895–1915* (exh. cat.). Grand Rapids Art Museum, 1987.

Moffatt, Frederick C. *Arthur Wesley Dow (1857–1922)*. Washington, DC: Smithsonian Institution Press, 1977.

Nelson, Scott H., et al. *A Collector's Guide to Van Briggle Pottery*. Indiana, PA: Halldin, 1986.

Pearce, Clark. *Addison B. Le Boutillier: Andover Artist and Craftsman*. Andover Historical Society, 1987.

Poesch, Jessie. *Newcomb Pottery: An Enterprise for Southern Women, 1895–1940*. Exton, PA: Schiffer, 1984.

Postle, Kathleen. *The Chronicle of the Overbeck Pottery*. Indianapolis: Indiana Historical Society, 1978.

Stickley, Gustav. *Catalogue of Craftsman Furniture Made by Gustav Stickley at the Craftsman Workshops, 1909*. Reprint, Watkins Glen, NY: American Life Foundation, 1978.

Thompson, Susan Otis. *American Book Design and William Morris*. New York: Bowker, 1977.

Trapp, Kenneth R. *Ode to Nature: Flowers and Landscapes of the Rookwood Pottery, 1880–1940*. New York: Jordon-Volpe Gallery, 1980.

Wattenmaker, Richard. *Samuel Yellin in Context*. Flint Institute of Arts, MI, 1985.

Weiss, Peg, ed. *Adelaide Alsop Robineau: Glory in Porcelain*. Syracuse University Press, NY, 1981.

Wheeler, Candace. *Principles of Home Decoration*. New York: Doubleday, Page, 1903.

Chapter Six

Burckhardt, Lucius. *The Werkbund: History and Ideology 1907–1933*. New York: Barrons Educational Series, 1980.

Campbell, Joan. *The German Werkbund: The Politics of Reform in the Applied Arts*. Princeton University Press, 1978.

Éri, Gyöngi, and Zsuzsa Jobbágyi. *A Golden Age: Art and Society in Hungary 1896–1914*. London and Miami: Barbican Art Gallery and Center for the Fine Arts, 1989.

Faunce, Sarah, et al. *Carl Larsson* (exh. cat.). New York: Brooklyn Museum and Holt, Rinehart and Winston, 1982.

Fenz, Werner. *Koloman Moser: Graphik, Kunstgewerbe, Malerei*. Salzburg and Vienna: Residenz, 1984.

Finskt 1900 (exh. cat.). Stockholm: Nationalmuseum, 1971.

Föreningen Handarbetets Vänner 1874–1949: Jubileumsutställning (exh. cat.). Stockholm: Nationalmuseum, 1949.

Georg Jensen Silversmithy: 77 Artists, 75 Years. Washington DC: Smithsonian Institution Press, 1980.

Gerk, János, Attila Kovács and Imre Makovecz. *A Századforduló Magyar Építészete* (Hungarian Architecture at the Turn of the Century). Budapest: Szépirodalmi Könyvkiadó, 1990. [English intro.]

Haiko, Peter, and Bernd Krimmel. *Joseph Maria Olbrich: Architecture. Complete reprint of the original plates of 1901–1914*. London: Butterworth Architecture, 1988.

Hård af Segerstad, Ulf. *Design in Scandinavia: Denmark, Finland, Norway, Sweden* (exh. cat.). Australia and Stockholm: State Galleries of Australia and Victoria Pettersons, 1968.

Hausen, Marika. *Saarinen in Finland*. Helsinki: Museum of Finnish Architecture, 1984.

Heskett, John. *Design in Germany 1870–1918*. London: Trefoil, 1986.

Hiesinger, Kathryn Bloum. *Art Nouveau in Munich: Masters of Jugendstil*. Munich and Philadelphia: Prestel with Philadelphia Museum of Art, 1988.

Hungarian Art Nouveau. Washington, DC: Smithsonian Institution Traveling Exhibition Service, 1977.

Hvitträsk: Koti Taideteoksena (Hvitträsk: The Home as a Work of Art). Keuruu: Museum of Finnish Architecture and Kustannusosakeyhtiö Otavan, 1987.

Jervis, Simon. *Furniture of about 1900 from Austria and Hungary in the Victoria and Albert Museum*. London: Victoria and Albert Museum, 1986.

Kallir, Jane. *Viennese Design and the Wiener Werstätte*. New York and London: Galerie St Etienne with Braziller and Thames and Hudson, 1986.

Keserü, Katalin. 'The Workshops of Gödöllö: transformations of a Morrisian theme'. *Journal of Design History* (Oxford) vol. 1, no. 1 (1988).

Lane, Barbara Miller. *Architecture and Politics in Germany 1918–45*. Cambridge, MA: Harvard University Press, 1968.

Latham, Ian. *Olbrich*. London: Academy Editions, 1980.

Louis Sparre 1863–1964 (exh. cat.). Stockholm: Prins Eugens Waldemarsudde, 1981. [English summary]

Madsen, Karl Johan Vilhelm. *Thorvald Bindesböll*. Copenhagen: Det Danske Kunstindustrimuseum, 1943.

McFadden, David Revere, gen. ed. *Scandinavian Modern Design 1880–1980*. New York: Abrams, 1982.

Nerdinger, Winfried, ed. *Richard Riemerschmid, vom Jugendstil zum Werkbund: Werke und Dokument*. Munich: Prestel, 1982.

Schweiger, Werner J. *Wiener Werkstätte: Design in Vienna 1903–1932*. New York and London: Abbeville and Thames and Hudson, 1984.

Sembach, Klaus-Jürgen. *Henry Van de Velde*. Stuttgart and London: Hatje and Thames and Hudson, 1989.

Smith, John Boulton. *The Golden Age of Finnish Art – Art Nouveau and the National Spirit*. Keuruu: Kustannusosakeyhtiö Otavan, 1976.

Tue, Anniken. *Frida Hansen (1855–1931): Europeeren i norsk vevkunst* (exh. cat.). Oslo: Kunstindustrimuseet, 1973. [English summary]

Tuomi, Ritva. 'Kansallisen tyylin etsimisesta: On the search for a national style'. *Abacus: Museum of Finnish Architecture Yearbook 1979* (Helsinki).

Varnedoe, Kirk. *Vienna 1900: Art, Architecture and Design*. New York: Museum of Modern Art, 1986.

Vergo, Peter. *Art in Vienna 1898–1918*. Oxford: Phaidon, 1981.

Windsor, Alan. *Peter Behrens: Architect and Designer 1868–1940*. London: Architectural Press 1981.

Zahle, Erik, ed. *Scandinavian Domestic Design*. London: Methuen, 1963.

List of Illustrations

Measurements are in inches and centimetres, height before width before depth.

book *Days to be Remembered*, $7\frac{3}{4} \times 6\frac{1}{2} \times \frac{3}{4}$ (19.4 × 16.5 × 2). Photo David Davison

63 Rug, *c.* 1928, Dun Emer Guild. Hand-knotted pile on jute warp, 89 × 107 (226 × 271.7). Photo David Davison

64 *The Wagner Girdle and Buckle* 1896, Alexander Fisher. Steel with enamel plaques, $3\frac{7}{8} \times 22\frac{1}{4}$ (9.8 × 56.5). By courtesy of the Board of Trustees of the Victoria and Albert Museum, London

65 *The Galahad Cup of Honour* 1902–03, Arthur Gaskin. Silver, enamels and lapis lazuli, $21\frac{1}{2} \times 7\frac{7}{8}$ (54.6 × 20). Cheltenham College. Photo by permission of the Birmingham Museum and Art Gallery

66 Writing desk, 1902, designed by Charles Rennie Mackintosh, gesso panels by Margaret Macdonald Mackintosh. Ebonized wood with metal and glass panels, $58\frac{1}{4} \times 48\frac{7}{8} \times 11\frac{3}{4}$ (148 × 124 × 30). Österreichisches Museum für Angewandte Kunst, Vienna

67 Cushion cover, *c.* 1900, Jessie Newbery. Linen appliqué embroidered in silks with edges of needleweaving, $22\frac{3}{4} \times 25\frac{1}{2}$ (57.7 × 64.7). By courtesy of the Board of Trustees of the Victoria and Albert Museum, London

68 John Duncan *The Awakening of Cuchullin*, *c.* 1894. Mural, Ramsay Lodge, Edinburgh. Courtesy Lloyds Bowmaker, Dealer Finance Division. Photo Royal Commission on the Ancient and Historical Monuments of Scotland

69 *The Victory* 1900–02, Phoebe Traquair. Silks and gold thread embroidered on linen panel, $74\frac{1}{2} \times 29\frac{1}{4}$ (188.2 × 74.2). National Gallery of Scotland

70 George Logan, library, designed for the Wylie and Lochhead Pavilion, 1901 Glasgow International Exhibition. Photo Glasgow Museums and Art Galleries

71 *Owl* 1898, designed by C. F. A. Voysey, woven by Alexander Morton and Co. Wool tapestry. By courtesy of the Board of Trustees of the Victoria and Albert Museum, London

72 Liberty chair, from their *Inexpensive Furniture* catalogue, 1905. Satinwood, $40 \times 17 \times 16\frac{1}{2}$ (101.5 × 43.2 × 41.9). By courtesy of the Board of Trustees of the Victoria and Albert Museum, London

73 Liberty waist-buckle, 1906, designed by Jessie M. King. Silver and enamel. Glasgow Art Gallery and Museum

74 Liberty 'Cymric' vase, 1902, designed by Archibald Knox. Silver and turquoise, 12 (4.7) h. Courtesy Mervyn Levy

75 'A Cottage Room', 1905, from a Heal and Son catalogue. Courtesy Heal's archives

76 Dryad 'Traveller's Joy' armchair, *c.* 1907, designed by Benjamin Fletcher, made at Dryad, Leicester. Woven cane, $38\frac{3}{4} \times 32 \times 22\frac{5}{8}$ (97.5 × 81.5 × 57.5). Cheltenham Art Gallery and Museums

77 Cabinet, 1924, designed by Gordon Russell at Russell & Sons. English walnut inlaid with ebony, yew and box with handles in ebony and laburnum, $56\frac{1}{2} \times 35\frac{5}{8} \times 15\frac{3}{8}$ (143.5 × 91 × 39). Steelcase Strafor plc. Photo Eileen Tweedy

78 Ethel Mairet's spinning and weaving room, Gospels, Ditchling, Sussex. From *The Queen* 1932

79 Vase, *c.* 1925, Bernard Leach. Mottled and chün glaze. $6\frac{1}{4}$ (16) h. University College of Wales, Aberystwyth

80 Eric Gill, first of the 'Stations of the Cross', 1913–18. Bas-relief, Hoptonwood stone, $66\frac{7}{8} \times 66\frac{7}{8}$ (170 × 170). Westminster Cathedral, London

81 Cram, Goodhue and Ferguson, St John's Church, West Hartford, CT, 1907–09. Perspective from *A Book of Architectural and Decorative Drawings* by Bertram Grosvenor Goodhue 1914

82 Bertram Goodhue, St Thomas's Church, New York, interior, 1914–20. Photo The Museum of the City of New York, Wurts Collection

83 Bertram Goodhue, St Thomas's Church, New York, exterior, 1903–13. Photo The Museum of the City of New York, Wurts Collection

84 Model of the Holy Grail window *Sir Bors Sucoures the Mayde*, *c.* 1919, by Charles Connick Associates for Proctor Hall, Princeton University. Stained glass, $24 \times 16\frac{1}{2}$ (61 × 41.9). The Charles J. Connick Stained Glass Foundation, Ltd. Photo Daniel Farber

85 H. H. Richardson, William Watts Sherman house, Newport, RI, 1874–76. Perspective by Stanford White, 1874, from *New York Sketch Book of Architecture*, May 1875. New York Public Library, Astor, Lenox and Tilden Foundations

86 Stevens and Cobb, 'House at Delano Park', Cape Elizabeth, ME, 1889. Perspective from *Examples of American Domestic Architecture* by John Calvin Stevens and Albert Winslow Cobb, 1889. New York Public Library, Astor, Lenox and Tilden Foundations

87 John Calvin Stevens, Richard Webb house, Portland, ME, 1906–07. Photo Richard Cheek

88 Wilson Eyre, William Turner house, Philadelphia, PA, 1907. From *The American Architect* 2 December, 1908

89, 90 Greene and Greene, David B. Gamble house, Pasadena, CA, 1908–09. Photos Tim Street-Porter

91 *Rip Van Winkle* fireplace, 1915, Henry Chapman Mercer, Moravian Pottery and Tile Works, Doylestown, PA. Unglazed smoked earthenware, 44 × 68 (111.8 × 172.7). Saugerties Public Library, Saugerties, N.Y. Photo Cleota Reed

92 Interior gate, 1926, Samuel Yellin workshop, Philadelphia, PA. Triple refined wrought iron, 34 × 60 (60.9 × 152.4). Courtesy Richard J. Wattenmaker

93 Frank Lloyd Wright, Ward W. Willits house, Highland Park, IL, 1902, presentation drawing. Black and brown ink, watercolour, gouache and crayon on opaque paper, $8\frac{3}{4} \times 32\frac{1}{4}$ (22.2 × 81.9). Frank Lloyd Wright Foundation

94 Frank Lloyd Wright, Charles Ross house, Delavan Lake, WI, 1902, plan

95 Arthur S. Heineman, bungalow, Pasadena, CA, *c.* 1911. Heineman Collection, The Greene and Greene Library, The Gamble House/USC, Pasadena

96 Arthur Burnett Benton, Glenwood Mission Inn, Riverside, CA, *c.* 1902–27. Perspectation drawing by William Sharp, 1908. Ink and watercolour, $14\frac{3}{4} \times 43$ (37.5 × 109.2). The Mission Inn Foundation, Riverside, CA

97 Irving Gill, La Jolla Women's Club, La Jolla, CA, 1912–14. Photo Peter Davey

98 Irving Gill, Walter Luther Dodge house, Los Angeles, 1914–16. Photo Marvin Rand

99 Bernard Maybeck, Guy Hyde Chick house, Berkeley, CA, 1914. Courtesy Bancroft Library, University of California. Photo Roy Flamm

100 Adler and Sullivan, Wainwright building, St Louis, 1890–91. Photo Hedrich-Blessing

101 Frank Lloyd Wright, Frederick C. Robie house, Chicago, 1906–08. Photo Sandy Milliken

102 Frank Lloyd Wright, Frederick C. Robie house, Chicago, 1906–08. Photo The David and Alfred Smart Museum of Art, The University of Chicago; copyright Domino's Pizza Collection, Ann Arbor, MI

103 Walter Burley Griffin, Hurd Comstock house, Evanston, IL, 1912. Photo H. Allen Brooks

104 George Niedecken, design for table/desk and chair, *c.* 1912, Henry B. Babson house, Riverside, IL. Ink and watercolour, $13\frac{1}{2} \times 20$ (34.3 × 50.8). Frank Lloyd Wright and Prairie School Collection, Milwaukee Art Museum, Gift of Mr and Mrs Robert L. Jacobson

105 Purcell, Feick and Elmslie, Merchants Bank of Winona, Winona, MN, 1911–12. Photo Collection David Gebhard, Santa Barbara, CA

106 Purcell and Elmslie, Purcell house, Lake Place, Minneapolis, 1913. Photo Collection David Gebhard, Santa Barbara, CA

107 William Coulter, Knollwood Club, Lower Saranac Lake, NY, 1899. Courtesy Adirondack Museum

108 Frank Lloyd Wright, 'A Fireproof House for $5000'. Perspective and plans from *The Ladies' Home Journal* April 1907

109 'A simple straightforward design from which many homes have been built', from *The Craftsman* January 1909. Photo courtesy The Winterthur Library: Printed Book and Periodical Collection

110 Harvey Ellis, design for an 'urban house', from *The Craftsman* August 1903. Photo courtesy The Winterthur Library: Printed Book and Periodical Collection

111 Will Bradley, drawing for a library, 1901, from *The Ladies' Home Journal* 1902. Watercolour with pen and ink, $25\frac{1}{2} \times 37\frac{1}{2}$ (64.7 × 95.3). The Henry E. Huntington Library and Art Gallery, San Marino, CA

112 Vase, 1903, decorated by Harriet Joor for Newcomb College Pottery, New Orleans. Earthenware with high gloss glaze, $9\frac{1}{4}$ (23.5) h. Private collection. Photo Robert A. Hut

113 Library table, *c.* 1906, Craftsman Workshops, Eastwood, NY. Oak and leather 30 × 55 (76.2 × 129.7). The Metropolitan Museum of Art, New York, Gift of Cyril Farny in memory of Phyllis Holt, 1976

114 Fall-front desk, *c.* 1903–04, designed by Harvey Ellis for Craftsman Workshops, Eastwood, NY. American white oak inlaid with pewter, copper and exotic woods, $46\frac{1}{2} \times 42 \times 11\frac{1}{2}$ (118.1 × 106.7 × 29.2). Virginia Museum of Fine Arts, Richmond, VA, Gift of Sydney and Frances Lewis

115 Morris chair, *c.* 1903, Craftsman Workshops, Eastwood, NY. American oak and leather, $41 \times 31\frac{1}{2} \times 38$ (104.1 × 80 × 96.5). Courtesy Cathers and Dembrosky, New York

116 *The Altar Book* 1896, decorations designed by Bertram Goodhue and illustrations by Robert Anning Bell for the Merrymount Press, Boston. $14\frac{7}{8} \times 11\frac{1}{8}$ (37.9 × 28.2). Princeton University Library, NJ

117 Vase, *c.* 1886–88, Hugh Robertson at the Chelsea Keramic Art Works, Chelsea, MA. Stoneware, red-blue reduction glazes

213

with gold highlights, 8 (20.3) h. Private collection. Photo Robert A. Hut
118 Embroidered mat, *c.* 1896–1900, Society of Blue and White Needlework, Deerfield, MA. Linen threads on foundation cloth, 9 (22.7) diam. Pocumtuck Valley Memorial Association, Memorial Hall Museum, Deerfield, MA
119 Punch bowl, 1910, Robert Jarvie, Chicago. Silver, 10¼ × 16¾ (26 × 39.3). Cliff Dwellers Club, Chicago
120 Table lamp, *c.* 1910, Dirk Van Erp Studio, San Francisco. Copper and stained mica, 19 × 19¾ (48.2 × 50.2). Collection Robb Carr
121 Creamer and sugar bowl, *c.* 1908, designed by Clara Pauline Barck Welles at The Kalo Shop, Chicago. Silver and jade: creamer 2¼ × 4¾ (5.4 × 12.1), sugar bowl 2¼ × 4⅝ (5.4 × 11.8). Courtesy Chicago Historical Society
122 *Paradise Lost* by John Milton, binding by Ellen Gates Starr, 1902, at Hull House, Chicago. 9⅞ × 6⅞ (23.8 × 17.5). The Department of Special Collections, The University of Chicago Library
123 Vase, 1915, Paul Revere Pottery of the Saturday Evening Girls' Club, Boston/Brighton, MA. Earthenware with matte glazes and incised decoration, 8½ (21.6) h. Courtesy Society for the Preservation of New England Antiquities, Boston. Photo J. David Bohl
124 Vase, *c.* 1898–1902, designed by George Prentiss Kendrick for the Grueby Faience Company, Boston. Buff stoneware with matte glaze, 10⅞ × 5¾ (27.5 × 14.6). The Kay Collection
125 Poster, 1895, Arthur Wesley Dow for *Modern Art.* Lithograph, 20 × 15¾ (50.8 × 39). The Metropolitan Museum of Art, New York, Leonard A. Lauder Collection of American Posters, Gift of Leonard A. Lauder, 1984 (1984.1202.35). Photo Bobby Hanson
126 Vase, *c.* 1908–20, Arthur E. Baggs at Marblehead Pottery, Marblehead, MA. Earthenware, 9½ × 6¼ (24.1 × 15.8). Collection Stephen Gray. Photo Robert A. Hut
127 Vase, 1909, decorated by Carl Schmidt for Rookwood Pottery, Cincinnati. Glazed earthenware, 13¾ × 5½ (34.9 × 13.9). Collection of The Newark Museum, purchase 1914
128 *Scarab Vase*, 1910, Adelaide Alsop Robineau, Syracuse, NY. Excised, perforated and glazed porcelain, 16⅝ (42.2) h. Collection of the Everson Museum of Art, Syracuse, NY. Photo Courtney Frisse
129 Vase, 1915, Overbeck Pottery, Cambridge City, IN. Earthenware, 10 × 7 (25.4 × 17.5). Collection Stephen Gray. Photo Robert A. Hut
130 Teco vase, 1904–05, designed by Fritz Albert for Gates Pottery, Terra Cotta, IL. Earthenware with matte glaze, 14⅝ × 4⅞ (36.5 × 12.4). Private collection
131 Desk and chair, *c.* 1900, Charles Rohlfs, Buffalo, NY. Oak and leather: desk 72 × 57 × 36 (182.9 × 144.8 × 91.4), chair 36 × 29 × 22 (91.4 × 73.7 × 55.9). The Manney Collection
132 Vase, 1903, Van Briggle Pottery, Colorado Springs. Glazed earthenware with

matte glaze, 11¾ × 4 (28.9 × 10.2). Collection of The Newark Museum, Estate of John Cotton Dana, 1929
133 *Meadow Grass* by Alice Brown, 1895, cover designed by Louis Rhead for Copeland and Day. 4¼ × 7⅛. By permission of the Houghton Library, Harvard University, MA
134 Box, 1929, Lucia Kleinhans Mathews at The Furniture Shop, San Francisco. Painted wood, 5 × 12 × 16 (12.7 × 30.5 × 40.6). Collection of the Oakland Museum, Oakland, CA. Photo Joe Samberg
135 Portière, *c.* 1884, designed by Candace Wheeler, fabric made by Cheney Brothers, Hartford, CT. Embroidered silk, sequins and glass beads, 93 × 58¾ (236.2 × 149.2). The Metropolitan Museum of Art, New York, Gift of the family of Mrs Candace Wheeler, 1928 (28.34.1)
136 Sugar basket, *c.* 1915, Arthur J. Stone, Gardener, MA. Silver, 5½ × 5½ (14 × 14). Courtesy ARK Antiques, New Haven, CT
137 Music stand, *c.* 1901–06, designed by Will Price at the Rose Valley Shops, Rose Valley, PA. Carved oak, 43 × 20 × 15 (109.2 × 50.8 × 38.1). Courtesy Mr and Mrs H. Myers
138 *Justinian and Theodora* by Elbert and Alice Hubbard, 1906, designed by Dard Hunter for the Roycroft Press, East Aurora, NY. Title page, 7¾ × 5¾ (19.7 × 14.6). Photo courtesy The Winterthur Library: Printed Book and Periodical Collection
139 'McKinley chair', *c.* 1894–1920's, designed by David Wolcott Kendall for the Phoenix Furniture Company, Grand Rapids, MI. Oak, 35 × 30 × 22 (88.9 × 76.2 × 55.9) Grand Rapids Public Museum
140 Plant stand, *c.* 1910, Charles P. Limbert Company, Grand Rapids and Holland, MI. American oak, 24 × 16½ × 16½ (61 × 41.9 × 41.9). Courtesy Cathers and Dembrosky, New York
141 Desk, *c.* 1894–1901, Stickley Brothers Company, Grand Rapids, MI. Oak inlaid with different woods, 43 × 26 × 35½ (109.2 × 66 × 90.1). Bryce Bannatyne Gallery, Santa Monica, CA
142 'In one sense a workroom is always a library', from *The Craftsman* December 1905
143 'Chimneypiece and fireside seats in a typical Craftsman living room', from *The Craftsman*, April 1907. Photo courtesy The Winterthur Library: Printed Book and Periodical Collection
144 Jardinière, 1900, Torolf Prytz for J. Tostrup, Oslo. Silver, cast and chased, 13¾ × 20⅞ (35 × 53). Kunstindustrimuseet, Oslo. Photo Atelier Teigen, Oslo
145 Dining room, *c.* 1903, designed by Louis Sparre at the Iris factory, Porvoo. Watercolour. Museum of Applied Arts, Helsinki
146 'The Flame' *ryijy* 1899, designed by Akseli Gallen-Kallela, woven by the Friends of Finnish Handicrafts. Woven wool, 128 × 67 (325 × 170). Gallen-Kallela Museum, Espoo, Finland
147 Herman Gesellius, Armas Lindgren and Eliel Saarinen, Finnish Pavilion, 1900 Paris Exposition Universelle. Museum of Finnish Architecture, Helsinki

148, 149 Gesellius, Lindgren and Saarinen, Hvitträsk, Lake Vitträsk, 1901–03. Photos Hvitträsk Museum
150 Coffee-pot, 1906, designed by Johan Rohde for Georg Jensen Sølvsmedie, Copenhagen. Sterling silver, 5⅛ (13) h. Statens konstmuseer, Stockholm. Photo courtesy Georg Jensen, Copenhagen
151 Portières, 1900, designed by Frida Hansen, woven by Det Norske billedvaeveri, Oslo. Wool in tapestry technique, 100¾ × 43¼ (256 × 110). Statens konstmuseer, Stockholm
152 Plate, 1901, designed by Thorvald Bindesbøll for Københavns Lervarefabrik, Copenhagen. Glazed earthenware, 2⅛ × 17¾ (5.5 × 45). Det Danske Kunstindustrimuseet, Copenhagen. Photo Ole Woldbye
153 Watercolour on paper, 1895. Watercolour on paper, 12⅞ × 17 (32 × 43). Statens konstmuseer, Stockholm
154 Writing desk, 1903, designed by Koloman Moser for the Charlottenlund Palace, Stockholm. Elm, rosewood, ebony, mother of pearl and ivory, 43¼ (109.8) h. Courtesy Barry Friedman Ltd, New York
155 Joseph Maria Olbrich, Olbrich house living-room, Darmstadt, 1900–01. Pencil and watercolour, 12⅞ × 6⅞ (32.7 × 17.5). Hessisches Landesmuseum, Darmstadt
156 *Women of Kalotaszeg* 1908, Aladár Körösfői-Kriesch, Gödöllő. Tapestry in Scherebeck technique, 64½ × 57 (164 × 145). Municipal Collection, Gödöllő. Photo courtesy K. Keserü
157 Sándor Nagy *Julia, Lovely Girl* 1913, Gödöllő. Cartoon. Sándor Nagy's house, Gödöllő. Photo courtesy K. Keserü
158 Ödön Lechner, Postal Savings Bank, Budapest, 1899–1901. Photo Hungarian Museum of Architecture, Budapest
159 Károly Kós, design for a manor house, from his *Magyar Iparművészet* 1908
160 Vase, *c.* 1900, Zsolnay factory, Pécs. Eosine-glazed ceramic, 16⅛ × 10⅝ (41 × 27). Private collection
161 Josef Hoffmann, Purkersdorf Sanatorium, Vienna, 1904–05. From *Deutsche Kunst und Dekoration* 1906–07
162 Wine goblet, *c.* 1905, designed by Otto Prutscher for the Wiener Werkstätte. Flashed and hand-painted glass, 8½ (20.6) h. Collection, The Museum of Modern Art, New York. Estée and Joseph Lauder Design Fund
163 Chair, 1904–06, designed by Richard Riemerschmid for the Dresdener Werkstätten für Handwerkskunst. Oak, 35¼ × 16¾ × 17⅞ (89.5 × 42.5 × 45.5). Staatliche Kunstsammlungen, Museum für Kunsthandwerk, Dresden
164 Side chair, *c.* 1895–98, designed by Henry van de Velde for Bloemenwerf, Uccle, Belgium. Padauk wood and rush, 37 × 17⅞ × 16 (94 × 44.1 × 40.6). Virginia Museum of Fine Arts, Richmond, VA, Gift of Sydney and Frances Lewis (85.82)
165 Railway dining-car interior, designed by August Endell for Van der Zypen & Charlier, exhibited at 1914 Cologne Werkbund Exhibition
166 Poster, 1907, designed by Peter Behrens for AEG, Berlin. Lithograph, 26¾ × 20½ (67 × 52). Courtesy AEG

Index